# Carolina Crimes

To ANN,
A freind in the
"Forensics" world.
Hope you enjoy
the book.

Best,

Rita Y. Shuler

10-27-06

# Carolina Crimes

## Case Files of a Forensic Photographer

Rita Y. Shuler

Charleston · London

History
PRESS

Published by The History Press
Charleston, SC 29403
www.historypress.net

Copyright © 2006 by Rita Y. Shuler
All rights reserved

*Cover Images*: SLED case files.

First published 2006

Manufactured in the United Kingdom

ISBN 1.59629.166.4

Library of Congress Cataloging-in-Publication data applied for.

*Sickness is a condition. Evil is a behavior. Evil is always a matter of choice. Evil is not thought: it is conduct, and that conduct is always volitional. And just as evil is always a choice; Sickness is always the absence of choice. Sickness happens. Evil is inflicted.*

Andrew Vachss

Andrew Vachss is an attorney who represents children and youth exclusively. A complete bibliography and comprehensive resources on child protection may be found at his dedicated website: www.vachss.com

In memory of my mama and daddy who gave me life and raised me right.

To Chase, my grandnephew and "crabbin-buddy." May he always love life and be as happy as I have been.

# Contents

Acknowledgements                                         13
Author's Note                                            17
Prologue                                                 19

South Carolina Law Enforcement Division                 27
Forensic Photography                                    33
South Carolina Death Penalty                            37
My First Month                                          40
Resentencing Trial of Rudolph Tyner                     63
Resentencing Trial of Ronald "Rusty" Woomer             73
The Composite                                           81
He Said, He Said                                        86
The Barbell                                            107
Signature Written in Blood                             111
The Body Print                                         118
Signatures Left Behind                                 122
The Business Card                                      139
The Rocking Chair                                      144
Twenty-eight Days of Terror                            156

Notes                                                 185
Bibliography                                          187
About the Author                                      191

# Acknowledgements

The stories told in this book are a part of South Carolina's history. Some segments of interviews, statements, court transcripts and published articles have been edited to facilitate reading.

First and foremost my deepest thanks to my very dear friend, Kathleen Thornley, for her support, patience, encouragement and for always being there when I needed that extra push to stay on track. Her advice and timeless hours of proofreading helped me bring it all together.

Very special thanks to my family and friends for believing in me and encouraging me all along the way, and Bill Conklin, my mentor and special friend over the years, for giving me the encouragement to keep going strong.

Special thanks to my first South Carolina Law Enforcement Division (SLED) crime scene team who took me under their wings from day one and showed me the ropes: Lieutenant Dan DeFreese, who always had the right answer for me, Lieutenant Ira Parnell, Lieutenant Jim Springs, Lieutenant Bill Anderson, Lieutenant Mickey Dawson, Agent Jeff Darling, Terry Glenn and Gail Duke.

My personal thanks to SLED agents Captain David Caldwell and Lieutenant Roy Paschal for their assistance, and for our many conversations when we really needed to talk.

Conversations with retired SLED agents, Major Jim Wilson and Captain Walter Powell, provided me with much of SLED's history as well as some very interesting "war stories," some of which I thought safer not to include.

I sincerely appreciate Joel W. Townsend Jr. and Oren L. Brady Jr. for sharing their fathers' information with me.

Conversations with Wanda Summers and Debra Helmick Johnson offered me much personal insight for their stories.

I am particularly indebted to Janet Meyer, librarian of the South Carolina Supreme Court for her patience and expertise in assisting me with the South Carolina death penalty statutes and appeals process.

Former and present SLED agents helped me with pertinent information of the cases and forensic procedures to help put it all together: Chuck Counts, Don Girndt, Lieutenant "Skeet" Perry, Lieutenant Ken Habben, Major Steve Smith, Lieutenant Ira Parnell, Captain David Caldwell, Lieutenant Tom Darnell, Captain Larry Gainey, Lieutenant Emily Rhinehart, Inspector Richard Hutton, Lieutenant Gaile Heath, Lieutenant Hoss Horton, Agents John Christy, Dan DeFreese, Diane Bodie, Kerri McClary, Joe Leatherman, Vello Paavel and David Black.

My thanks to the following for assisting me with obtaining the investigative case files, court transcripts and other significant information: SLED agents and personnel, Captain Teresa Woods; Lieutenant Mike Brown; Lieutenant William "Skip" Whitmire; Sebrena Matthews; Cindy Dudley; Tammy Rawls; Mary Perry; Pat K. Martin and Denise Eargle; from the Richland County Solicitor's Office, former Solicitor Knox McMann, Debra Moore, Catherine Dievendorf and Thomas Amos; from the Lexington County Solicitor's Office, Solicitor Donnie Myers; from the Aiken County Solicitor's Office, Solicitor Barbara Morgan, Investigator Norwood Bodie and Stephanie Powers; from the Clarendon County Solicitor's Office, Deputy Solicitor Ferrell Cothran Jr. and Carole Bartlete; from the office of attorney general of South Carolina, Chief Deputy Attorney General Don Zelenka and librarian Susan Husman; Dr. Joel Sexton, forensic pathologist, Newberry County Memorial Hospital; Dr. Sandra Conradi, forensic pathologist, Medical University of South Carolina; Lennie Hicks, former investigator with Richland County Sheriff's Office; Bruce Jernigan, former instructor with South Carolina Criminal Justice Academy; Lieutenant Doug Richway, Manning Police Department; Lieutenant Bobby McLean, Lake View Police Department; Sheriff James Metts, Lexington County Sheriff's Office; Sheriff Harold Grice, Dillon County Sheriff's Office; Sheriff Bill Coffey, Spartanburg County Sheriff's Office; Kathi Turner, Georgetown County Sheriff's Office; Dennis Patterson and Sharon Small, South Carolina Department of Corrections; Amanda Stone, South Carolina State Library; Bill Rogers, executive director, South Carolina Press Association; Assistant Chief Joseph Graham, Kingstree Police Department.

*Even when faced with the murderous madness of criminals and in the presence of the silent agony of their victims, it is incumbent upon us to choose between escape and solidarity, shame and honor.*

Elie Wiesel

# Author's Note

M any times I am asked, "How did you do it? How did you live with it every day? How did you separate your work from your personal life? How did you sleep at night?"

I am a runner. I get out early mornings and get much physical and mental reward from my runs. Each day signals a new adventure, a new sensation and simply just another day to love life. I found myself almost feeling guilty when I went into work feeling so good. Running put me more in tune with my senses than I had ever been before, and it is a major part of my peacefulness with my life.

Some things I could leave in the lab and get back to later; some I could not. Some went home with me at night; but that was all a part of it. I had an intense passion for my work and an inner peace within myself where I could go and escape the bad and evil…for a while. I got used to them, but I never got over them.

As I worked with the cases, I would go through stages of anger and sadness. They got into my head. They got into my heart. Yes, they bothered me, but it would have bothered me more had I not felt something.

I have an amazing curiosity of criminal behavior and a bottomless pit of whys. What is the mindset of these people? Why do they do what they do? In their minds is it a moment of what they call power and control that takes them to the point of committing these senseless acts of evil? Is it because they have never been in control of their own self? Do different backgrounds

play a part in their actions? What gives them the right to take away the right of someone else? I guess we all wish we had a crystal ball to get the answers and the whys, but one thing I do know from dealing with this, in-depth, every day for twenty-four years, through my eyes and the eyes of my camera, is how precious life really is.

I tell the stories as I worked in their midst with sincere compassion and respect for the families and loved ones, and trust that my part helped in giving them some element of comfort.

# Prologue

It was a cold December afternoon in 1953. I was eight years old, and what my parents would tell me that day would be with me for the rest of my life.

The story was front-page headlines in *The State* newspaper.

In Pamplico, South Carolina, which was about seventy-five miles from our home in rural Orangeburg County, twenty-two-year-old Harvey B. Allen and fifteen-year-old Betty Claire Cain left for a date on Sunday night, December 6, 1953. Their families reported them missing when they failed to return home later that evening.

Allen's bloodstained car, a 1953 Plymouth, was found by schoolchildren around nine o'clock the next morning behind a nearby school. The front window on the driver's side was broken out, and some of Allen's clothes were thrown around inside the car. Blood and strands of auburn hair were found in the trunk.

Without delay, an intensive manhunt was launched for the pair. Around six o'clock that evening, Miss Cain's body was found in a shallow grave of straw, dirt and gravel at a popular area known as "lover's lane" or "the bluff" to everyone in Pamplico. Her head was missing.

Just yards away from the decapitated body were broken glass and bloodstains in the dirt. A bloody piece of tree limb approximately two and a half feet long was found a short distance away.

The bluff overlooking the Great Pee Dee River is about three miles outside of Pamplico down a country road lined with cornfields and trees. During

further investigation around the area, a tee shirt belonging to Allen was found in a tobacco barn near a fishpond. Evidence that a car had bogged down nearby was also found.

I held on tight to my mama's hand as she was reading this. It was the first time I had heard of something so horrible. I went to bed and pulled the covers over my head in fear of the monster out there that could do something so horrible as this.

We followed the details of the story in *The State*. On Wednesday, December 9, Mrs. Rosa Graham, who lived about two miles from the bluff, contacted law enforcement officers and informed them that car lights woke her up after midnight on Sunday night. The car drove by her house on a dirt road that dead-ended at an old, abandoned well. The well was camouflaged by cornstalks and was not plainly visible from the main road leading to the bluff.

Checking out all possible leads, officers went to the area. There in the well, they discovered Mr. Allen's body and Miss Cain's head. They both had gunshot wounds to the head. Burlap cotton sheets, a rubber car mat and a lady's coat were also found in the well.

South Carolina Law Enforcement Division Assistant Chief J.P. Strom and Lieutenant Millard Cate assisted with the crime scene investigation. They found several sets of shoeprints around the well. Later that day, Deputy Sheriff Ray Shupe found a muddy, bloodstained shovel under Mrs. Graham's house.

Then came a break in the investigation. Mrs. Graham's daughter, Margaret, who lived about a half-mile from the well, reported she had not seen her husband, J.W. Page, since the Sunday night the slayings occurred until the news of the discovery of the body and head in the well ran in the newspaper. He had come home, packed some clothes and said he was going back to Tarboro, North Carolina, to see his lawyer. She believed he had escaped from a North Carolina prison camp.

A check of Raleigh, North Carolina, prison records showed Raymond Carney, a thirty-eight-year-old black male who also used the alias J.W. Page, had escaped from a Wilson County prison camp in North Carolina in March of that same year. He had a long list of arrests and was described as cunning and mean. A photograph of Carney was obtained and identified by his wife and mother-in-law as the man they knew as J.W. Page. His wife also told officers he had a snub-nosed revolver.

At the South Carolina Law Enforcement Division in Columbia, Lieutenant Cate performed ballistic tests on the bullets from the victims. The results revealed that the pair had been shot in the head with a .38-caliber revolver.

Tests also revealed a bullet found in a tree in front of Carney's house was from the same gun that killed the victims.

Wanted posters were circulated, and the wide manhunt began for the six-foot, 185-pound Raymond B. Carney, aka J.W. Page.

Rewards were offered for evidence sufficient to convict the killer or killers. *The State* reported Governor James F. Byrnes announced that the state would pay $1,000. The Charleston, South Carolina, newspaper, the *News and Courier*, offered a $500 reward because of its interest in law and order. The Negro Baptist and Missionary Board of South Carolina was stirred up by the murders and offered a $200 reward. The Ira E. Brown Express Co. of Florence, Conway and Charleston offered $250, the town of Pamplico offered $200, individual citizens of the town offered $300 and Florence County Sheriff John Hannah offered $50.

Many possible sightings of Carney were reported and checked out in South Carolina and North Carolina, but all proved to be unfounded.

Then the news everyone wanted to hear appeared in *The State* on Sunday, December 20. Just before 5:00 p.m. on Saturday, December 19, Langston (Peanut) Cox of Johnsonville and Delmus Moore and Hugh Turner of Pamplico were hunting birds in a patch of woods near Johnsonville, South Carolina, sixteen miles from the scene of the murders. They spotted a black man in the woods acting suspiciously. As they approached him, he walked away quickly. They kept him in sight as he stopped at a nearby house and started talking to a man outside. One of the hunters knew the man who lived at the house. He walked up to the owner of the house and asked him if he knew the man. He said, "No, I've never seen this man before," and that's when all three hunters turned their shotguns on Carney. Tired, weak and dirty, Carney gave up peacefully, and they carried him to the Johnsonville jail.

When news got out that Carney had been caught, crowds of angry citizens flooded the grounds around the Johnsonville jail. Governor Brynes quickly sent orders for Carney to be brought to the State Penitentiary in Columbia and placed in the maximum-security building for safekeeping.

Carney admitted to the slayings of the couple and became very talkative and anxious as he gave his statement.

> I needed some money, so I went to the river and waited for a car. I waited about an hour and a half, but no car come then, so I started home. When I got to the road across a field, I saw a car going to the river, so I went back to the river and got close enough to hear them talking. I watched them for a while, then went up and busted the

window and jerked the door open. I said this is a stick-up, and the man grabbed my coat and arm. I pulled back, and when I got my hand free, I shot him. The girl started screaming, and I pulled her out the car and laid her down on the ground and pulled her pants down. I knew she would tell, so I shot her, too. I put her back in the car and carried both of them to where the car got in a bog. I walked to my house almost a mile away and got several planks to get the car out the bog. After I got out of the bog, I went back to the bluff and cut the girl's head off with my pocketknife so it would take longer to identify her. I was going to cut the boy's head off, too, but got scared because it was taking so long. I buried the girl's body at the bluff and thought about the well behind Mrs. Rosa's house. I got a shovel from Mrs. Rosa's house, and some burlap sheets from a tobacco barn, so I took the boy's body and the girl's head, wrapped them up in the sheets and put them in the well. I sort of figured putting them in different places would confuse the law. I threw the shovel under Mrs. Rosa's house, and later on buried the gun behind my house. I drove the car to the school and left it. I had stole a watch and $14 from the boy. I stayed in the area around my house and the bluff when ya'll was looking for the killer. I was living in tobacco barns and deserted shacks, and eating taters, and what I could steal from people's gardens. This is the truth as near as I can remember it. I mean to tell the truth, so I can get right with God, and ask him day by day to forgive me for this awful sin I done.

A pocketknife was found on Carney when he was captured. The gun was located behind Carney's house where he told officers he had buried it along a path.

Lieutenant Cate performed bullet comparison tests on Carney's gun. Results showed the bullets from the victims and bullets found in the tree in Carney's yard were fired from Carney's gun.

The *Florence Morning News* reported that this normally quiet farming community was turned into a tourist Mecca, despite a steadily falling rain. Observers estimated more than fifty thousand persons visited the scene. My parents, brother and myself were among the onlookers. The bluff had a wet coldness about it that made me shake all over. The dirt path leading to the well was hardened like concrete by the thousands of footsteps of the curious onlookers.

My mama stayed close to me and held on to me as I looked over into the cold, abandoned well. She caught my shirttail and said in her soft voice, "Don't you fall in there." I just stood there staring down into the well, thinking

about the body and head that lay there for two days and nights before they were found.

Unbeknownst to me, this would be my first crime scene, and it would surface again on my first day as forensic photographer of the South Carolina Law Enforcement Division.

Raymond Carney went to trial in March 1954, just three months after the murders. It took about fifty minutes to draw a twelve-man all white jury. The trial took only one day. No testimony was offered by the defense. The jury deliberated approximately one hour and thirty minutes.[1]

Carney was found guilty and the verdict carried no recommendation for mercy, making the death penalty mandatory.[2] Judge Steve Griffith sentenced him to death in the state's electric chair between 4:00 a.m. and 7:00 p.m., May 7, 1954.

The *Florence Morning News* reported that Raymond Carney was electrocuted at seven o'clock Friday morning, May 7, 1954. Fifty-eight persons witnessed the execution.

This was my first memory of the electric chair and an electrocution.

I grew up in the small rural community of Providence, which is about sixty miles from Columbia, the capital of South Carolina, and sixty miles from Charleston, the historic port city on South Carolina's coast.

After graduating from a class of thirty-eight students at Holly Hill High School, I attended the Orangeburg Regional Hospital School of Radiologic (x-ray) Technology in Orangeburg, South Carolina. After training, I began my profession

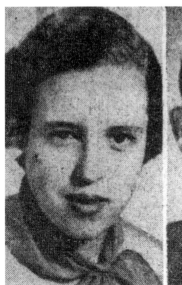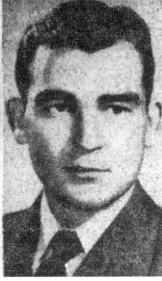

Betty Claire Cain and Harvey B. Allen. *Courtesy of* The State.

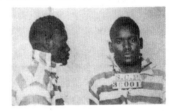

Wanted poster for
Raymond Carney, alias
J.W. Page. *Courtesy of SLED.*

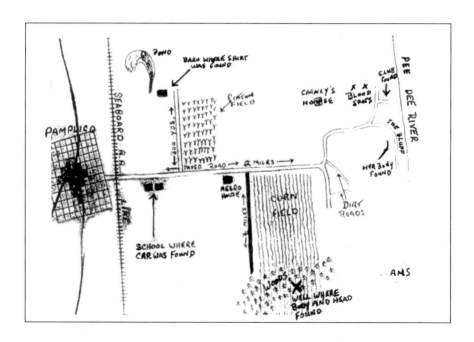

Sketch of scene of Pamplico double homicide. *Courtesy of the* Florence Morning News.

# Prologue

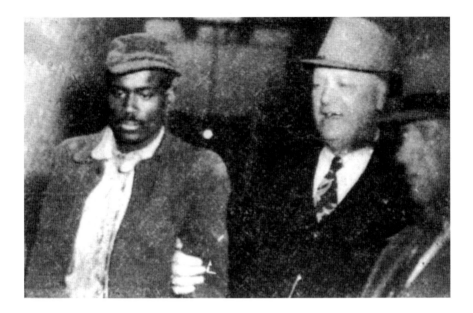

SLED Agents Melton and Patterson with Raymond Carney at the South Carolina State Penitentiary in Columbia after his capture in Johnsonville. *Courtesy of* The State.

as radiologic technologist at Providence Hospital in Columbia. Interestingly enough, the hospital shared the same name as the community where I grew up.

There were times when x-rays were needed to aid with death investigations. On one occasion, I assisted the pathologist and a police officer in the morgue to x-ray a homicide victim who had been shot in the chest. The pathologist needed to see the location of the bullet to retrieve it for investigative purposes. The entrance wound was clearly visible in his chest, so I x-rayed his chest. No bullet was found. The pathologist then requested a complete body x-ray. The bullet was located in the knee area. It had entered the chest, lodged in an artery and traveled with the blood flow down to the knee.

My interest in forensic science and criminal investigations grew over the years. Twelve years into my x-ray career, I attended an x-ray seminar in San Francisco, California, and enrolled in a two-day course, forensic pathology, which showed photographs and radiographs of physical evidence graphically presented in the court and legal system. I flashed back to memories of the double murder in 1953. I was totally captivated with this incredible forensic science that puts together the truth of such horrendous acts.

I've always felt dreams are never too big or too small. The important thing is to have a dream and go for it. So I did. I had to be a part of this forensic

field. Photography had been a hobby of mine since my parents gave me a Kodak brownie camera when I was nine years old. I figured I was already one step ahead.

Two weeks after returning to South Carolina, contacts and plans fell into place so smoothly it was almost scary. I knew this was telling me all was right with my choice of changing careers and my life. It came easily. Each step led me in the direction of the South Carolina Law Enforcement Division (SLED) Forensic Photography Laboratory.

October 7, 1977, was my first day with SLED. Only minutes after I arrived that morning, my orientation put me face to face again with the 1953 double murder in Pamplico.

As I toured the crime scene unit, which I would be working closely with, Lieutenants Bill Anderson and Ira Parnell opened a file drawer and showed me an eight-by-ten photo of a decapitated head. Lieutenant Anderson said, "You will be working with cases like this."

Surprised looks came on their faces as I said, "I know this case," and told them my story of living through it when I was eight years old.

They showed me the original case file, which included investigative documents and crime scene and evidential photographs. They walked me to the forensics lab display case. In the case was Carney's knife, the knife that was able to cut through a spine and sever a head from a body. I just stood there staring at the knife. In disbelief, I thought, "My God, it's just a regular pocketknife."

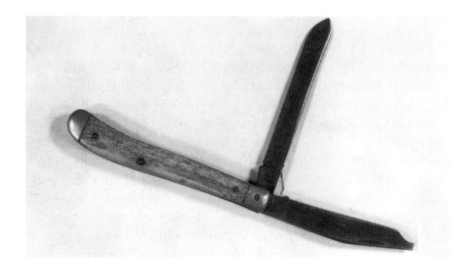

Raymond Carney's knife on display at SLED. *Photo by Rita Y. Shuler.*

# South Carolina Law Enforcement Division

The South Carolina Law Enforcement Division is a state level law enforcement and investigative agency with statewide jurisdiction. SLED was created in 1947 by an executive order issued by then-Governor J. Strom Thurmond at the request of the state's sheriffs and police chiefs. It began its operation with approximately fifteen employees. The governor of South Carolina appoints the chief of SLED. SLED has had four chiefs since it was established in 1947.

SLED's first chief, Joel Davis Townsend, was truly a pioneer in South Carolina law enforcement. At the age of eighteen, he joined the Saluda town police and became chief before he reached the age of twenty. He later served with the Greenwood police force, leaving there to become a deputy United States marshal for the western South Carolina district. In 1929, he became one of the first five members of the South Carolina Highway Patrol and was assigned as chief officer of patrol activities for the First Army maneuvers in 1941. For this work, he received a citation from Lieutenant General Hugh S. Drum and was officially commended by General George S. Patton. In 1942, South Carolina Governor Emile Harley drafted him on a leave-of-absence to become captain of the guard at the South Carolina penitentiary during an emergency. He returned to the Patrol a year later as chief of the State Bureau of Investigation.

Governor J. Strom Thurmond appointed Joel Townsend the chief of the South Carolina State Constabulary in January 1947. The State Constabulary

had been in effect since 1935 to enforce the state liquor law and to assist any law enforcement officer in detection of crime and the enforcement of any criminal laws in South Carolina. Upon Mr. Townsend's appointment as chief, the Bureau of Investigation and the Constabulary were consolidated to form the South Carolina Law Enforcement Division.[3] After two years as chief, Governor Thurmond appointed Chief Townsend to the South Carolina Industrial Commission, where he served until his death.

Oren Lindsey Brady was the second chief of SLED. He was a native of Landrum, South Carolina. At the age of eighteen, he was a chain gang guard for Spartanburg County Sheriff's Office, and in 1929, Spartanburg County Sheriff N.L. Bennett appointed him day-jailer. Three years later he became chief of detectives for Spartanburg County. In 1941, he had a conversation with two individuals that led to an arrest in a series of murders in Edgefield County. It was during this investigation that he met then-judge for the Eleventh Judicial Circuit Court of South Carolina, J. Strom Thurmond. After Chief Townsend left SLED in 1949, Governor Thurmond appointed Oren L. Brady chief of SLED. In 1956, Chief Brady's term ended as chief of SLED. He returned to his home county of Spartanburg and continued to serve as a resident SLED agent until his death.

James Preston Strom was the third chief of SLED. He was the son of McCormick County Sheriff Walter Strom. Growing up, he spent a lot of time at the McCormick County jail, and at the age of sixteen he went with deputies to chase bootleggers. He joked a lot about being born with blue lights in his blood, and in 1938, at the age of twenty, he became a deputy, working with his father. He went to work for SLED in 1947 just after SLED was organized and started moving rapidly through the ranks. After eighteen months he was named lieutenant. In 1956, then-Governor George Bell Timmerman appointed him chief of SLED.

Chief Strom created the South Carolina Criminal Justice Academy to train law enforcement officers and instituted the first crime laboratory in South Carolina. He organized the first bloodhound tracking team at SLED.

Over the years, Chief Strom became known as the patriarch of law enforcement in South Carolina and was sometimes referred to as the J. Edgar Hoover of South Carolina law enforcement. His belief for the suspect was to make sure he was guilty before you affect his reputation, freedom or his pocketbook.

Leon Gasque, son of Marion County's sheriff, grew up in Marion, South Carolina. Gasque started as a night desk officer at SLED in 1950. He worked his way to agent, and in 1964, he was named captain and appointed

SLED's second-in-command to Chief Strom. Chief Strom said, "He is my right-hand man. All of SLED depends on his leadership and his ability to handle major breaking events and criminal investigations."

Captain Gasque died of a heart attack in September 1986 at the age of fifty-four. His last major assignment was being in charge of security arrangements for the National Governor's Conference at Hilton Head Island, South Carolina, in August of 1986. He assigned SLED agents to security operations at this conference. I was one of them.

Detective Robert Stewart with the Cheraw, South Carolina, Police Department met Chief Strom in 1972 during an undercover marijuana investigation. In 1975, Chief Strom hired Stewart as a white-collar crime investigator for SLED. In 1979, he was promoted to lieutenant. In January 1987, four months after the death of Captain Gasque, Lieutenant Stewart was named major and promoted to SLED's second-in-command. Chief Strom was reappointed term after term and remained chief for thirty-one years until his death in December 1987.

After the death of Chief Strom, Major Stewart was appointed chief of SLED the following month, January 1988. Chief Stewart has a quiet and confident manner, and as well as his highly professional level with his staff, he also has his personal level. He constantly reminds his agents and personnel, "I always have an open door policy if you need to talk to me." Chief Stewart is highly regarded among all law enforcement officials in the state and with the public.

Some of SLED's accomplishments under Chief Stewart's leadership include the SWAT (Special Weapons and Tactics) team's upgrade with state-of-the-art equipment and the establishment of DNA (CODIS—Combined DNA Index System), fingerprint (AFIS—Automated Fingerprint Identification System) and firearms (IBIS—Integrated Ballistics Identification System) computer databases.

SLED is now staffed with over 300 sworn agents and over 150 support personnel. Investigative services, the basic foundation of SLED, works an ever-increasing load of criminal investigations and provides technical services and manpower assistance to local, state and federal entities throughout the state on request. The departments and units that make up investigative services are separated into functional areas to provide specialized services. Agents reside in all forty-six counties of the state so they are readily available when needed. Agents also work out of SLED headquarters in Columbia and stand ready to respond twenty-four hours a day, seven days a week.

Along with my duties as supervisory agent of the SLED Photography Department, I assisted with special assignments, such as security, crowd control and prisoner extraditions.

Ku Klux Klan marches were frequent in South Carolina in the '70s and '80s. Agents walked the entire route with the marchers. I photographed the event from start to finish and assisted with crowd control and security.

An ongoing assignment was photographically documenting the burning of marijuana that was seized during SLED drug investigations.

A very memorable assignment was being a part of SLED's security detail during Pope John Paul II's visit to Columbia in 1989.

Some assignments proved a little challenging. On one of South Carolina's below-freezing days, I assisted SLED investigators with a case of possible stolen state property on a golf course. I crawled through icy water in a drainage ditch in order to get inside a culvert to photograph a South Carolina state stamp on the interior of the culvert.

Prisoner extraditions carried me to many states in the United States. I flew into the airport in Sioux City, Iowa, in September 1989 where only two months before United Airlines flight 232 had crash-landed on the same runway. On the return trip from Iowa with a prisoner, the pilot announced that Hurricane Hugo was right below us in the Atlantic Ocean, and the projected path would be a direct hit to South Carolina. And a direct hit it was. On September 22, 1989, Hurricane Hugo devastated the entire state of South Carolina.

In 1990, a full-service, state-of-the-art forensic services laboratory was opened and located next to the original headquarters building. Before the new seventy thousand square-foot laboratory was built, forensic services were performed in about ten thousand square feet of space located in the basement of the headquarters building. The forensic laboratory provides the state of South Carolina with capabilities to perform analysis of forensic evidence with the highest degree and competence. It is staffed with skilled forensic experts to furnish the state with expert testimony on the analyses performed.

SLED received accreditation by the Commission on Accreditation of Law Enforcement Agencies (CALEA) and the American Society of Crime Lab Directors (ASCLD) in 1994.

In 2003, Governor Mark Sanford assigned SLED as lead terrorism response agency for the state of South Carolina.

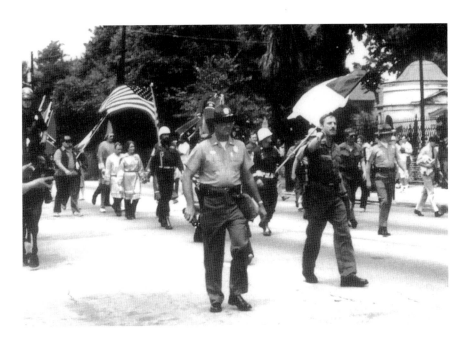

Ku Klux Klan march in Charleston, South Carolina, in the 1980s. *Courtesy of SLED.*

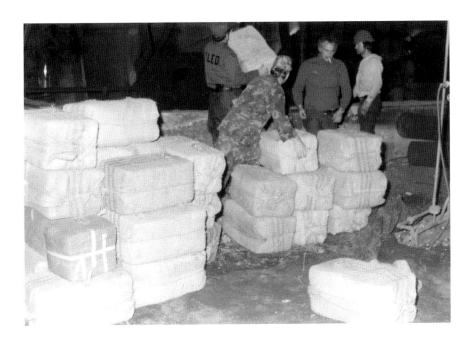

SLED narcotic agents destroying bales of marijuana in an industrial incinerator. *Courtesy of SLED.*

Shuler in drainage ditch. *Courtesy of SLED.*

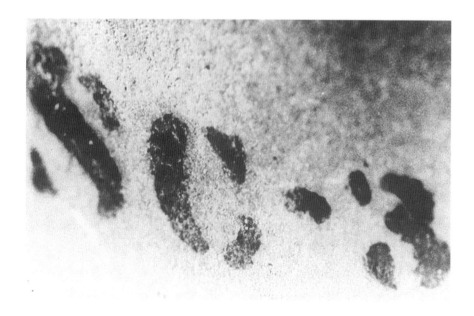

Photograph of South Carolina stamp on inside of culvert. *Courtesy of SLED.*

# Forensic Photography

Forensic means "of scientific techniques of crime investigations." Evidence is anything that has been left, removed, altered or contaminated during the commission of a crime.

Forensic photography is an essential tool for criminal investigations. It records the visible and in some cases the invisible evidence discovered at the crime scene. Photographic evidence can be stored indefinitely and retrieved when needed.

Photographs of the crime scene are documented records of the scene as it was first observed. They take the crime scene into the courtroom and graphically depict the same condition in which the assailant left it.

The crime scene photographer uses a three-step process: taking overall views of the entire scene, a mid-range shot of important areas to show locations of items and a close-up to show key details of items. Placing inch or centimeter scales in the mid-range and close-up shots is imperative so that the actual size is documented regardless of the amount of reduction or enlargement. The scales are used when printing photographs to exact (1:1) size for comparison of known evidence to possible suspects. It is important to take multiple shots of everything during the initial processing. Crime scene photography cannot be exactly redone after the scene has been processed.

Photographs are highly relevant in capital punishment trials to illustrate precisely the aggravating circumstances (serious conditions of a crime) that

they are intended to show by revealing the pre-mortem and post-mortem physical torture the victim endured.

The SLED Crime Scene Unit responds to the crime scene. The crime scene investigators photograph the scene and collect evidence. Additional evidence is collected from the victim and suspect when available. The forensic photographer works in conjunction with the crime scene investigators with photo documentation of the evidence. In essence, the forensic photographer's work begins at the crime scene, working as the middleman between the investigators and the court system.

The SLED Photography Lab provides photography assistance to all units of SLED and to all law enforcement agencies in South Carolina. This is not simple point and shoot photography. This is the application of specialized photographic equipment, techniques, lighting and exact exposures to capture maximum quality details of evidence on film.

Lighting is extremely critical when photographing evidence. How much light, the direction of the light and how it falls on the evidence are major factors in capturing the evidence on film. Lighting can bring out fine details that are not seen with normal viewing, but too much or too little light can also cause crucial details to be lost. The developed negative will sometimes reveal even more detailed definition of the evidence than what is seen through the lens of the camera.

Basic evidence photography protocol is a good starting point for the preliminary photography set-up, but most of the time the photographer has to be creative in achieving the maximum quality results, inventing his own little tricks to capture the images.

I would eat, sleep and breathe in the midst of the evidence from start to finish. Some evidence I would work with all day long, sleep on it overnight and come back to the next morning. Unlike crime scene photography, which you only get one shot at, photography performed in the lab can be redone.

Each piece of evidence in a case is totally unique to that case and all are crucial pieces of the puzzle, no matter how large or how small.

Such was a case of a body found in a creek in South Carolina about one hundred yards from the North Carolina-South Carolina state line. I photographed the subject's right thumb for ridge detail. Unbeknownst to me at the time, the body was the father of a national sports figure. Events soon surfaced in Fayetteville, North Carolina, and the body was identified through dental records as James Jordan, father of Chicago Bulls superstar Michael Jordan. The photograph of the right thumb ridge detail was matched to Mr. Jordan's known right thumbprint.

Forensic photographers testify in court.

Over a period of ten years, defendant farm worker Warren Douglas Manning was tried five times for the kidnapping, armed robbery and murder of South Carolina State Trooper, First Class George Radford.

In Dillon County in 1988, Trooper Radford stopped Manning for a defective headlight. He radioed the dispatcher for a driver's license check on Manning that showed that Manning was driving under suspension. Trooper Radford's body was found the next day in his patrol car that was partly submerged in a farm pond several miles from where he stopped Manning. He had been shot in the head with his .357-caliber service revolver. The revolver was found in a tobacco barn behind Manning's house. Manning worked near the pond where Trooper Radford's body was found.

Each time this case went to court, two sets of crime scene photos were printed: one for the state and one for the defense. The photos were not printed until the solicitor and the defense attorney requested them, so they were printed at different times.

The first trial was in 1989. Manning was convicted and sentenced to death. The South Carolina Supreme Court overturned the verdict because the judge misled the jury about the meaning of reasonable doubt.

The second trial in 1993 ended in a mistrial because of a hung jury.

The third trial was in 1995. During testimony, the defense attorney observed that the close-up photos of the gun in the tobacco barn in his set of photos were facing the opposite direction of the photos of the gun in the solicitor's set of photos.

I testified to the inconsistency of the photographs of the gun. The two sets of photographs were printed at different times, and when the defense attorney's set was printed the negative strip that included the frames of the close-up of the gun was placed in the photo enlarger upside down. This caused the photos of the gun to be reversed. Testimony cleared the inconsistency, and the trial proceeded.

Manning was convicted and again received the death sentence. The South Carolina Supreme Court overturned the verdict because the judge improperly allowed a jury to be picked in another county before the court attempted to seat a jury in Dillon County.

The fourth trial in 1999 also ended in a mistrial because of a hung jury.

The fifth trial was later in 1999. Warren Douglas Manning was acquitted because jurors said there was lack of evidence to convict. He walked out of the courtroom a free man.[4]

Forensic photographers may never have personal contact with the victims or suspects and may not be in the center of media coverage on a case, but their work with the physical evidence proves vital to an investigation.

# South Carolina Death Penalty

S outh Carolina laws were inherited from the common law of England. As far back as colonial days there were many offenses punishable by death.

Murder is the killing of another with malice aforethought, either express or implied.[5]

In 1869, Act 91 was passed abolishing capital punishment in South Carolina in all cases except willful murder.[6]

In 1894, Act 91 was amended to include the provision in each case that if the person is found guilty of murder, the jury may find a special verdict recommending him or her to the mercy of the court, whereupon the punishment shall be reduced to imprisonment with hard labor during the whole lifetime of the prisoner.[7]

That law remained in effect until 1972, when the United States Supreme Court ruled that a case in Georgia (*Furman v. Georgia*)[8] constituted cruel and unusual punishment and violated the Constitution. The Furman case, in effect, declared most death penalty statutes to be unconstitutional, and capital punishment laws were abolished in thirty-five states, including South Carolina. Death sentences were removed for all prisoners on death row and they were given life imprisonment. This brought executions in the United States to a halt. In South Carolina, eleven men on death row had their sentences commuted to life imprisonment.

In 1974, the South Carolina General Assembly passed a statute that gave a mandatory death sentence to the crime of murder committed while in the

commission of such aggravating circumstances as rape, kidnapping, armed robbery and physical torture.[9]

In 1976, the United States Supreme Court upheld Georgia's death penalty statute in *Gregg v. Georgia*.[10] From this case, the U.S. Supreme Court set guidelines for the death penalty for other states.

The South Carolina Supreme Court then ruled that the state's 1974 statute did not meet the U.S. Supreme Court guidelines, and all South Carolina death sentences between 1974 and 1976 were commuted to life in prison. In 1977, South Carolina modeled their capital punishment statute after Georgia, and the South Carolina General Assembly passed the state's capital punishment statute, 16-3-20. The statute required the jury or judge in capital cases to consider all relevant aggravating (serious conditions of a crime) and mitigating (less severe conditions of a crime) circumstances in determining whether to recommend a death sentence. This incorporates two-phase proceedings. The first phase is to determine guilt or innocence. If found guilty, and after a twenty-four-hour waiting period, unless waived by the defendant, then there is a second phase to present additional evidence to consider statutory aggravating and statutory mitigating circumstances to recommend a death sentence, life imprisonment or a minimum term of imprisonment for twenty years. If the defendant and the state waive trial by jury or the defendant pleads guilty, the sentencing proceeding will be conducted before the judge.

Life imprisonment means until death of the offender with no eligibility for parole or any credits that would reduce the mandatory life imprisonment.

A mandatory minimum term of imprisonment of twenty years means no eligibility for parole or any credits that would reduce the mandatory minimum term of imprisonment for twenty years.

In the sentencing phase, if a statutory aggravating circumstance is found beyond a reasonable doubt, the defendant must be sentenced to either death or life imprisonment. If no statutory aggravating circumstance is found, the defendant must be sentenced to either life imprisonment or a mandatory minimum term of imprisonment for twenty years. The statute has been amended over the years to include additional aggravating and mitigating circumstances, minimum terms of imprisonment and a capital defendant's parole eligibility.[11]

Under South Carolina's appellate practice, a criminal defendant has a right to appeal his conviction and sentence. Whenever a death penalty is imposed, the South Carolina Supreme Court automatically reviews the sentence. After the automatic appeal, before any further action or appeal

can be maintained, there must exist a justifiable controversy. South Carolina gives the defendant the right to have a progression of appeals to do all that can be done to save his life. These appeals can go on for years.[12]

Prior to June 1995, Section 24-3-530 of the South Carolina Code of Laws provided that all persons receiving the death penalty shall suffer such penalty by electrocution. The first electrocution in South Carolina was carried out on August 6, 1912. Prior to 1912, execution was by hanging in the county in which the person was convicted. The last electrocution, prior to the June 1972 ruling by the United States Supreme Court, was Good Friday, April 20, 1962. The first electrocution after the 1977 reinstatement of the capital punishment statute was January 11, 1985.

On June 8, 1995, the S.C. General Assembly amended Section 24-3-530 so that persons sentenced to death may elect to suffer such penalty by lethal injection. This election must be made in writing fourteen days before the execution date or it is waived. If the person waives the right of election and the sentence was imposed prior to June 8, 1995, the penalty will be administered by electrocution. If the person waives the right of election and the penalty was imposed on or after June 8, 1995, the penalty will be administered by lethal injection.

The first lethal injection in South Carolina was given on August 18, 1995. For eight years, twenty-two inmates on death row chose lethal injection.

October 4, 1996, was the last electrocution in South Carolina until 2004. On Friday, May 28, 2004, a death row inmate convicted of killing two women in their homes during robberies in 1992 was electrocuted. He was sentenced to death prior to June 8, 1995. He did not choose electrocution. He just didn't ask for lethal injection.[13]

# My First Month

As residents of the Lakewood Trailer Park on Percival Road in Columbia, South Carolina, came out of their trailers around 7:45 a.m. on Tuesday, October 18, 1977, they stepped upon a gruesome discovery. The body of a young woman was lying on the sidewalk of the trailer park in a puddle of blood. She had been shot in the stomach and in the arm. An ID in her pants' pocket identified her as Betty F. Swank, a twenty-one-year-old white female.

The Richland County Sheriff's Department responded. Further investigation revealed that Mrs. Swank lived with her husband and fifteen-month-old son in The Palms apartment complex, which is about three miles from the Lakewood Trailer Park. Mr. Swank worked with the military police at Fort Jackson Army Base in Columbia. He told officers that the last time he saw his wife alive was when she left for her midnight shift job around 11:30 p.m. Monday night.

Mrs. Swank's car was found later that morning abandoned on Percival Road just a few miles from Polo Park, a popular softball complex. The right rear tire was flat.

At that point investigators knew little about what happened to Betty Swank. As the officers were processing the crime scene, one of the killers was in a car driving slowly past the trailer park that morning. He had heard on the radio that a young woman's body was found in the Lakewood Trailer Park, and he felt the need to return and find out if she was dead. When he saw all the officers at the trailer park, he quickly left the area.

# My First Month

Eleven days later, on Saturday, October 29, 1977, it was a dismal, cloudy day in Columbia. Tommy Taylor, a seventeen-year-old sophomore, and Carlotta Hartness, a fourteen-year-old freshman, both students at Wildewood Academy in Columbia, left their homes around noon that Saturday for Camden, South Carolina, thirty miles away. They were doing some historical research for a term paper Tommy was working on. Tommy was driving his dad's 1976 white Oldsmobile Cutlass. They told their families about several sites they would be checking out and said they would be home by dark.

Tommy loved sports and was on the Wildewood Warriors football, baseball and basketball teams. Carlotta was a cheerleader for the Wildewood Warriors and a member of the school's volleyball and basketball teams.

After visiting several sites in Camden, they started back to Columbia. As they drove past Polo Park, which is just off Interstate 20 across from Wildewood Academy, they turned into the softball complex and stopped the car. They did not notice the blue Chevrolet Camaro lurking in the shadows with three white male occupants who had been shooting up with drugs and drinking beer all day.

The Camaro slowly pulled alongside their car and stopped. Tommy and Carlotta had no way of knowing that the three had raped and killed twelve days earlier, and had boastfully decided they would go out and find somebody else to rob and a girl to rape.

By nightfall, when Tommy and Carlotta had not returned, the Taylor and Hartness families called the Richland County Sheriff's Department and reported Tommy and Carlotta missing.

An investigation ensued. Richland County Sheriff Frank Powell confirmed a report that the couple had been in Camden and left around 4:00 p.m. to return to Columbia. Officers on patrol were notified to be on the lookout for Taylor's 1976 white Oldsmobile Cutlass.

Around 3:30 a.m. the following morning, Lieutenant Dave Perry with the Richland County Sheriff's Department pulled up to a white Oldsmobile Cutlass parked in the Polo Park softball complex. As he moved in closer, he observed a white male slumped back between the bucket seat and the steering wheel. He appeared to have been shot in the face. The window on the passenger side of the car was shattered.

The car was registered to Joe Earle Taylor, Tommy's father, and the body inside was later identified as Tommy Scofield Taylor. There were no signs of a struggle, and there was no sign of his friend, Carlotta Hartness.

Officers made casts of tire tracks around the car. Lead fragments were removed from the rear gearshift housing, an area in front of the gearshift and the right passenger door of Taylor's car.

No weapon was found.

Officers did not know that the killer had come back to the car just hours before to make sure Tommy was dead.

A search for Miss Hartness began immediately. Agents and bloodhounds from SLED joined Richland County Sheriff deputies in the search. Personnel from the Fifth Circuit Solicitor's Office also responded to the area to assist. At daybreak, a sheriff's airplane joined the search from the air. As it circled overhead, hundreds of citizens joined in the ground search.

Around 2:10 p.m. Sunday afternoon, Richland County Sheriff's investigators, Lott and Harper, turned onto a frontage road about seven and a half miles from where Tommy's body was found. They turned off the frontage road onto a dirt road, and about twenty-five yards up ahead they saw a nude body lying in the sand.

They proceeded on foot toward the body, careful not to disturb anything. The body was a white female, lying face down. There was some clothing under her body. Over to the side were shoes and a bra. They observed what appeared to be blood on the body and on the ground underneath the body. There were cuts and signs of mutilation to her body.

Investigator Leon Lott, now sheriff of Richland County, radioed headquarters and reported that they had found a female body. SLED's crime scene team was called to assist with the crime scene processing. SLED Agent Jim Springs arrived on the scene. He photographed the area and the body. He then proceeded to process the scene and collect evidence. Two fired .22-caliber cartridge cases were recovered near the body. Agent Springs made casts of tire tracks and shoeprints in the area to preserve the impressions.

These murderers were notorious for returning to the scene of their crimes, and only hours before the officers found the girl's body, one of the killers had returned to the scene of the crime and abused and mutilated the body even more.

The body was transported to Dunbar Funeral Home in Columbia and identified as Carlotta Whitley Hartness. At the funeral home, Agent Springs photographed the body and collected oral, vaginal and rectal swabs from the body.

Carlotta Hartness had five bullet wounds to the right side of her head. The cause of death was due to bullet wounds to the head with hemorrhage. Findings showed she had been sexually assaulted, and the approximate time of her death was 6:30 p.m., Saturday, October 29, 1977.

Medical reports showed Tommy Taylor had two bullet wounds on the left side of his face. The cause of death was due to bullet wounds to the head with cerebral hemorrhage, and the approximate time of his death was 4:30 p.m. on Saturday, October 29, 1977.

Monday, October 31, 1977, was my twenty-fourth day on the job with SLED. That morning the film and evidence from the scenes were submitted to the photography department. Step by step the scenes developed before my eyes, and I flashed back to the murders in 1953. Even though it had been twenty-four years prior, the scenarios were so very similar. Innocent teenagers were out enjoying life, and in just moments, strangers lurking in the shadows who were nobodies to them ended their lives.

I photographed a piece of glass that was removed from Miss Hartness's body. I shuddered at the thought of the horrid person who had touched this glass only hours before.

With no solid leads to go on, Sheriff Powell sent out a public appeal for anyone who might have seen anything or have any information about the Taylor-Hartness murders at Polo Park to contact the Richland County Sheriff's Department.

Tips started coming in. Most led nowhere until a call came in from some University of South Carolina college students who were riding motorcycles in Polo Park the afternoon of the murders. They had seen two cars in the park, a white Cutlass and a blue Camaro with a white top and out-of-state tags.

A woman passing by an exit next to Polo Park that Saturday afternoon called and reported she saw a young person with long blond hair running up an embankment. She said, "I couldn't tell if it was a boy or girl, but they appeared to be carrying something."

A blue paint chip was found on a root during a follow-up investigation of the Hartness body scene.

Early Saturday morning in Saluda, South Carolina, Mrs. J.B. Black reported her 1977 Chevrolet Caprice was stolen from the home of a friend she was visiting in Saluda. Her friend's two sons, Joey Mahaffey, seventeen, and Ronnie Mahaffey, sixteen, and their friend Terry Roach, seventeen, had come over that Friday to spend the night.

Mrs. Black woke up when one of the boys came into her room, took her purse and car keys and left. She called Saluda County Sheriff's Department and took out a warrant for the boys' arrests.

The two women knew Terry Roach's father lived in Seneca, South Carolina, so Saluda County Sheriff's Department informed the Oconee County Sheriff's

Department in Seneca of the incident and the outstanding warrants and the possibility that the boys might end up at Mr. Roach's house.

John McIntosh, prosecutor with the criminal division of the U.S. Attorney General's Office in South Carolina, was ready to put his all into this case. He checked out all unsolved cases that might have any similarities or common links to these murders. The Betty Swank murder several days earlier came up.

McIntosh requested bullet comparison tests on the bullets recovered from Betty Swank, Carlotta Hartness and Tommy Taylor. The tests would determine the caliber of the bullets and if they were fired from the same weapon. SLED Agent Jim Springs performed the tests, and results revealed matching unique patterns, which were transferred from the barrel of the firearm to each bullet. This determined that the bullets were fired from the same weapon, which was a .22-caliber rifle.

As of Monday, October 31, the weapon used to kill Tommy Taylor, Carlotta Hartness and Betty Swank had not been found. A concentrated search continued for the murder weapon, and on Tuesday, November 1, officers walking through a thinly wooded area about three-quarters of a mile from where Carlotta Hartness's body was located found a .22-caliber Remington rifle on the ground. Next to the gun was a box of ammunition with a price marker still attached.

Although investigators had no way of knowing that these killers had already returned to the scene of each of their crimes, they decided to set up a stakeout with the gun hoping whoever put it there might come back to retrieve it because of all the media coverage of the murders. No one returned.

Oconee County officers were waiting on Roach and Mahaffey's possible arrival at Roach's father's house to serve the outstanding warrants for the stolen car in Saluda.

It wasn't until sometime Sunday that Terry Roach and Ronnie Mahaffey ended up in Oconee County. Terry had called his father and asked to borrow his car for a few days. They had hired a cab to take them on the 250-mile trip from Columbia to Seneca, and when they got there directed the cab driver to a house other than Mr. Roach's. They jumped out and ran away without paying the cab fare. Within minutes after the boys walked into Mr. Roach's home, officers arrived and took Roach and Mahaffey into custody.

Terry Roach was transported back to Saluda County on Monday, October 31, but because Ronnie Mahaffey was only sixteen years old, a family court petition had to be issued before he could be released. Mahaffey was transported back the next day.

And what a trip it turned out to be. Mahaffey started talking about the area around Wildewood Academy and Polo Park where the car they stole had bogged down. He appeared to know a lot about the area, and in his ramblings he made comments about the teenagers' murders. The transporting officer immediately informed investigators working on the Taylor-Hartness homicides of Mahaffey's statements. A search was initiated for the stolen car, and it was found bogged down several miles from where Tommy and Carlotta were murdered.

Investigators were certainly interested in talking to Ronnie Mahaffey, and without delay SLED agents Lieutenant Sam Frierson and Steve Helmly met with Mahaffey. Mahaffey's parents were present at the interview.

Mahaffey talked:

> I moved to Columbia from Atlanta, Georgia in 1975, and moved into a trailer park with my father. About a year later Joseph Carl Shaw, a MP at Fort Jackson Army Base moved into the trailer park, and we got to be good friends. J.C. knew where to get drugs, and I started doing some drugs. He already knew my older brother, Joey. He introduced me to Robert Williams and Kathy Bowers who lived with him at the trailer park, and were also stationed at Fort Jackson.
>
> J.C., Bob and Kathy were doing some drug dealing out of their trailer and were later evicted from the trailer park. J.C. moved back on post at Fort Jackson. Bob and Kathy got a house. I didn't see them for a while.
>
> My brother Joey met Terry Roach when they were both in John G. Richards's Juvenile Correction Facility in Columbia. They were in there for charges against them, for drugs, alcohol, car theft, and housebreaking. Somehow, they escaped from the facility and hooked up with J.C. to get drugs. That's when Terry Roach met J.C. Shaw.
>
> When I heard Joey had escaped, I went looking for him. I went to see J.C. Shaw, and he took me to Bob and Kathy's house where Joey and Roach were. That's the day I met Terry Roach.
>
> We all hung together for about three weeks at the house. One night we started drinking and getting high on drugs, and me, J.C., Terry and Bob decided to go out and find a girl to rape.
>
> As best I remember it was a Monday night. We got in J.C.'s car, a blue and white Camaro convertible with Kentucky

tags. J.C. had a .22-rifle and handed it to Bob who was sitting in the front passenger seat. Terry and me sat in the back. We decided to just park in a gas station lot, face the car toward the road, leave it running and leave the lights on so we could see who was in the cars as they rode by. We didn't wait long, and a car came by, and there was a girl in it by herself. J.C. said, "There's one. Let's follow her." We pulled out right behind her and followed her until there was no cars except hers and ours. Bob stuck the gun out the window and started firing shots. We seen the tire go flat. She pulled off the road near a house, so we rode on past her, but we wasn't done. We turned the car around and went back to where she was. She was at the house knocking on the door. We pulled up beside her and asked if we could help her. She said she had a flat tire, and she had friends in the Lakewood Trailer Park just up the road that could help her. We offered to take her to the trailer park, and she said, "Ok," and got in the back seat. As we got to the trailer park she pointed out her friend's trailer, but J.C. just kept on riding by. She said, "Are you going to let me out?" J.C. said, "Yes, but first we're gonna have some fun." We drove on down a little ways to Crystal Lake and everybody got out of the car. Bob had the rifle in his hand. J.C. got a blanket out of the trunk and laid it on the ground. We told her to take her clothes off. All of us made sex with her except Bob. After we were finished, we let her put her clothes back on, and we got in the car to take her back to the trailer park. Bob slipped up and called J.C. by name, and she picked up on it. She said, "Aren't you the one that works with my husband at Fort Jackson?" J.C. said, "Yes," and realized he had picked up somebody that might be able to recognize him. He stopped the car and let her out about a hundred yards from the trailer park. Then J.C. said, " I've got to shoot her." Bob was on the passenger side, and J.C. asked him to shoot her. Bob said, "No, I won't do it." J.C. turned the car around, pulled back up beside her and asked if he could take her on up to the trailer park. She screamed, "No," and started running away from us. Bob handed the rifle to J.C. He leaned out of the window. He shot her once and she yelled, and kept on running. Then J.C. shot her a second time, and

maybe a third. She ran into the trailer park, and we didn't see her again. We drove back to the house to spend the night. Later on that night, J.C. and Bob went back to the trailer park to see if they could see her or find out what happened to her, but they didn't find out anything. The next morning we heard on the radio a body was found in the trailer park, but J.C. still wasn't satisfied. He had to know if she was dead. He drove back out to the trailer park. There was a lot of officers around so he left. Later that afternoon, we read in the paper that she was dead.

After a break, Mahaffey continued,

After that night, a couple of weeks passed before I heard from any of them. Then I got a call one Friday to go to my mother's house in Saluda and meet my brother, Joey, and Terry Roach. That's when we stole the car and went back to Columbia to party. We picked up a couple of six packs of beer. It was around 3:30 Saturday morning. We got a room at the Thoroughbred Motel on Two Notch Road. Joey stayed in the room, and Terry and me ended up by ourselves drinking, riding around, and cutting donuts. We took turns driving and horsing around until we hit some muddy area where a new road was under construction. The car got bogged down in the mud, and we left it and took off to a nearby Minute Mart. We caught a cab back to the motel and fell asleep.

The next day, Saturday, Terry and me hooked up with J.C. Shaw again. Since J.C. had a car, we asked him to take us to a laundromat to wash clothes. Around 10 o'clock that morning after we put our clothes in the washer, we decided to go get some marijuana or something to get high on. We went to a house on Two Notch Road and got some "Crystal T," and then went to see a person named Doc to run it up, you know shoot it up through the vein. We kept shooting up with drugs and drinking beer. Around mid-afternoon, while our clothes were drying, we went to McDonald's to get something to eat. While we were eating hamburgers at McDonald's, we decided to go prowling in J.C.'s car and find a girl to rape. Sometime after 5 o'clock Saturday afternoon we rode past Polo Park. We saw a white Cutlass parked

near the softball field. There was a boy and girl in the car. We parked at Wildewood School, across from the softball field. J.C. was driving. Terry was in the front passenger seat. He had the .22-rifle in his lap. I was in the back seat. We left the schoolyard and pulled into one of the driveways leading to where the white car was. We pulled up slow to the driver's side of the white car so both cars were facing the same way. Shaw told Roach, "Now," and Roach threw the gun up to the window and told the boy, "We want your money." Shaw went around to where the girl was, opened the door and told her to get out of the car. She got out, and Shaw told her to get in the back seat of his car next to me. Shaw got back in the driver's seat and shut his door. He turned to Roach and again gave him the command, "Now, do it." Roach pulled the trigger two or three times, and the boy slumped back in his seat. One of the bullets hit the window on the passenger side of the Cutlass and shattered it to pieces. We drove off. Shaw kept telling the girl not to scream.

About a mile up the road, he pulled on to a dirt road that looked like nobody ever traveled. It came to a fork. We stopped and got out the car. Somebody told the girl to take her clothes off. She did. J.C. said he was going to be first. Then Roach went around to where she was. After about fifteen minutes, he came back and said, "Next." Then I went around to where she was, and said I couldn't do it. Then Shaw said, "You have got to do it," and I did. All the time this was going on, she kept begging and pleading for her life. She kept saying, "Please, if you want money, my parents will give you money. My mama loves me too much for me to die." But we just kept on.

While J.C. was with her, I took the wallet we stole from the boy and took a five-dollar bill from it. We dug a hole about fifteen feet away from the car and buried the wallet. J.C. told the girl to lie back down and put her head in the sand. She wouldn't do it. J.C. got upset and drew a circle in the sand. He drew an X in the middle of the circle. He yelled at her and told her to put her head face down on the X. She was shaking and crying, and finally just dropped her head down on the X. By this time the girl knew we was going to kill her. Roach had the rifle. I heard about three shots go off. Then Roach gave Shaw the rifle. She wasn't dead yet. She was still moving, so Shaw shot her again, then again.

We left the girl's body there, got back in the car and drove off. Up the road we stopped, and J.C. told me to get out and throw the gun and bullets in the woods. I ran up an embankment and threw them as far as I could.

To make sure the boy was dead, we rode back to the park and up to the white car. His body was slumped even more backwards. We were certain now he was dead. We left and went to the Fort Jackson Army post and bought beer, a bag of Doritos, and a roll of tape with the five dollars we stole from the boy's wallet.

It was about 6:30 when we got back to the house. We ate and listened to the stereo. Shaw went back to his barracks at Fort Jackson. Everybody else went to bed.

The next morning, Shaw came back over to the house and told us he had just driven by where we shot the boy, and there were cops everywhere. Then he told us after he got back to the barracks that night, he couldn't sleep. He had to satisfy himself the girl was dead, too. He got up and went back to the girl's body and did some bad things to her with glass and sticks. He said, "I just had to make sure she was dead."

Later that night, Terry and me took off to Terry's father's house in Seneca. That's when officers came and got us and brought us back to Saluda.

Terry Roach was interviewed that same evening. He gave much of the same details of the events and said, "I did have sex with Mrs. Swank, but did not shoot her. J.C. Shaw was the one that shot her. When we went to Polo Park that Saturday, my mind was fuzzy because I had done a lot of drugs and drinking, and I told Shaw and Ronnie, 'Man, I don't want no part of this.' J.C. and Ronnie had sex with her. I did not have sex with her. J.C. and Ronnie asked me if I wanted to shoot her, and I told them I wasn't gonna shoot nobody. I watched as J.C. told her to put her head to the ground, and then he shot her five or six times in the head."

Even though their statements showed conflicting details, Shaw's name in their confessions provided the crucial link needed to incriminate Joseph Carl Shaw.

By nightfall, Ronald Eugene Mahaffey and James Terry Roach were charged with the murders of Tommy Taylor, Carlotta Hartness and Betty Swank.

Joey Mahaffey was not with them when the murders were committed.

An alert was put out for Joseph Carl Shaw and his blue and white Camaro. Around 8:30 Tuesday evening, Shaw was pulled over near Fort Jackson. The passenger in the car with him was Robert Williams.

Williams gave a statement of his involvement the night Betty Swank was killed. He said, "I was the one that shot the lady's tire. We took her to Crystal Lake. I was real drunk, and I was passed out on the backseat most of the time. I didn't rape her or shoot her. J.C. was the one that shot her with his .22-rifle he got from a person named Ray Inabinet. I think it was stolen."

Officers asked Williams about Saturday, October 29. He said, "I wasn't with them. Roach told me what they had done that afternoon. He said he aimed the gun at the guy and told him to give him his money and then shot him in the face, and when he fell back in the seat, he shot him a couple more times. They put the girl in the Camaro and drove to a wooded area. All three of them raped the girl, and told her to lie down in the sand, and he shot her in the head four times. Then Shaw grabbed the gun out of his hand and shot her one more time."

Williams was charged with the murder of Betty Swank.

Shaw admitted to the murders of all three victims but said he did not fire the fatal shots. He also admitted that he went back to the girl's body and did things to it with glass and sticks because of visions and voices that came to him in a bizarre dream that night after going to bed.

Shaw was charged with the murders of Tommy Taylor, Carlotta Hartness and Betty Swank.

Ray Inabinet was located and admitted he stole the rifle during a break-in on October 13, and he sold it to J.C. Shaw for thirty dollars.

Bullet identification examinations had already revealed that bullets removed from all three victims were fired from the same weapon, a .22-caliber rifle.

Bullet comparison examinations were performed on test-fired bullets from the Remington .22-caliber rifle found at the crime scene and bullets removed from all three victims. It was concluded that all the bullets were fired from the .22-caliber Remington rifle.

Cartridge case identification exams were performed on the known cartridge cases from the Remington .22-caliber rifle and cartridge cases recovered from Shaw's Camaro and cartridge cases found near Miss Hartness's body. Results revealed that all the cartridge cases had the same unique markings, which concluded that they were at one time loaded or fired from the same Remington .22-caliber rifle. Cartridges do not have to be fired from a rifle for these markings to show up. Just loading the cartridge

into the rifle can cause identifiable markings. Firearm identifications are sometimes referred to as "mechanical fingerprints" on the bullets and cartridge cases. These markings are unique to the firearm as fingerprints are unique to an individual.[14]

The price marker on the ammunition box found at the scene was identified as being purchased from Fort Jackson Army Base in Columbia. Fort records showed the buyer to be Joseph Carl Shaw.

Officers dug up Tommy Taylor's wallet. Taylor's parents identified the wallet and its contents as being Tommy's.

With assistance from the FBI, it was concluded that the paint chip found on the root close to where Miss Hartness's body was found was consistent with the paint on Shaw's vehicle, and shoeprints and tire tracks found at the crime scenes were consistent with Shaw's shoeprints and the tires on Shaw's vehicle. All accounts led to Joseph Carl Shaw being the mastermind of the plans.

It was reported in *The State* on Saturday, November 5, that it had been a somber week at Wildewood Academy. The faculty and parents had seriously considered canceling the homecoming football game that Friday night, but Tommy and Carlotta's parents asked that the game be played as scheduled. Carlotta was a member of the homecoming court and out of love and respect for the Hartness family, the football team and cheerleaders voted to award the honor of homecoming queen posthumously to Carlotta. They presented flowers to her mother during halftime ceremonies.

The case was scheduled for court much faster than most murder cases in South Carolina in recent years. A court date was set for December 12, 1977, only six weeks after the murders.

Prior to court, I shot aerial photographs of the murder locations for display during the trial. As I leaned out of the helicopter door, I choked up as I focused in on the area where the crazed killers stuck the gun to Tommy Taylor's head and blew away his life as Carlotta Hartness looked on. I could not imagine the fear and horror she endured as they drove her seven and a half miles, pulled her out of the car, pushed her to the ground, forced her to undress, humiliated her over and over, raped her and shot her one, two, three, four, five times, all the while begging and pleading for her life.

This was the first capital case to be tried under South Carolina's revised death penalty statute, Section 16-3-20, 1976 Code of Laws of South Carolina.[15]

On Monday morning, December 12, 1977, potential jurors gathered in the Richland County Courthouse. In a surprising move before court

proceedings began, Joseph Carl Shaw appeared before Judge David Hartwell and entered pleas of guilty to armed robbery, kidnapping, criminal sexual conduct, two counts of conspiracy and two counts of murder. Shaw's mother and stepfather were present in the courtroom when the charges were read.

Sixteen-year-old Ronald Eugene Mahaffey pleaded guilty to the same charges as Shaw. In a plea bargaining agreement with the solicitor by terms of the state, Mahaffey would receive a life sentence in exchange for testimony against his two co-defendants, Shaw and Roach. This agreement would hold for his testimony in the Betty Swank case, also.

James Terry Roach held on until the next morning, requesting a jury trial. Jurors again assembled in the courthouse, and in another unexpected move, Roach appeared before Judge Hartwell and entered pleas of guilty to armed robbery, kidnapping, criminal sexual conduct and two counts of murder, but entered a plea of *nolo contendere* (without admitting guilt) to two counts of conspiracy.

Even though Shaw, Roach and Mahaffey entered guilty pleas, which eliminated the need for a jury trial, the state would still seek the death penalty for Joseph Carl Shaw and Terry Roach.

There would be no jury trial, but under the state's death penalty law in 1977, when the death penalty is being sought, a hearing is required to show if the murder was committed while in the process of an aggravating circumstance such as armed robbery, kidnapping or rape, and the judge would impose the sentence in the absence of a jury.

Along with the guilty pleas, Judge David Hartwell viewed and listened to the evidence in the case. The state introduced seven photographs into evidence. The photographs showed the scenes of the crimes as found by the law enforcement officers and the post-mortem abuse to Miss Hartness's body. They were admitted as evidence not only to show the circumstances of the crime, but also Shaw's character, and to substantiate that Shaw returned to the scene of the Hartness murder and mutilated her body.

Mahaffey was the state's key witness against Shaw and Roach. He gave his gruesome testimony, going into graphic details of the events of the murder of Tommy Taylor and the rape and murder of Carlotta Hartness.

Robert Williams testified to his and Roach's conversation on Saturday night after the murders.

SLED Forensic Serologist John Barron testified semen was found on the vaginal swab collected from Miss Hartness at the funeral home, but there was no way to trace it to a particular individual.

A private psychiatrist for defendant Joseph Carl Shaw testified that in the last two years Shaw had gone through a divorce, been jilted by a girlfriend, was denied military promotion, arrested on drug charges and removed from his job as military policeman. "I think this contributed to quite a bit of emotional disturbance at the time of the murders, mainly in the form of extreme anger and hostility especially toward women."

Shaw's mother told of his troubled childhood:

> J.C. was two years old when his natural father and I divorced. When he was four years old, I remarried. He went to Mass every Sunday and served as an altar boy. He never did do well in school, so he dropped out after the tenth grade. He worked for a while in construction work and never got into any serious trouble until he was about seventeen when he stole some gasoline. He got married when he was eighteen years old, joined the army and was stationed at Fort Jackson Army Base. His wife became pregnant, but lost the baby, and about a year later she left him. That's when he started drinking and taking drugs. It got so bad he tried to kill himself. I know in my heart there's no way he would have ever done these things if his wife hadn't left him, and he could have come back home and got out of the service. He would have been fine.

Roach's parents spoke next. Mrs. Roach said,

> Terry was slow in school. He had a kidney problem that kept him from playing football, and he quit school after the ninth grade. That's when we saw a change in him. When he was fourteen years old, he was away from home a lot and started hanging around with the wrong crowd and smoking pot. He got into some trouble, so we admitted him to the juvenile facility in Columbia. We all love him, and I hate he got into this trouble he is in.

Mr. Roach told Judge Hartwell, "I was a truck driver, and I was gone a lot when Terry was growing up. I feel like I didn't spend enough time with him, and he got out of hand."

A forensic psychiatrist testified to his evaluation of Roach. His diagnosis was that of antisocial personality disorder and possible borderline retardation because of a low IQ, but he did say, "Terry Roach does understand right

from wrong. He just chooses not to accept what he wants to do whenever he wants to do it. That is, he doesn't obey the laws of society."

In closing arguments, Assistant Solicitor John McIntosh summarized, "People should be responsible. They are responsible for their alcohol consumption. They are responsible for their drug usage. They are responsible for these crimes: the armed robbery, the kidnapping, the rape, and the murders. These crimes speak for themselves."

Solicitor Jim Anders was brief and ended with, "Your honor, Roach and Shaw have shown no mercy, no remorse. They had no compassion for anyone. This is one of the most brutal crimes I have ever been associated with. I have never seen one in my life this bad. If there has ever been a crime committed in South Carolina where two people should be put to death, this is it. They are the ones that pulled the triggers."

All of a sudden there was an outburst in the courtroom. Mrs. Roach screamed, "Let me out of here. I want out of here. Mahaffey done it, too. He's got off free. He lied to save his life."

Judge Hartwell allowed her to leave the courtroom and ordered that all doors be locked, and instructed that no one was to leave or enter the room.

Anders continued, "Your honor, I think something should be said about Mahaffey. I hope he gets multiple life sentences plus years on top of that for rape, murder and any other acts he was involved in. He didn't pull the trigger. Williams didn't pull the trigger. Shaw and Roach did the killings and we ask they be put to death."

The defense argued the state had taken it upon themselves to play God in this matter. "They are saying Mr. Mahaffey, who is just as guilty as anyone, is going to live, and yet we want you to kill Roach and Shaw. There is Mahaffey sitting there content as a cow. He is not going to be killed. He made a smart deal."

In summary, the defense asked, "Your honor, on behalf of the defendants, we ask they be given justice and justice would be a life sentence."

Judge Hartwell asked Roach and Shaw if they would like to make any argument or statement to the court on their behalf. They both replied, "No, sir."

On December 16, 1977, Judge Hartwell imposed sentences for the three defendants.

Ronald Eugene Mahaffey was sentenced to life imprisonment. Judge Hartwell asked if he would like to say anything.

"Yes, your Honor. It don't so much have to do with exactly what is going on. I don't know whether the parents of those kids are here or not, but if they are, I would like to apologize to them if I could."

Joseph Carl Shaw stood facing Judge Hartwell as he imposed the sentence of death by electrocution. He did not wish to speak.

A tearful James Terry Roach stood before Judge Hartwell as he imposed the sentence of death by electrocution. He did not wish to speak.

In summary, Judge Hartwell said, "The powerful evidence of this case shows the viciousness and depravity of the crimes and overwhelmingly shows Mr. Shaw's and Mr. Roach's characters. This warrants the imposition of the death penalty for both. It is not a result of prejudice, passion or any other arbitrary factor. May God have mercy on your souls."

In addition to the death sentences, Roach and Shaw were sentenced to thirty years for criminal sexual assault of Miss Hartness, five years each on two counts of conspiracy and twenty-five years for armed robbery of Mr. Taylor.

In January 1978, Solicitor Anders agreed not to seek a death sentence against Williams, Mahaffey, Shaw and Roach if they pleaded guilty to the murder of Betty Swank. They entered their pleas and were sentenced to life for her murder.

Seven years and one month after the sentencing, I was among the waiting and watching crowd outside the prison the early wintry morning of January 11, 1985; the morning Joseph Carl Shaw was electrocuted for taking the lives of two innocent teenagers. I thought about Betty Swank, the other innocent victim whose life was taken away by Shaw.

In the still of the cold, misty darkness, I heard yells from the crowd waiting for Joseph Carl Shaw to die. "If he killed he should be killed." Some carried signs that read, "This is long overdue." "Justice is finally being served." "Burn baby Burn."

This was the first electrocution in South Carolina in twenty-two years.

It was 3:30 a.m. From outside the prison fence in a near-freezing wind, I focused on the dimly lit windows of the "death house." Several persons moved slowly in the darkness and entered the building. At 4:45 a.m., Joseph Carl Shaw was escorted from his holding cell into the execution chamber.

I could hear the humming of the generator that would release the power to put Shaw to death. Around 5:25 a.m. the generator shut down. Seconds of silence fell over the waiting crowd, and minutes later a prison official made the announcement, "Ladies and gentlemen, the sentence of the state of South Carolina and Joseph Carl Shaw was carried out at 5:16 a.m. today."

The crowd applauded. Somehow, I felt relief and peace, and at the same time I was shaking all over. I watched as the hearse that carried Shaw's body moved slowly out of the prison gate and disappeared into the darkness of the city. I had seen and felt the final minutes of a horror story that will remain stamped in South Carolina history, and in my memory.

A reporter for *The State* stated that Shaw read from a handwritten note just before he was executed Friday morning. His words included, "I want to say I am sorry to all three families, the Swanks, the Taylors and the Hartnesses for the grief and loss they have suffered. I realize their grief will continue, but I hope they have some peace once all this publicity about me ends. Killing was wrong when I did it. It is wrong when you do it. I have no bitterness toward anyone. May God bless and forgive you all."

Joseph Carl Shaw was thirty years old when he was executed.

The electrocution of James Terry Roach was scheduled for five a.m. on Friday, January 10, 1986. This would be the second electrocution in South Carolina since the reinstatement of the death penalty in 1977. Roach was then twenty-five years old, but because of his age when the murders occurred, and arguments that he was borderline mentally retarded and had been diagnosed with Huntington's disease (progressive loss of mental abilities causing the brain to continually deteriorate), his upcoming execution garnered international media coverage.

Solicitor James Anders appeared on the ABC news program *Nightline*, featuring a live call-in broadcast nationwide centering on Roach's electrocution.

Nightly news in Columbia reported that Governor Dick Riley received a personal telephone call from Mother Teresa from Rome pleading for mercy for Roach. Governor Riley very politely told her he would not grant him clemency.

The *Columbia Record* reported that during an interview with Roach he said, "There's nothing I can do except say I'm sorry those people are dead and sorry for all the suffering I've caused those people's parents, 'cause I see how all this has torn my family to hell, too. My execution is just gonna be another murder."

The electrocution went off as scheduled. I chose not to be in the crowd this time. I thought I was finally done with it, but some cases just never seem to go away.

Two days after Roach's execution, a Department of Corrections officer asked for my assistance with developing and printing a roll of film. The contents of the film were photographs of the body of James Terry Roach on a gurney in the autopsy room. The photographs documented the condition of his body after the execution and before the autopsy was performed. His lifeless body rested easy on the gurney as if he were sleeping. I closed the envelope on this case once again, and filed it back in place.

Ronald Mahaffey died in prison in February 2003 at the age of forty-one.

Betty Swank. *Courtesy of* The State.

Tommy Taylor and
Carlotta Hartness.
*Courtesy of* The State.

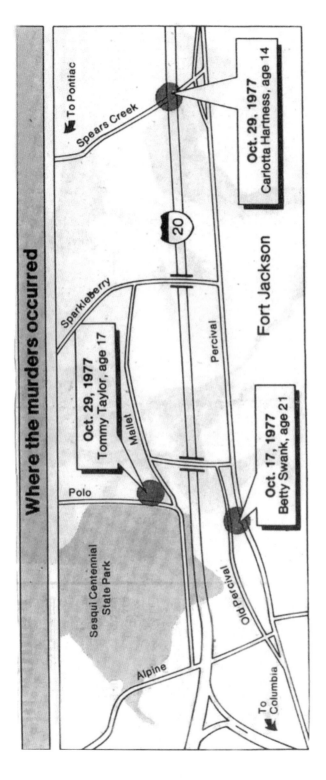

Where the three murders occurred. *Courtesy of* The State.

Aerial view of Polo Park softball complex. *Courtesy of SLED.*

Tommy Taylor's body was found in his car at Polo Park. The passenger window was shot out. *Courtesy of SLED.*

The 22-caliber rifle belonging to Joseph Carl Shaw was found in the woods. *Courtesy of SLED.*

The box of ammunition found in the woods was purchased by Joseph Carl Shaw. *Courtesy of SLED.*

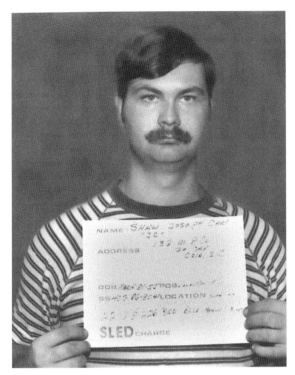

Joseph Carl Shaw. *Courtesy of SLED.*

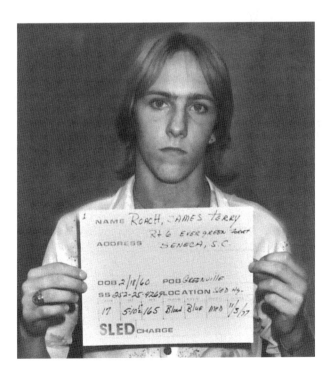

James Terry Roach.
*Courtesy of SLED.*

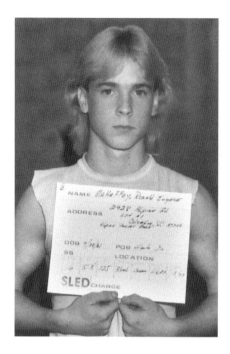 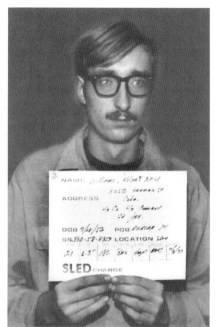

Ronald Eugene Mahaffey. *Courtesy of SLED.*   Robert Neil Williams. *Courtesy of SLED.*

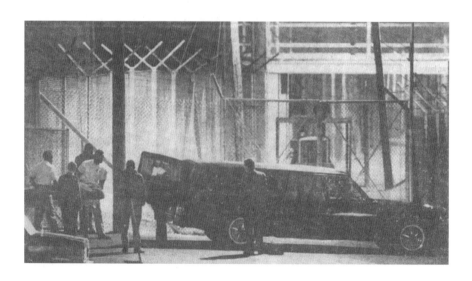

Body of Joseph Carl Shaw being placed in the hearse outside the "death house" after his execution. *Courtesy of* The State.

# Resentencing Trial
# of Rudolph Tyner

In South Carolina, jurors are sequestered during a death penalty trial, from the time they are selected until the final minute when the judge releases them. Law enforcement officers spend twenty-four hours a day with them. They lodge with them, eat with them and make them as much at home as they can while away from home. The jurors are not allowed any personal communication with anyone unless an officer is present.

I was one of the assigned officers to secure the jury of the resentencing trial of Rudolph Tyner in October 1980.

In Conway, South Carolina, in August 1978, Rudolph Tyner was tried and sentenced to death by a Horry County jury for the murders of a retired military couple, Bill and Myrtie Moon. The South Carolina Supreme Court overturned the verdict because special prosecutor Donnie Myers relayed inappropriate information to the jury in his closing arguments during the sentencing phase of the trial.

The Moons owned a small grocery store in the Burgess community, which is about four miles from Murrells Inlet, South Carolina, a rich historic little fishing village on South Carolina's coast known for its great seafood.

Around 9:45 p.m. on Saturday, March 18, 1978, a customer discovered the Moons' bodies crouched over on a blood-filled floor behind the counter. The cash register drawer was open.

Without delay, Horry County officers spoke to friends and family of the Moons. They remembered two black men hanging around and coming into

the store for the past several days. One of them had recently moved to the Burgess community from New York and would run his mouth while in the store about white folks. They knew the other to be from the Burgess community. They both worked in the community and lived only miles from the Moons' store.

Within hours of the shooting, Rudolph Tyner, eighteen, originally of New York, and Carl Davis, seventeen, of the Burgess community, were taken into custody, questioned, arrested and charged with murder and armed robbery.

The Moons were shot with a .12-gauge shotgun. A .12-gauge shotgun and about $200 were recovered from Tyner and Davis when they were arrested.

Tyner and Davis admitted to the murders and robbery and gave a full confession.

Carl Davis pleaded guilty and received a life sentence.

Tyner was tried in Horry County in 1978 and sentenced to death.

Circuit Judge Marion H. Kinon ruled that Tyner could not receive a fair trial in Horry County because of the publicity surrounding the previous trial in 1978; therefore, the 1980 resentencing trial of Rudolph Tyner was moved to Marion County. The trial began on October 6, 1980.

Assigned officers transported the jurors to their homes to pack enough clothes for at least a week and to say their goodbyes to their families. They were lost in silence at first, and all admitted that they were a bit afraid of the unknown. I assured them that officers were there to keep them safe and assist them in every way.

Testimony opened Wednesday, October 8. Rudolph Tyner, on trial for the brutal murders of Bill and Myrtie Moon, was a total stranger to them except for their knowing of him being an occasional customer in their store.

Officers transported the jurors to and from the courthouse every day and were in the courtroom during the entire trial.

The Moon family walked into the courtroom hand in hand. Their faces showed emotions of lingering sadness and fatigue. They had already been through all of this two years ago.

They looked up as Tyner walked into the courtroom and sat with his attorneys. Unemotional, Tyner looked around the room and slyly scanned the family. He then faced forward as the judge opened the proceedings. The Moon family would once again be reliving the nightmare of that fatal Saturday night in March 1978 when their parents were murdered and found lying in a pool of their own blood.

Testimony of witnesses began. A customer, who was most likely the last person at the store before the shooting, testified that he saw two people near

the road by the store around the time of the murders. A resident of Murrells Inlet testified that he saw two black males walking away from the store as he drove by shortly after the time of the shootings.

As the testimony continued, Rudolph Tyner looked around the courtroom and at times actually grinned.

Janice Cimo, daughter-in-law of the victims, worked at the store. She testified she had seen Tyner in the store several times the day of the murders.

Tony Cimo, son of Mrs. Moon and stepson of Mr. Moon, testified he heard his dog barking the night of the incident. He walked outside to check on the dog and saw a black male walking down the road a short distance from the store.

A psychiatrist told the jury Tyner was sane, and he knew right from wrong at the time of the slayings. Tyner's mother also testified that her son knew right from wrong, and if she punished him for doing something wrong, he would say he was sorry, but would do it again.

In the final arguments, Assistant Solicitor Morgan Martin told the jury that they should give Tyner the punishment he deserves, and that was death.

Tyner's attorneys strived to show he was not mentally competent because he was a borderline retarded person.

In the first trial in Conway in 1978, Tyner told the jury, "I am sorry for the trouble I have brought to the people of South Carolina." In this trial, he gave his personal plea for mercy from the jury: "I know it is hard for the Moon family 'cause it is hard for my family. I have repented, and I pray every day since it happened."

The jury began deliberations around 4:45 p.m. on Friday, October 10, to consider the death penalty for Tyner. After four hours, they failed to reach a decision. Judge Kinon dismissed the jury for the evening around 10:00 p.m.

The jury continued deliberations at 9:00 a.m. on Saturday, and after one and a half hours recommended the death penalty for Tyner. Judge Kinon imposed the death sentence at 10:30 a.m., Saturday, October 11, 1980. Tyner remained silent as he was sentenced.

There was a different overall feeling as I drove the jurors away from the courthouse this last time. Fatigue showed on their faces, but also a look of relief. They had performed a tremendous task during the past five days. They were ready to go home.

As I was driving home, something Rene Guyton, one of the Moons' four children, said to reporters after the verdict, kept rolling over in my mind, "The family is glad it's all over. At least we hope it's over. We thought it was over two years ago."

Moon's Grocery Store, where the murders occurred. *Courtesy of SLED.*

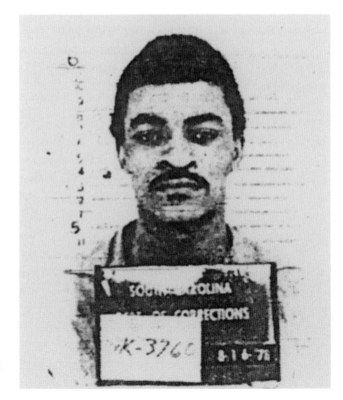

Rudolph Tyner.
*Courtesy of Department
of Corrections.*

Almost two years after Tyner's sentence, he made headlines in *The State* newspaper:

BLAST KILLS DEATH ROW INMATE
South Carolina Department of Corrections, Columbia, South Carolina
Sunday, September 12, 1982

At approximately 4:45 p.m. on Sunday, September 12, 1982, Rudolph Tyner was killed when a homemade bomb exploded in his second-tier cell on death row. It appeared he was putting the bomb together when it exploded. There was a short, loud blast and it was over. Radio parts and wiring were found in Tyner's cell.

Inmates were allowed to have radios, so Tyner's death was ruled accidental, and it was believed Tyner had caused the explosion.

An autopsy was performed on Tyner the following day. The report confirmed Tyner died from multiple trauma caused by damage to his central nervous system when the bomb blew up in his face. It was still thought to be accidental. The blast blew off Tyner's left hand and ear. Fragments from the bomb penetrated his skull, brain and other parts of his body.

During the days that followed, rumors surfaced in the prison that Tyner's death might not have been accidental. It might have been murder.

SLED investigators assisted the Department of Corrections with the investigation.

Evidence from his cell was sent to SLED and the FBI. I made copies of the photographs taken of Tyner, his cell after the explosion and close-ups of the parts of the homemade bomb.

This brought Rudolph Tyner back into my life, and I remembered the words of the Moons' daughter, Rene, as she was leaving the courtroom the last day of the trial: "The family is glad it's over. We thought it was over two years ago."

For the Moon family, another nightmare was about to begin.

During the two years after the final trial that sentenced Tyner to death for the murders of Mr. and Mrs. Moon, their son Tony could not let it go. He had even attacked Tyner at the courthouse when he was convicted, and it became an obsession for him. He was frustrated by four and a half years of repeated trials and the prospect of long appeals. He wanted to see Tyner get what was coming to him. He had seen how the victim got so much consideration, and he knew no one had been electrocuted in South Carolina since 1962. He also knew Tyner would get a Thanksgiving dinner, but his

Mama and Daddy would not. He always thought the law was supposed to provide justice, but there was appeal after appeal, and Tyner just went on living. Tony lost faith in the legal system, so he knew the whole story had not been told yet. One way or another there would be an end to it.

After several weeks of investigation, the homemade bomb that blew up and killed Rudolph Tyner was discovered to be the result of two years of planning by the Moons' son, Tony Cimo.

Tony was a brick mason in Murrells Inlet. He schemed with James Cooper, a carpenter from that area, to assist him in recruiting South Carolina's most notorious mass murderer, Donald Henry "Pee Wee" Gaskins, to get rid of Rudolph Tyner. Three other inmates at the Department of Corrections, Jack Martin, Gerald "Pop" McCormick and Charles Lee, also assisted in the conspiracy.

Pee Wee Gaskins was one of South Carolina's most inexhaustible killers. A South Carolina native from Prospect, a small rural community in Florence County, he got his nickname, Pee Wee, from his five-foot, four-inch stature.

Articles in *The State* reported that the gruesome truth of Gaskins's victims started surfacing in 1975 when a missing thirteen-year-old girl was linked back to spending time in Gaskins's home. He was charged with contributing to the delinquency of a minor and went to jail. After this, other missing persons were traced back to having known Gaskins. An associate of Gaskins informed authorities that Pee Wee told him he had killed people and he had his own private graveyard in Prospect. He took officers to the area of the graves, and the first digging was on Thursday, December 4, 1975. Several bodies were unearthed. The digging continued for several days and other bodies were found.

Pee Wee's digging frenzy continued, as he periodically told officers where other bodies were buried. After one of the diggings he said, "There's more bodies that's still in the ground, but you've got enough for now."

Gaskins confessed to more murders and admitted that he had murdered his first victims, his niece and her friend, in 1970 in Sumter, South Carolina, because they were into drugs. They got into an argument about the drugs, and he beat them to death.

Wherever he went, death seemed to follow. Age wasn't a factor with him. He killed children. He killed at least one baby. He crushed necks. He cut throats. He stabbed. He poisoned. He drowned his victims. He beat them to death with his fists. He shot them execution style. Whatever it took. One victim met his demise from a soft drink laced with photographic developer. Pee Wee could kill and not think twice about it. He was a man without a

heart or conscience, and then in the same breath would say he would not allow people to come to his house drunk around children. So when Tony Cimo put this task of killing Rudolph Tyner to Pee Wee, he had no problem with it at all.

Prior to 1976, Gaskins had been on death row, but his death sentences were commuted to life in prison when the South Carolina 1974 death statute ruling was changed to meet the United States Supreme Court guidelines for the death penalty in other states.

In 1982, Pee Wee was used as a "handyman and runner" on Cell Block II, the high securities building in which death row inmates were housed. Death row was on the second and third tier of this building. Tyner's cell was there, so Pee Wee had full access to Rudolph Tyner.

Gaskin's first attempts at killing Tyner were by sprinkling poison on his food. This wound up only making him sick to his stomach but did not kill him. So Pee Wee went to explosives. He rigged a device similar to a portable radio and told Tyner this would allow them to talk from cell to cell. Tyner followed Gaskins's instructions to hold it to his ear, plug it in the wall receptacle and they would talk to each other. When he did, it exploded and killed Tyner.

Gaskins taped his conversations with Cimo in which they plotted Tyner's death, thinking he could use them later to blackmail Cimo. Pee Wee had agreed to murder Tyner for money, but he was also going to blackmail Cimo to pay him even more money. This tape was found in Gaskins's cell and was a major piece of evidence that linked Tony Cimo to the bombing.

How Pee Wee got the explosives remains a mystery. At Gaskins's trial, Solicitor James Anders said, "Pee Wee had the run of the cellblock, he knew people on the inside and outside. He knew how to get what he wanted."

On Monday evening, October 4, 1982, authorities called Cimo at his home in Murrells Inlet and used the pretense of meeting with him about a job. He quickly agreed and upon arrival at the given location was placed under arrest and transported back to Columbia by plane that same night.

Lieutenant Steve Smith of SLED assisted in Cimo's arrest. Smith said Tony was very cooperative but quiet during the flight back to Columbia. At one time he said to him, "Tony, I have no idea how you feel, having your parents murdered, but there is no such thing as real justice in this world." Tony smiled shyly and spoke almost in a whisper, "Oh...but I think there is some justice."

The inmates that assisted Gaskins with Tyner's murder were charged with murder and conspiracy to commit murder.

Pee Wee Gaskins was tried for the murder of Rudolph Tyner and sentenced to death.

Donald "Pee Wee" Gaskins was electrocuted Friday, September 6, 1991, at 1:10 a.m. He was the fourth person to die by electrocution after the death penalty was reinstated in South Carolina in 1977.

Rudolph Tyner was the last person Gaskins would ever kill. In his own way, Pee Wee beat the system one more time before he was executed. Tyner was supposed to die in the electric chair. Pee Wee got to him first.

Tony Cimo was charged with murder and conspiracy to commit murder. He received three concurrent sentences for his role in the death of Rudolph Tyner; five years for conspiracy for murder, eight years for threatening to kill by explosives and eight years for failure to report knowledge of a bombing.

He served three years of his sentences, of which he spent most of his prison time on work release, and was warmly welcomed back home to Horry County.

In a June 2001 *Associated Press* report, Tony's sister, Rene, said he had no regrets about having killed Tyner. "He told me over and over, I think constantly of Tyner laughing while Mama and Daddy begged on their knees for their life. I did what I did, and that was it."

Before his parents' murders, Tony was involved in a serious boating accident. In June of 2001, Tony Cimo died at the age of fifty-two at his home from an apparent overdose of pain medication.

This case was featured in a CBS movie in 1986, *Vengeance: The Story of Tony Cimo*.

"Pee Wee" Gaskins (second from left in back) escorted by SLED agents and officer with Department of Corrections. *Courtesy of SLED.*

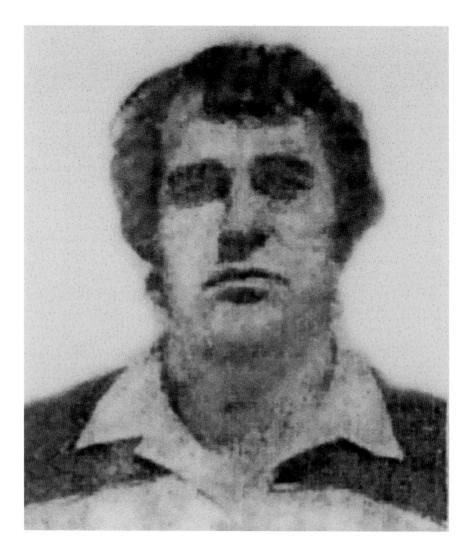

Tony Cimo conspired with Gaskins in prison to kill Tyner. *Courtesy of* The State.

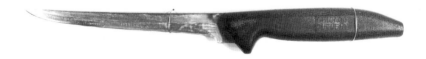

One of Pee Wee's weapons, known as "Pee Wee's toothpick," on display in SLED's Forensic Laboratory. *Photo by Rita Y. Shuler.*

# Resentencing Trial of Ronald "Rusty" Woomer

In Horry County in July 1979, Ronald "Rusty" Woomer was sentenced to die in the electric chair for the abduction, rape and murder of Della Louise Sellers. Woomer was granted a new sentencing trial when the State Supreme Court ruled that the original jury in 1979 received insufficient instructions from Judge David Hartwell and heard inappropriate arguments from Horry County Solicitor Jim Dunn.

I was assigned to assist with the sequestered jury during the resentencing trial.

My thoughts went back to February 1979, the day when this case came into the photography lab. SLED crime scene investigator Jim Springs told me the details of the case that led to four persons being killed in a one-day, 135-mile, three-county crime spree along the South Carolina coast from Cottageville to Myrtle Beach.

Acting on directions from Fred Whitehead, a local coin shop operator in Myrtle Beach, South Carolina, twenty-six-year-old Rusty Woomer and thirty-six-year-old Eugene Skarr traveled down from West Virginia and checked into the Komo-Mai Motel in Myrtle Beach. Whitehead instructed them to go out and rob some coin collectors, and he would pay them well for the job.

On Thursday, February 22, 1979, Woomer and Skarr left the motel around midday to drive 135 miles to Cottageville, South Carolina, to carry out the robbery of coin collector John Turner. They popped a few Quaaludes and started tossing back big swigs of Canadian Mist whiskey straight from the bottle.

The events of the day led to far more than a robbery. By the end of the day, sixty-seven-year-old John Turner, thirty-seven-year-old Arnie Richardson, thirty-five-year-old Earl Dean Wright and thirty-five-year-old Della Louise Sellers were dead at the hands of Woomer and Skarr.

The pair arrived in Cottageville around 4:00 p.m. and entered Mr. Turner's home. After robbing him of his coin collections, Woomer shot him in the head with a .32-caliber pistol. They then headed back toward Myrtle Beach.

On the way back, their 1972 tan Ford Maverick started overheating. About 6:00 p.m., they pulled up to a house in Georgetown, South Carolina, to get some water for the radiator. Woomer and Skarr burst into the home of Arnie Richardson, but water was the last thing on their minds. They started screaming and demanding money and guns. When they finally left the house Arnie Richardson and Earl Dean Wright, his sister-in-law who was visiting him, lay dead on the living room floor from shotgun blasts to the face and chest.

Mr. Richardson's five-year-old daughter was also at home with him. She was standing at the end of the couch where her father was sitting. As the fatal shots crumpled her father, he fell over on her as he hit the floor. The gunmen apparently thought the child was dead as they left the house. In her weakness, she tried to wake her daddy. When she could not get him to answer, she got on her bicycle and rode four and a half miles to her aunt and uncle's house. When they opened the door, their frightened, bloodstained niece, trembling and crying, looked up at them and said, "My daddy won't wake up. Somebody killed my daddy."

The next stop for the crazed pair was Jack's Mini Mart in Pawleys Island, which is about twenty-five miles from Myrtle Beach.

Don and Louise Sellers, who worked at the Mini Mart, were enjoying one of the island's laid-back days when Skarr, carrying the sawed-off shotgun, and Woomer, with the .32-caliber pistol, entered the store. Several customers came in behind them. Woomer yelled at them to lie down on the floor. Within minutes, Wanda Summers, who also worked at the store, walked in. Wanda's husband, Jimmy, and their five-year-old daughter, Traci, stayed outside in the car. Woomer quickly went outside and told them to get inside. The pair robbed everyone in the store and took money from the cash register. Then they left and took Louise Sellers and Wanda Summers with them.

Woomer and Skarr drove around with Mrs. Sellers and Mrs. Summers until they came to what appeared to be a deserted dirt road. It had been drizzling rain all day. The road was muddy. The grass was wet. Here they took the ladies out of the car, raped them and shot them. Mrs. Sellers was

shot with the .32-caliber pistol. Mrs. Summers was shot with the sawed-off shotgun. One of the blasts blew away everything below Wanda Summer's lower jaw. She was unconscious, but still breathing. When Wanda finally came to, she struggled to get up, went to help Louise and somehow, by the grace of God, started screaming.

The family who lived down the road heard the gunshots and Wanda's screams and came to her assistance in the darkness of night. They were Dean and Rene Guyton. Rene's parents were Bill and Myrtie Moon, the couple that was murdered in March 1978 in my foretold story, "Resentencing Trial of Rudolph Tyner."

EMT personnel arrived on the scene and transported Louise Sellers to a Charleston hospital. She died around 12:10 a.m. the following morning.

Wanda Summers was taken to a Myrtle Beach Hospital and miraculously survived.

Mr. Sellers and Mr. Summers gave a description of the assailants' car and officers in the area were alerted to be on the lookout for the tan Ford Maverick.

Around 11:30 p.m. that night, the Maverick was seen parked outside the Komo-Mai Motel. As officers moved in on Woomer and Skarr, they heard a gunshot from inside the motel room. Skarr had shot himself in the head with a shotgun. Woomer was in another room in the company of a female and was apprehended.

Woomer's resentencing trial began Monday, July 13, 1981, in Horry County, the same county as the first trial.

The defense and prosecuting attorneys questioned prospective jurors.

Neatly groomed, blond-haired, blue-eyed Rusty Woomer also addressed each prospective juror. He spoke in a monotone voice saying, "I am the defendant on trial, and if you are picked to be on this jury, my life will be in your hands."

Jury selection took several days. A jury of seven women and five men were picked from the prospective pool.

Judge Ernest Finney told the jury that Woomer had already been convicted of murder, and this trial would determine whether Woomer would get a sentence of life imprisonment or death in the electric chair.

The victims' families sat together. There were times during the testimony when they couldn't hold back the tears, but they held on to their strength and held on to each other.

In opening arguments, Solicitor Jim Dunn said to the jury, "The pain Rusty Woomer inflicted on his victims would speak for itself."

Chief defense council Cleveland Stevens followed, "This is not an easy case. It is difficult because some lives have been taken here."

Don Sellers testified to the events the afternoon they were working in the convenience store when Woomer and Skarr entered the store with guns and wanted money. "Woomer was very demanding and started yelling his orders as he held a gun to Louise's head. Louise told him to take the money if that's what he wanted. At that time, a local bricklayer and his daughter entered the store. Woomer yelled and motioned them over next to us. In a few minutes, Wanda Summers entered the store. Wanda worked during the day helping us at the store. Her husband, Jimmy, and their daughter, Traci, stayed in the car. Traci's sixth birthday was in a few days, and they had just picked up two new puppies for her birthday present. Woomer ordered Wanda to act like she was shopping. Woomer then went outside to the car and brought Jimmy and Traci into the store. After much shouting and demanding money, Woomer and his partner left the store with Louise and Wanda. I begged and pleaded to Woomer not to hurt my wife."

SLED Agent Lydia Glover was with the sequestered jury during the first trial. Lydia told me as Wanda Summers testified she had to hold a cup and a towel over her jaw area to soak up the drooling saliva as she spoke.

This time around Mrs. Summers's face showed the signs of many surgeries on her jaw. A titanium jaw piece had been implanted to reshape the muscles and skin of her face. Even with all of this, she had a certain glow to her. I could only imagine the extreme pain she had endured while begging Woomer to let her live. She told the story of her death-defying night at the hands of Rusty Woomer, and how she fought with her every breath to live. She was determined to live to see her daughter, Traci, have her sixth birthday.

Dean and Rene Guyton testified how they helped Wanda Summers the night she was shot. Dean Guyton said, "After hearing gunshots, we turned on the outside lights and saw a female running up the road. It scared us when we saw her face. It looked like everything below her nose was blown away. She was trying to talk, but her mouth was gone. She was making gurgling noises."

After a short recess, Woomer returned to the courtroom and kissed his mother before taking his seat.

Woomer's mother took the stand. She spoke softly during her testimony, saying, "Rusty was a well-behaved child."

Then the words of Woomer, "I've prayed for Mrs. Summers. I've prayed for Mrs. Sellers. I feel terrible. Just like Mrs. Sellers didn't want to die, I

don't want to die. Mr. Dunn said the Ten Commandments say, "Thou shalt not kill, but that also means thou shalt not kill me."

I was in the courtroom as the jurors listened to the witnesses and heard the evidence. Emotions ran deep as their minds filled with the powerful testimony. The intensity of their silence told its own story. The trial could never be discussed, but even under these circumstances, you get to know a lot about a person when you are with them the entire time: their little everyday habits, what they like to eat and drink, their work. They talk about their families and show you photos of their children and grandchildren, and talk to you about how much they love and miss them. In the same sense, they get to know you, to trust you and thank you for being there with them.

During Solicitor Dunn's closing arguments, he picked up the sawed-off shotgun, cocked it and clicked it twice. "That's how the four victims were murdered." Gasps could be heard all through the courtroom.

Then with his arms stretched to full length, he waved the .38-caliber revolver through the air and spoke loudly, telling again how Woomer shot Mrs. Sellers in the head to make sure she was dead. I literally ducked my head during this chilling performance. Dunn used this means of action when he would ask the witness a question. He would turn around and face the jury while the question was being answered and then sharply turn back to the witness and say, "What?"

In summary, he said, "Rusty Woomer has found the three S's: sorry, saved and sympathetic. Yes, sorry that he got caught. If you sentence Rusty Woomer to death, you will tell all the Rusty Woomers that you don't come to Horry County and shoot the faces off our mothers. You don't come to Horry County and shoot our wives. You don't come to Horry County and rape our mothers and wives."

Defense attorney David Bruck brought out in his closing arguments that Woomer was under the influence of Skarr during the murders.

After eleven long days, the jury deliberated two and a half hours and recommended the death penalty for Rusty Woomer.

There was that same kind of silence as my previous sequestered jurors as I drove the jurors from the courthouse back to the motel to pack their belongings and to return home. The strain and fatigue of a powerful task showed on their faces. We had spent eleven days in a world within a world, and a part of that world would always remain with all of us, even though the trial was over.

After eleven years on death row, Ronald "Rusty" Woomer was set to be electrocuted early Friday morning, April 27, 1990. I was assigned to the

security and crowd control detail outside the Department of Corrections. I arrived to my post at 6 p.m. that Thursday evening as the sun was setting. The crowd consisted of supporters and protestors of the death penalty. I was with the crowd for seven hours, hearing the comments and conversations. Signs in the crowd read, "Burn Rusty Burn," and "Thou shalt not kill." A car full of women drove by and shouted, " Burn him."

Solicitor Jim Dunn spent some time among the crowd and with him was a tombstone he had made with the names of all of Woomer's victims engraved on it. The monument now sits in the front yard of the Horry County Courthouse in Conway, South Carolina.

Woomer was the first person to be electrocuted in South Carolina's new Capital Punishment Facility on Broad River Road in Columbia, South Carolina. His was the third electrocution in the state since capital punishment was reinstated in 1977.

The anxious supporters applauded when the announcement was read, "The electrocution of Ronald 'Rusty' Woomer was carried out at 1:12 a.m."

There was more applause and cheers as the hearse that carried Woomer's body slowly passed the waiting crowd, exited the Department of Corrections grounds and disappeared into the darkness of the night.

I was there in the final moments of Woomer's life. That night, the last proceeding of this case was carried out. *The State* newspaper reported that this was exactly eleven years, two months, four days, six hours and forty-two minutes since he murdered Della Louise Sellers.

Several weeks after Woomer's execution, I toured the death chamber, viewed the electric chair and Woomer's now empty cell at the Department of Corrections. There was only one small window opening in the cell. It was up close to the ceiling and was secured with iron guardrails. The guide told me that through that opening Woomer had observed a mother bird building her nest in the razor-tipped wire outside. He watched her every day as she laid her eggs and nestled them until they hatched. He watched them fly out of the nest and to their freedom. The empty nest was still there.

On June 13 and 14, 2001, I attended the book signing of Dale Hudson and Billy Hill's book, *A Reason to Live, The True Story of Wanda Summer's Love, Courage, and Determination to Survive*. As I entered the room, it was personally moving to look around and see the surviving victims, Wanda and her family, after twenty years. Wanda was glowing. I walked up to her, introduced myself and told her of my part in the trial in 1981. She gave me a smile and a hug, and whispered softly, "Thank you."

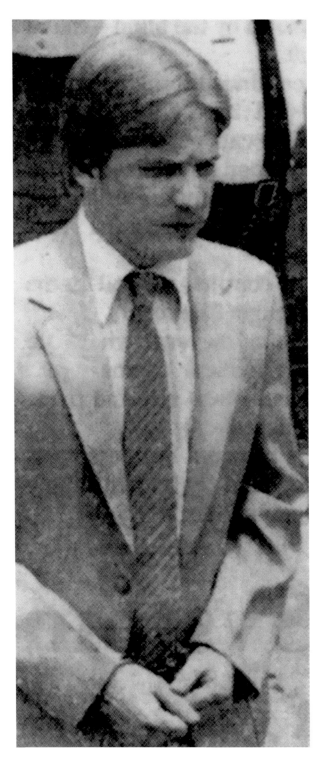

"Rusty" Woomer outside Horry County Courthouse. *Courtesy of* The State.

Jimmy Summers, author Shuler and Wanda Summers at the latter's book signing in 2001. *Photo by Rita Y. Shuler.*

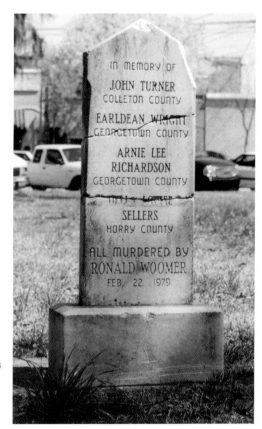

Tombstone that Solicitor Jim Dunn had engraved with all of Woomer's victim's names now stands in the yard at the Horry County Courthouse in Conway, South Carolina. *Photo by Rita Y. Shuler.*

# The Composite

**M**any times I have been asked, "What was the most interesting case you worked?" There were many, but the composite of 1981 was the most self-rewarding.

At 11:30 a.m. on Monday, June 22, 1981, the Georgetown County Sheriff's Department received a call from the Georgetown County waste disposal plant. Workers at the plant saw a human arm on a conveyor belt leading to a trash grinder. Further searching through the garbage uncovered another arm, two legs and a plastic bag that contained a head and the buttocks of a white female. The mid-torso of the body was not found.

An autopsy of the body parts was performed at the South Carolina Medical College in Charleston, South Carolina.

Findings showed she had probably been dead less than twenty-four hours before the body parts were discovered. The extremities apparently had been dissected with a knife and a saw, probably of the hacksaw type. She was twenty-five to thirty-five years of age and approximately five feet two inches to five feet six inches tall. She probably weighed between 125 and 135 pounds. Her ears were pierced, and her shoe size was five and a half to six. She had extensive dental work, including a number of extractions and a good bit of fillings in the remaining teeth.

Because of the condition of the body parts and her missing torso, the autopsy was inconclusive as to the cause of death, but the manner of death was designated as homicide.

In an effort to determine the woman's identity, Georgetown County Sheriff's Department contacted the South Carolina Law Enforcement Division and requested a facial composite of how the woman might have looked when she died.

A composite of the victim was necessary because a photograph of the woman's face could not be published in the newspaper and media due to its condition.

On Tuesday, June 23, Agent Lydia Glover and I went to the Medical College. I photographed the head and face of the victim.

If possible, in a criminal investigation a verbal description of the perpetrator is normally obtained from a witness or surviving victim so that a facial composite can be sketched by an artist or by using a manual composite system. Since we did not have a living victim in this case, Agent Glover and I worked with the head and photographs of the head and face to compile a facial composite using a manual composite system.

We used a Sirchie Photo-fit Composite Kit. The kit consists of over eight hundred photographs of facial features: eyes, eyebrows, noses, lips, chins, moustaches, beards, hair, glasses, headwear and age lines. They are printed on jigsaw-like pieces that slot into a template to compose photographic lifelike faces.

Agent Glover and I had received on the job training in the use of the Sirchie composite system. We worked with the witness and/or victim as they selected the facial features from the kit that matched their description of the perpetrator to achieve an optical likeness. Composites are not an exact likeness, only a similar likeness. There were times when the completed composites looked so much like the perpetrator that it was scary.

Photographs of the facial composite of the unidentified female were media circulated statewide along with a description of her probable physical appearance determined by the autopsy.

On June 21, 1981, J.J. Parker filed a missing person's report with Lexington County Sheriff's Department in Lexington, South Carolina. His thirty-two-year-old roommate and her little white poodle, Prissy, left their apartment to go for a walk around 10:30 p.m. on Saturday, June 20, 1981. She had not been seen or heard from since. She was wearing blue jeans and a white tee shirt that had 7 and 7 printed on it. The missing person's report was circulated to all state police departments and sheriff offices.

The Georgetown County Sheriff's Office had received over seventy calls concerning the composite after it was run in the newspaper.

On Thursday, June 25, the North Myrtle Beach Police Department contacted the Georgetown Sheriff's Office and informed them that the former wife of J.J. Parker and her son had seen the composite that was published in a Myrtle Beach newspaper. She said the composite looked like her former husband's girlfriend, Linda Cope, from Lexington, South Carolina.

Georgetown investigators then contacted a friend of Ms. Cope's, Jan Crutchfield, who was listed as a contact person on the missing person's report. Ms. Crutchfield advised authorities the description of the missing person, Linda Cope, was similar to that of the body in Georgetown. She provided the Georgetown County Sheriff's Office with two photographs of Ms. Cope, and the information of Ms. Cope's ex-husband, James Cope, who lived in Rossman, North Carolina.

Local authorities in North Carolina assisted Georgetown County and contacted Mr. Cope. He provided them with dental records of his ex-wife, Linda Mackey Cope, and they immediately forwarded them to the Georgetown County Sheriff's Office. A positive identification was made through Ms. Cope's dental records.

On Monday, June 29, 1981, Georgetown County Sheriff Michael Carter contacted Lexington County Sheriff James Metts and informed him the body that had been discovered in the Georgetown waste disposal area was identified as Linda Mackey Cope.

Ms. Cope and her poodle left to go for a walk that summer evening and never returned. Parts of her body ended up 125 miles from her apartment in a garbage dump. Somewhere along the way she had been murdered and her body dismembered. The whereabouts of the missing body parts and the torture that occurred during these miles remain unknown except to the person or persons that committed this brutal murder.

Prissy, the poodle, was never found.

Linda Cope would have celebrated her thirty-third birthday on June 25, 1981.

The killer or killers have never been found. The case remains one of South Carolina's cold cases.

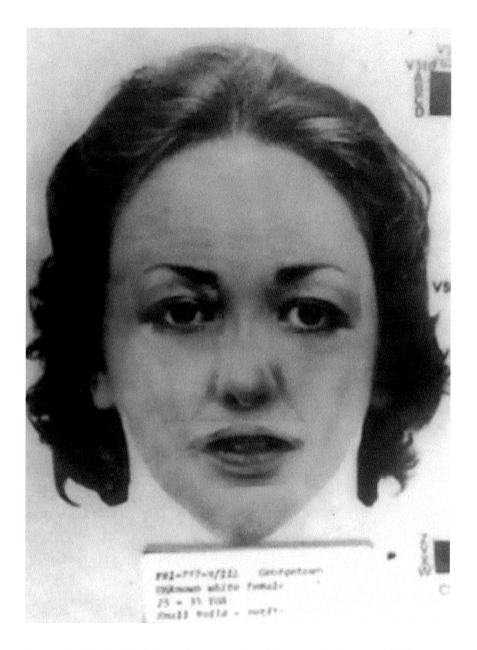

Composite of unidentified victim that was circulated by the media. *Courtesy of SLED.*

# Friend Identifies Dead Woman

Press Staff And Wire Reports

Georgetown County Sheriff Mike Carter said Tuesday that the dismembered remains of a woman found there last week are those of Linda Mackey Cope, 33, of Lexington County.

Carter said a friend of the victim recognized a composite sketch in a newspaper and contacted him. Researchers and pathologists at the Medical University of South Carolina verified the report through dental records obtained from a dentist in Brevard, N.C.

Article appeared in *The State. Courtesy of* The State.

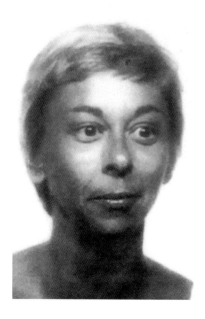 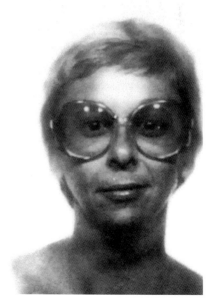

Linda Mackey Cope, victim of unsolved murder. *Courtesy of SLED.*

# He Said, He Said

**M**rs. Lula Mae Bass owned and operated Bass Liquor Store, located just a few feet from the South Carolina-North Carolina state line on South Carolina County Highway 41. It's just down the road from the "South of the Border" tourist attraction on Interstate 95.

On Thursday, January 30, 1992, Mrs. Bass and her daughter, Amy, were both at the liquor store. They were going to Lumberton the next day to pay Mrs. Bass's taxes. Mrs. Bass took some money from the cash register, put it in her coat pocket, left around 7:00 p.m. and told Amy she was going home. Her house was only about a mile from the liquor store, and her address was in Lake View, South Carolina. One could stand in Mrs. Bass's front yard and see the South Carolina and North Carolina state line signs.

Mrs. Bass was seventy-three years old and lived alone. Her children would stop by and check on her every day. On Friday morning, January 31, 1992, Amy received a call from her sister, Nancy, telling her she had called their mother three times that morning and the line was busy, so she went over to the house. "Mama didn't answer the door, so I went around to the windows and called to her. I still didn't get an answer. I saw the lights were on and the telephone was off the hook, lying on the floor."

Nancy didn't have a key to their mother's house, and knowing her mother, she just thought she was busy or pouting and just wouldn't come to the door. Nancy was a teacher at Lake View Elementary School and she had to

South Carolina state line, Bass residence in background. *Photo by Rita Y. Shuler.*

report to school early that morning, so Amy told her to go on to work, and she would go back over and check on their mama.

Amy called their brother, Tommy. He said he had already been to their mother's house earlier that morning to feed the animals and was supposed to eat breakfast with her. He knocked on the door, but she didn't answer. He, too, knowing his mother, just thought she didn't want to be bothered or she might have already left for Lumberton to pay her taxes.

Amy told Tommy she was going back over to check on her. Around ten o'clock, Amy turned into the front drive of her mother's ranch style home. As she turned the corner of the house, she knew something was wrong because her mother's car was still parked where it had been the night before. The same chilling fear came over her as it had fifteen years before when she was entering her father's lakeside cabin to check on him. There she found her father seriously wounded in the cabin, and he later died.

She parked near the back door of her mother's house. She unlocked the door and reached to turn the alarm off and realized the alarm was already off. She now feared the worst as she stepped over the telephone receiver that was off the hook and lying on the floor. She looked up and toward the kitchen. She saw her mother's body covered in blood on the floor. Her first

thought was, "This can't be happening again. Maybe Mama just fell and injured her head." As she moved closer to her mother's body, she saw a knife sticking out of her right side and when she leaned closer, she discovered another knife sticking out of her right shoulder. She thought back, "Fifteen years ago it was Daddy. Today it's Mama." She kneeled down and picked up the phone from the floor and dialed the Lake View Police Department and the Dillon County Sheriff's Office.

Tommy started worrying when Amy said she was going to check on their mama. He told a friend who was with him, "Something's not right, Bud. I called the store, and Mama isn't at the Line [the State Line Bar and Grill, a neighboring restaurant]. It's past nine o'clock, and she's not with Amy. Something's not right. I'm going to the house. I swear I hate for Amy to have to find Mama if something is wrong…like she found Daddy."

Tommy arrived at his mama's house, jumped out of his truck, and as he was nearing the door, yelled, "Amy, is Mama okay?"

Amy screamed back, "Tommy, Mama is dead!"

Tommy ran into the kitchen and over to his mama lying on the kitchen floor. Shocked with the sight of his mama in a puddle of blood, the first thing he did was pull the knife out of her shoulder. He then gently lifted her head and hugged and kissed her. He held her tight and laid her head up against his chest. Tears rolled down his face.

After somehow composing themselves as best they could, Amy and Tommy checked the house and found their mother's bed had not been slept in. They checked the pockets of the jacket she usually wore. The money she had put in the pocket when she left the store the previous night was missing.

Lake View Rescue Squad arrived on the scene. Shortly thereafter, Dillon County Sheriff Harold Grice arrived and called for assistance from SLED's Forensic Team to process the crime scene.

SLED crime scene investigators Tom Darnell and John Christy arrived at the scene. They searched the exterior of the area for shoeprints and tire prints or any other evidence that might be pertinent to the crime. They entered the house and the first thing they observed was a pair of eyeglasses lying on the floor over to the side. They went into the kitchen and saw a white female's body turned on her left side on the floor. She was fully clothed. Blood was under and around her entire body. In her right side was a knife pushed all the way in so that only the handle was visible. Under her head was a pair of pruning shears with twenty-four-inch wooden handles covered with blood. In between the handles of the

shears was another wooden handled knife, also covered with blood. This was the knife her son, Tommy, had pulled out of her right shoulder.

Proceeding very carefully, Darnell and Christy performed a walk-through search, seeing what they had and what needed to be done. They took great caution as they examined the floor for footwear impressions that might be present. By simply using a flashlight or other light source while kneeling on the floor, they oblique-shined the light across the floor area. Footwear impressions were found and marked with tape so as not to disturb them while conducting the rest of the walk-through of the scene.

There were bloody footwear impressions visible on other areas of the floor throughout the house. One was near the victim's feet and one at the threshold of the door leading toward the den. Agents Darnell and Christy made an attempt to actually cut the tile floor up and transport it back to the photography lab to have it photographed in the controlled lab lighting set-up. With this particular flooring, the tile could not be removed, so Darnell and Christy sprayed the bloody impressions with amido black dye to enhance the bloody impressions. The amido black procedure of formulating and treating the bloody evidence by spraying or dipping is a proven technique in the development of blood-related impressions on all types of porous and nonporous surfaces, including human skin. In many cases, amido black will develop impressions faintly contaminated with blood and not visible to the naked eye. The dye reacts to the protein present in blood to make it visible to the human eye. It gives the blood a blue-black appearance.[16]

Darnell and Christy photographed the amido-enhanced footwear impressions at the scene. The film was submitted to the photography lab. I printed a 1:1 (exact size print) of the footwear impressions to be used for comparison analysis.

A dusty footwear impression was found in the bedroom just in front of a dresser. The toe area was pointed toward the dresser. Two drawers of the dresser were pulled open and rummaged through. Other dusty footwear impressions were found in the hallway and adjacent bedrooms.

A gel lift was used to capture the dusty footwear impressions. A gel lift is a rubberized adhesive material that when placed over the impression will transfer the dusty impression onto the lift. This procedure is very advantageous for capturing print impressions from evidence that will not be carried back to the laboratory.

In the photography lab, I photographed the dusty impressions on the gel lifts using a cross-lighting procedure with a high intensity light source. This

procedure entails moving the light source around the lift to the best angle that makes the print visible. I then printed a 1:1 of each impression to be used for comparison analysis.

The entire crime scene was processed for fingerprints and palm prints.

Latent (hidden or invisible) fingerprints and palm prints are left by accident and are usually partial (only part of the print), not the whole print. Partial prints are very identifiable if sufficient characteristic details (features of the ridges) are present. Not everyone leaves prints. It is possible one can touch something and not leave a print. It can depend on the condition of the hands and the surface that was touched or how it was handled. This is one of the silent witnesses that can be left behind, the assailant's signature that is his own made by his own skin ridges. No two persons have the same fingerprint. No two persons have the same palm print. No two persons have the same footprint. They can never be duplicated.[17]

As Mark Twain wrote in *The Tragedy of Pudd'nhead Wilson*:

> Every human being carries with him from his cradle to his grave certain physical marks which do not change their character, and by which he can always be identified. These marks are his signature; his physiological autograph and it cannot be counterfeited. No other person in the world has his autograph of delicate characteristics and markings.

Amido-enhanced footwear impression in blood found in Mrs. Bass's house. *Courtesy of SLED.*

Using a magnetic brush, Agents Darnell and Christy brushed black magnetic powder on all areas in question. Prints are 99 percent moisture, so the powder adheres to moisture if latent prints are present in the area. Anything the assailant could have touched was dusted. Usually the evidence is taken back to the SLED laboratory for further print examination and photographed in the controlled lab environment. In this case, when the prints became visible after dusting at the scene, they were lifted from the surface. Lifting a print is performed by applying a piece of clear lift tape firmly over the print. When the tape is peeled back, the print adheres to the tape. The tape with the lifted print is then pressed onto a white or black lift card. The location where the print is lifted from is documented on the lift card.

The lifts were brought back to SLED for photographic documentation. I photographed the lifts and printed 1:1 exact size photographs of the fingerprint and palm print lifts to be used for comparison with the suspect's known prints. A known print is the actual inked print of a person. This is done by applying ink to the finger and palm and pressing them onto a card or paper.

If the suspect had a prior arrest record, the fingerprint card would be on file at the arresting agency and/or SLED. The card can be retrieved and compared to the latent print. In order for a print to be identifiable, characteristics of ridges, dots, bifurcations and ending ridges have to be present and positively matched to the known print of a suspect. If it does not have sufficient ridge detail to make a match, then it is not identifiable.

Gel lift of dusty shoeprint found in Mrs. Bass's house. *Courtesy of SLED.*

Since the introduction of AFIS (Automated Fingerprint Identification System) in 1997, unknown prints can be entered into the database to search for a possible match. AFIS is a storage, search and retrieval computer system for fingerprints, palm prints and demographic data. The system has the ability to search against the unknown print and provide the fingerprint examiner with a "candidate list" of prints from the database for a possible match. The information it gives has to be interpreted by an expert print examiner to make the final identification of an exact match.[18]

Agents Darnell and Christy lifted eighteen latent prints from the home of Mrs. Bass. After additional analysis at the lab, they found thirteen of the prints identifiable. Some belonged to family members as well as the assailant.

As the investigative team was processing the crime scene, Ms. Geraldine Watson contacted Lieutenant Bobby McLean of the Dillon County Sheriff's Office. Ms. Watson was the niece of Mrs. Bass and owner of the State Line Bar and Grill, which is right next to the Bass Liquor Store. She became concerned when she noticed Mrs. Bass was not at her liquor store by 9:00 a.m. Friday morning. She knew her aunt was always there to open her store on time.

She informed Lieutenant McLean that she was at her club that same day when Terry Grice (no relation to Sheriff Grice) came in. He was upset and told her of a plan he and some friends had talked about to rob Mrs. Bass. Terry said, "I think I know who done it, and I will help the police try and locate these guys."

Arial photo of North Carolina-South Carolina state line, Bass Liquor Store and State Line Club. *Courtesy of SLED.*

She assisted Lieutenant McLean in making plans to meet with Terry at a cemetery in North Carolina. The cemetery was two miles across the state line from the Bass residence. Lieutenant McLean called for investigative assistance from Lieutenant Fred Knight with SLED to meet him at the Bass home.

Sheriff Grice and Ricky Britt, an investigator from North Carolina, were also present at the Bass residence and accompanied Lieutenant McLean, Lieutenant Knight and Ms. Watson to the cemetery where Terry Grice was waiting.

Terry told them that Thursday afternoon, January 30, his cousin, Tommy Campbell, and his cousin's friend, David Thompson, came to his mother's house.

> Tommy and David talked about going down to Mrs. Lula Mae Bass's house and wait until she came home from her store and get some money from her.
>
> Tommy asked me, "You going down there with us, aren't you?" I said, "Yeh, I'll go."
>
> We left the house about 5 o'clock Thursday afternoon and headed for a friend's house. While we were there, David Thompson asked me again, "You are gonna go down to Mrs. Bass's with us, right?" I told him, "Nah man, I changed my mind, I ain't gonna go." Then I gave him the pipe wrench.

Surprised with that comment, Lieutenant Knight said, "What? What pipe wrench?"

"A pipe wrench in my coat pocket that Tommy told me to bring."

"And what was he going to do with the pipe wrench?"

"He didn't say why, he just told me to bring it. Then all three of us talked again, and David and Tommy asked me again if I was going with them. I told them, 'No, you guys will be getting in trouble down there, and I ain't going.'"

Knight asked, "What happened to the pipe wrench?"

"David took it and put it in his coat pocket, and they told me they were headed to Mrs. Lula Mae Bass's house with that pipe wrench to rob her."

Terry Grice agreed to cooperate fully with the officers and to wear a body wire to help officers find his cousin, Tommy Campbell, and his friend, David Thompson.

Sheriff Grice, Lieutenant Knight and Terry Grice traveled to the Robeson County Sheriff's Office in Lumberton, North Carolina. There, the wire was placed on Grice. Officers again asked Grice if he was sure he knew what

he would be doing. Terry answered, "Yes, I'm gonna be 'buggin' Tommy Campbell and David Thompson."

Sheriff Grice and Lieutenant Knight transported Terry Grice to David Thompson's house. Terry walked up and talked to Thompson's mother, and when he was walking back toward the surveillance vehicle he stopped and talked to David Thompson. Some cursing went on between the two, but Thompson would not tell Terry anything.

The officers and Terry Grice then traveled to Fairmont, North Carolina, to the mobile home of Tommy Campbell. Terry went inside and was having a conversation with Campbell as officers knocked on the door of the Campbell home. Campbell came to the door. The officers identified themselves and motioned for Grice to leave the trailer. They asked Campbell's permission to search his vehicle. Campbell consented.

Officers then requested consent to search the mobile home of his mother, Edna Campbell. Mrs. Campbell consented.

After searching the mobile home, Investigator Britt, Lieutenant Knight, Tommy Campbell and his sister traveled to the Robeson County Sheriff's Office. Campbell said he knew and trusted Officer Ricky Britt, so he wanted to talk to him. While speaking to Britt, Campbell said, "I want to tell ya'll what we did to Mrs. Lula Mae."

Tommy started his statement at 10:48 p.m. that night. "I was at my Aunt Judy Grice's house on Thursday. Her son, Terry Grice, was there, and later on that day a buddy of his, David Thompson, came to her house. David talked to Terry Grice and me and told us he had everything planned for what we was gonna do that night. We was gonna go down to Mrs. Lula Mae's house and bust in and take a pipe wrench and hit her 'side the head."

Lieutenant Knight asked, "Tommy, do you know Mrs. Lula Mae Bass?"

"Yes sir, known her a long time. She been a long good friend...longtime. She's a nice person. She sells liquor in her store and out of her house."

Tommy continued, "Me, David and Terry left the house together to go help another friend, Smitty, move a refrigerator. Terry stayed behind at Smitty's when David and me left and went to the State Line Club to drink a beer. David had the twelve-inch pipe wrench he got from Terry Grice stuck down in his coat. We stayed at the State Line Club for about ten minutes, then left and walked through the woods down to Mrs. Lula Mae's house. It was dark, and we stood outside in the pecan trees for about two hours, watching and waiting 'cause Mrs. Lula Mae's daughter, Amy, was at her house. Her boy must have been there too 'cause his truck was parked next to Mrs. Amy's car. David kept telling me how he was gonna bust her head."

Asked what they were wearing, Campbell replied, "I had on white pants, a blue and white shirt, blue cap, army camouflage jacket and these shoes I have on now. David had on blue jeans, black jacket, black cap and I forget what kind of shirt."

Officers asked Campbell's permission to collect his clothes and shoes at completion of his statement. He consented. These articles of clothing were transported to the SLED laboratory for further analysis.

Campbell continued, "When we left from down by the trees, David told me to go to the door and ask for a fifth of liquor and he'd stay outside so Mrs. Lula Mae couldn't see the pipe wrench in his hand. Then he'd jump in quick and hit her in the head."

Lieutenant Knight moved in close to Campbell and said, "Go ahead Tommy, tell us what ya'll did to Mrs. Lula Mae."

"Well, I rung the doorbell and she popped on the light, and I asked for the fifth of liquor. David was still standing outside with the pipe wrench, and when she came back and handed me the liquor, David jumped in and hit her on the top of the head with the wrench. He kept hitting and hitting her on the top of the head. Mrs. Lula Mae starting hollering, and she was bleeding bad. He kept beating her and beating her and knocked her glasses off her head. She had her hands over her head, and she tried to run away. David started hitting her again, and she fell on the kitchen floor. David was yelling, 'Where is the money? Where is the money?' He started raging and went to a closet and pulled out something with two long handles on it...something you cut hedges or weeds with. He put them around her neck and started choking her with them. I saw a bunch of blood."

Lieutenant Knight interrupted, "Tommy, what did you do to Mrs. Bass?"

"Well, I took a hit or two at her, 'cause David told me to. David said, 'If I go down you going down, too.'"

Knight asked Campbell if Mrs. Bass was moving when he kept on hitting her and he said, "Yeh! She was moving and screaming and fighting for her life. David was still raging, and he went and got a knife and stuck her in the neck and stomach while she was laying in the floor and still bleeding all over the place. He kept on doing this for a long time. He said he had to make sure she was dead."

Knight interrupted again, "So you were just standing there and David Thompson was doing all this to her, and the only thing you did was to hit her with the pipe wrench two or three times?"

"Yes, sir."

Knight asked, "Did either of you step in the blood and track it through the house?"

"Naw not me, but David might have. I didn't step in any. I stayed away from it, but we both got to walking and plundering all over the house looking for money. Going in and out of every room and through all the dressers and closets. Mostly in Mrs. Lula Mae's bedroom, in her dresser drawers and some in the kitchen drawers."

"How much money did you get?"

"About $300, I think."

"Did you take anything else?"

"Yeh! We, no, David took a gallon of liquor and a silver pistol. He showed me the pistol."

"So, here we got David Thompson taking money, liquor and a pistol from the house, and you, what did you take?"

"I didn't take nothing."

"And David was doing all the beating and stabbing. How long did it take ya'll to kill her?"

"About forty-five minutes to an hour."

"So she lived for a long time while ya'll were in there."

"Yeh! We…David wanted her to live 'til she told him where the money was. She just keep screaming and yelling, 'Don't kill me, don't kill me,' and kept begging for her life. We didn't know she was dead until we left the house."

Knight asked, "Where was the pipe wrench when you left the house?"

"David Thompson had it, and he threw it in the woods or maybe the field after we left the house."

"Where did ya'll go when you left the house?"

"David went to the State Line Club. I went to Sonny Boys, and then we left there and caught a ride into Lumberton. We was walking around the streets and thinking about what we had done, and I was thinking heavy about what David had done to Mrs. Lula Mae. David shouldn't have killed Mrs. Lula Mae. I told David he shouldn't have killed Mrs. Lula Mae."

As Tommy Campbell was ending his statement, Knight said, "I want to get this perfectly straight Tommy. When you and David Thompson went to Mrs. Lula Mae Bass's house, is it true you and David planned to kill her?"

"He did, I didn't."

"But you went along with him and hit and beat her when he told you to."

"Yes, sir."

Tommy Lee Campbell, age twenty-two, from Fairmont, North Carolina, was arrested for the murder of Lula Mae Bass at 11:20 p.m. on Friday night, January 31, 1992.

After midnight on the same night, officers went to the home of Mrs. Louise Thompson, mother of David Thompson, and asked for consent to search her home. She consented, but said David didn't sleep in her house much. He stayed out back in a little shack building. She told officers she had seventeen children and David had a twin sister.

The officers proceeded to the shack out back and called Thompson's name. As he opened the ragged door, they asked if they could search the building he was in. He consented and signed the form. As they entered his shack, they saw a woman in his bed he said was his girlfriend. They found a pistol and some money in a cardboard box next to the bed. They were later identified as Mrs. Bass's pistol and some one hundred bills, which in all probability were the $100 bills that were stolen from Mrs. Bass's home.

David Thompson was transported to the Robeson County Sheriff's Office in Lumberton, North Carolina. He consented to give a statement of what happened to Mrs. Lula Mae. SLED Agent Lieutenant Fred Knight was again present during the statement.

Thompson's statement was almost a mirror image of Campbell's, with one major difference. Thompson said the whole idea of robbing, beating and killing Mrs. Bass was planned and carried out by Tommy Lee Campbell.

Shack that David Thompson lived in. *Courtesy of SLED.*

$100 bills found in Thompson's shack. *Courtesy of SLED.*

Victim's gun in box by Thompson's bed. *Courtesy of SLED.*

He stated, "On Thursday, I went to Fairmont, North Carolina, to Tommy Campbell's house. My brother went with Tommy's sister. That's how I got to know Tommy. I've known him for about two or three years. There was a young dude at the house, too, named Terry Grice."

Knight asked him what they talked about.

Thompson said,

> We went outside and he gave me some beer and some moonshine. He drank some with me, but the young dude didn't. We talked about going down to the State Line Club right on the line. We went, but we didn't stay long. Tommy talked about taking care of something at a lady's house, to get some liquor and stuff. So Tommy and me walked down to the lady's house. The young dude turned around, so he didn't go with us. He said he'd catch up with us later. We walked up to her driveway, and it started drizzling rain and getting dark. There was two cars in the yard, and Tommy walked over to the burgundy or black car and got something out of it. I think it was Ms. Amy's car. We went out and waited in the woods under some pecan trees to kind of get out of the rain and wait for the other people to leave. After about fifteen minutes, Tommy went toward her back door. He always went to the back door to get liquor when her liquor store was closed. The lady that came to the door must have known him because when she saw him she said, "Hello stranger, haven't seen you in awhile." He told her he wanted some liquor. When she brought it back and handed it to him, he started hitting her with the pipe wrench the young dude had given us.

Knight asked him who had the pipe wrench. Thompson stuttered, "I had it right here in the pocket of this coat, 'cause they told me to tote it, right? They told me they were gonna use it to get a bicycle rim for a ten speed or buzz bike or something like that."

David continued telling his story.

> When Tommy started hitting her she started hollering, "Oh! You killing me." Then she fell to the floor back in the kitchen. When I went in, she was laying on the floor and wasn't saying nothing. Tommy had some kind of things

around her neck up under her chin like pruning clippers with two long wooden handles on it. He looked like he was trying to choke her with them handles. There was a heap of blood around her on the floor. Tommy had some money in his hand and handed it to me. I believe it was about four or five hundred dollars. Then he started going all through the house hunting for more money, and he was in the back bedroom for a long time. Tommy told me to open a drawer on one of her dressers that was right side the door when I came in, so I touched that drawer.

Thompson pointed to his shoe and said, "I stepped in some of her blood that was all over the floor when I walked past her. Some of the blood got on my foot and all that shit."

Thompson was wearing the same shoes he had on the night of Mrs. Bass's attack, and on the shoes were red stains that had the appearance of blood. He gave consent for the officers to take his shoes and clothes after the interview, which would be transported to SLED for examination and analysis.

David Earl Thompson, age twenty-eight, from Lumberton, North Carolina, was arrested at 1:10 a.m. on Saturday morning, February 1, 1992.

Within forty-eight hours after the murder of Mrs. Bass, both of her alleged murderers were behind bars.

Lieutenant Knight talked to Tommy Bass. He said, "I was at Mama's house the night before she was killed feeding her animals and chickens. She fixed me a sandwich."

Lieutenant Knight said, "Tommy, I need to ask you. Was your Mama selling liquor out her house?"

"Just as fast as she could out the back door for about twenty or thirty years. Super Bowl day she had a good day. It's for after hours for people that drink and want a drink of liquor Sunday morning or afternoon. Regular customers knew not to come after 10 or 11 o'clock, cause she'd be in bed and wasn't about to get up for them. She kept the doors locked and always turned the light on before she looked through the door. She wouldn't open that door unless she knew them."

Amy told officers, "Mama would take money from her store home with her each evening. I remembered there being at least one $100 bill in the stack and some twenties and tens in the money she brought home that day." Amy remembered on Friday morning when she started over to her mother's

house that she picked up her pocketbook and noticed it felt really light, but she didn't think too much about it. Later on she found her billfold and credit cards were missing.

Officers asked Amy if she had gone through her mother's house to check for anything that might be missing. "Yes, Mama kept a small pistol in her nightstand in her bedroom, and it's not there now."

Amy's personal items and the pipe wrench were later found at the edge of a wooded area on the side of the Bass residence.

The state originally planned to try Tommy Lee Campbell and David Thompson together for the murder and robbery of Mrs. Bass, but before the trial, the state made a motion for Campbell and Thompson to be tried separately.

For court presentation, Agent Darnell prepared a test impression of Tommy Campbell's known right tennis shoe for comparison purposes to the questioned shoeprint. A test impression is prepared by applying black powder to the outsole of the shoe and actually having someone put the shoe on his foot and step on a sticky, glue-like transparency sheet. The impression of the outsole of the shoe adheres to the transparency sheet. By placing the test impression directly over the questioned shoeprint impression any matching characteristics that are present can be lined up exactly.

I photographed the shoeprint impression found in Mrs. Bass's bedroom, the outsole of Campbell's known right tennis shoe and the test impression of the outsole of Campbell's known right tennis shoe. I prepared a photographic chart for court presentation by printing each photograph 1:1, exact size, orienting the prints to the same orientation and mounting the three photographs side-by-side on foam-core board.

Agent Darnell marked off each matching area that was visible on the photograph of the questioned shoe impression to each matching area on the photograph of the known shoe outsole and the photograph of the transparency of the outsole by placing red arrows next to each matching characteristic.

The palm print impression lifted from the table in Mrs. Bass's hallway was a positive match to Tommy Campbell's known left palm print. Because an exact size fingerprint and palm print is small, I enlarged the prints approximately twelve times the size of the actual print, oriented the prints to the same orientation and mounted them side-by-side on foam-core board. The enlarged court chart is more clearly visible to the jury to show the matching points and ridges of the prints. For court presentation, Agent Darnell charted (marked off with red lines and numbers) ten matching points on the latent palm print to ten matching points on the known palm print.

## Tommy's Trial

The *Dillon Herald* reported that the news media vans and television cameramen outside the old Dillon County Courthouse on Monday morning, September 18, 1995, gave the appearance of the O.J. Simpson trial in California.

Solicitor Gordon McBride and Assistant Solicitor Knox McMahon were going for the death penalty for Campbell. During opening arguments, Solicitors McBride and McMahon presented Tommy Lee Campbell as the instigator in the brutal murder of Lula Mae Bass.

Amy Bass Parker began testimony on Wednesday, September 20, 1995. Solicitor McMahon prodded her gently as she told of the events leading to her mother's murder.

On cross-examination, Campbell's attorney played on the fact that the Campbell and the Bass families were friends with one another, and at one time the Campbells lived in a tenant house on the Bass farm.

Sheriff Harold Grice told how the arrests of Campbell and Thompson came within hours after the murder of Mrs. Bass because the third man who had been asked to participate backed out and informed authorities soon after Mrs. Bass was killed.

Then came the testimony of Agent Tom Darnell, crime scene investigator and fingerprint and footwear expert with SLED. Agent Darnell explained the crime scene walk-through of the murder scene. He described how they found the long-handled pruning shears and the steak knives near the body. Darnell told how shoeprints and fingerprints left behind at the crime scene placed the suspect in the home of Mrs. Bass, and the shoeprint impression found on the hardwood floor in front of a dresser in Mrs. Bass's bedroom was a positive match to the outsole of Tommy Campbell's known tennis shoe. Darnell presented the shoeprint chart during his testimony, pointing out seven matching areas such as cuts, marks and gouges, marked with the red arrows, explaining in detail how each characteristic lined up exactly on each photograph.

In summary of Agent Darnell's testimony on the shoe impression left at the Bass home and the known right tennis shoe of Tommy Campbell, Darnell stated, "No other shoe in the world made that impression. That impression was made by that shoe without a doubt."

Next, Darnell presented the photographic palm print chart, pointing out the ten points of identification that were present in both the latent and the known prints. He showed how this was a positive match because each point appeared in exactly the same position or the same relative position when

comparing the latent and known print together. He also explained that even though he only marked off ten matching points, there were actually fifteen or sixteen matching points in the prints, but to keep the chart clearly visible to the jury and not crowded up with red lines and numbers, he only charted ten. He further explained that there is no minimum number of points for identification required before an expert in the field can say it would be a positive match, but each print has to be examined totally on its own.

In summary of the palm print left at the Bass residence and the known left palm print of Tommy Lee Campbell, fingerprint expert Agent Darnell stated, "This latent palm print was positively made by the left palm of Tommy Lee Campbell to the exclusion of anyone else in the world."

Campbell's attorney, LaFon LeGette Jr., cross-examined Agent Darnell. He dwelled on the footprint found in dust in Mrs. Bass's hallway and the three bloody footprints found near her body in the kitchen, and a pair of High Action tennis shoes collected from David Earl Thompson. Darnell explained he found same class characteristics, same design, shape and size when he compared the footprints and Thompson's shoes together, but they lacked the necessary or random identifying marks that were needed to make a positive comparison.

When asked by LeGette if a palm print found on Mrs. Bass's dresser was positively and absolutely David Thompson's, Darnell answered, "That's correct."

LeGette was leaning toward establishing reasonable doubt by shifting the blame on David Thompson as the one who actually committed the crime and not the defendant on trial, Tommy Lee Campbell.

On Friday, the third day of testimony, a spellbound courtroom and jury heard the chilling taped voice of Tommy Lee Campbell as he told the shocking story of the brutal murder of Mrs. Lula Mae Bass. Sitting at the table with his attorneys with a Bible in his hand, Campbell listened to his own voice as he laid the blame on David Earl Thompson. The tape ran for about an hour as the jury listened to the entire statement given by Campbell. It ended with Campbell saying, "David was the one that planned to kill Mrs. Lula Mae, not me."

After the state and defense rested, Solicitor McMahon began summation. He addressed the jurors, telling them,

> At this stage of the trial, you are concerned only with one issue.
> Is the defendant guilty or innocent of the offenses charged?
> Did Tommy Lee Campbell conspire to rob and murder Mrs.

Lula Mae Bass based on what you heard in the courtroom? Remember the family, and what was going on. Amy Bass was running the store for her mother. Mrs. Lula Mae is at home expecting her children to come over, Tommy and Amy. Little did they know that night would be their last night together. Tommy's mama was in the house fixing him a sandwich, and the same knife with which she had fixed her son a sandwich is later either embedded in her side or stuck in her neck. You know the one...the one her son took out of his 73-year-old mama's neck. While Amy and her brother were in the house with their mama, Tommy Lee and David stayed out by the pecan trees for a good two hours, talking and planning about how to bust Mrs. Lula Mae's head. It doesn't matter who had that pipe wrench in their hand. It doesn't matter who struck the first blow or who stabbed her or who put the wooden handles around her neck to choke her. Both Tommy Campbell and David Thompson are responsible for all that. The hand of one is the hand of all. The foot of one is the foot of all. Tommy says, "Yeh! I hit her, I hit her, and she was screaming. She was fighting for her life." He says all this, but he blames it all on David, and that's not enough. Then they had to stab her with knives, knives that came from her own kitchen, but wait, that's still not enough. They go and find a pair of pruning shears with long wooden handles to try and choke her. Oh! But David did it all.

The jury went to the jury room around 3:00 p.m. on Sunday, September 24. It only took them about fifty minutes to find Tommy Lee Campbell guilty of murder, armed robbery and two counts of criminal conspiracy.

After the twenty-four-hour waiting period, the sentencing phase began at approximately 4:30 p.m. on Monday, September 25.

Solicitor McMahon cautioned the jury that he would show them graphic color photos during this phase that were not allowed in the guilt or innocent phase to show the physical torture imposed on Mrs. Bass by Tommy Lee Campbell. He spoke gently, "This you will remember for the rest of your life."

Pathologist Dr. Sandra Conradi testified to performing the autopsy on Mrs. Bass. She told the jury Mrs. Bass was conscious throughout most of the ordeal because of her defense attempts in warding off the twenty-three blows from the pipe wrench. The photographs clearly showed the bruising

to her hands while trying to protect her head from the blows. Conradi explained, "A person cannot defend themselves if they are unconscious."

She also told of the fourteen broken ribs found during the autopsy, emphasizing how painful even one broken rib could be. "Multiply that pain by fourteen."

Dr. Conradi concluded her testimony saying, "One of the knives injured Mrs. Bass's liver while she was dying, slowing down her heart and blood flow. Mrs. Bass suffered intolerable pain and torture before her death."

Court resumed the following morning. Mrs. Bass's daughters, Nancy and Amy, again gave their grave details of the morning of January 31, 1992.

Amy's voice trembled as she said, "I just couldn't leave my mama. I stayed with her 'til they took her body away, and I cleaned up all her blood where Mama had been. Mama's murder really hit my brother hard, and changed his life."

Moments of silence elapsed after Amy left the stand. The courtroom was quiet as Solicitor McMahon walked over to a plastic model of a head he used for presentation. He gave a shocking display of how Tommy Campbell struck Mrs. Bass in the head with a pipe wrench by himself, striking the plastic model three or four times with the same pipe wrench.

McMahon closed by saying, "Tommy Lee wasn't reading the Bible the night of January 30, 1992, when he did that to Mrs. Bass, and if he was just a follower why didn't he just stay home that night."

Public Defender LeGette relayed to the jury how Tommy Campbell and his brother and five sisters were raised in a wretched home environment. Their parents would lock them out of the house and they had to find shelter in other places, sometimes in junk cars.

Dillon County jailers and detention officers said Campbell got down on his knees and prayed, and that he read the Bible.

LeGette closed by saying, "Tommy Campbell was a follower, not a leader. I don't think he went into this with the purpose of killing. Campbell followed David Thompson's lead in committing the crime."

After eight full days of trial, the jury began the sentencing phase deliberations Wednesday afternoon. Six hours passed and no agreement was reached. Judge Anderson sent the jury back to the motel.

The jury returned to the courthouse and resumed deliberations Thursday morning. A decision was finally reached at 2:42 p.m. A life sentence was recommended for Tommy Lee Campbell.

This life sentence meant Tommy Lee Campbell couldn't even be considered for parole until he has served thirty years. He will be fifty-five years old.

### David's Trial

David Earl Thompson was sitting in his cell at the Dillon County jail when a life sentence was imposed on his accomplice, Tommy Lee Campbell, for the murder of Mrs. Lula Mae Bass.

Three months later on January 25, 1996, David Earl Thompson pleaded guilty to murder, armed robbery and criminal conspiracy.

Thompson gave a different account of the murder. He said, "Tommy did it all. I didn't have any part in killing Mrs. Bass. Tommy was the one that kept on hitting her with the pipe wrench and stabbed her with the knives from her kitchen. He was the one that tried to choke her with the handles of the pruning shears. Tommy gave me the gun and about $100 you found in my bedroom out back of my mama's house."

Thompson did admit to going to the Bass house with Campbell and told how he had to jump over the body on the kitchen floor.

The state recommended to Judge Ralph Anderson that the same sentence given to Tommy Lee Campbell be imposed on David Earl Thompson in exchange for his guilty plea.

Thompson's attorneys agreed, even though they believed their client was telling the truth about his participation in the murder.

Judge Anderson was informed by one of Thompson's attorneys that Campbell claimed to be a changed man. He found religion and began preaching in prison. Campbell said he would even take the stand, now, and testify that David Thompson never did anything to Mrs. Bass. Quite different from his two hundred-page statement in which he kept saying what David made him do.

Solicitor McMahon replied, "I don't believe David Thompson or Tommy Campbell. Campbell claims he was saved. The only thing he was saved from was the electric chair."

McMahon reiterated the evidence of the palm print found in Mrs. Bass's bedroom that was positively identified as the palm of David Thompson, although Thompson kept saying he didn't remember going into Mrs. Bass's bedroom.

Thompson's attorney replied, "David Thompson was a follower. He suffered from lapse of memory at times, and this explains why he didn't remember going into the bedroom."

Judge Anderson imposed the same sentence for David Thompson as he did for Tommy Lee Campbell, life sentence and thirty years before parole could even be considered. He will be fifty-eight years old.

# The Barbell

Shortly after midnight on a clear winter night, March 21, 1990, Philip Earl Reed from Westville, Indiana, was driving east on Interstate 26 in upstate South Carolina. He was about eight miles from the North Carolina state line. Mr. Reed was employed with Sicomac Carriers, Inc., of Parsippany, New Jersey, and was traveling from Oklahoma to Gastonia, North Carolina.

A truck driver traveling behind Reed saw his truck swerve off the highway and come to a stop on the shoulder. The truck driver pulled over, went to the truck and found a white male slumped over in the driver's seat, bleeding profusely. He called for help. Spartanburg County sheriff's deputies responded. When they arrived, Mr. Reed was not breathing and on the floorboard of his truck they found a bloody, rusty barbell.

Spartanburg County investigators concluded that the barbell had been tossed from an overpass bridge, crashed through Mr. Reed's windshield and smashed into his chest as his truck passed below. They transported the barbell to the SLED latent print lab to be processed for prints. It was a thirty-pound barbell, probably used for weightlifting. There was duct tape wrapped around the holding area of the barbell.

Latent print examiner Don Girndt used a cyanoacrylate (super glue) fuming development procedure to process the barbell for latent prints.

The super glue fuming method of processing latent prints was first utilized by the Criminal Identification Division of the Japanese National Police Agency

in 1978. The latent prints are made visible by vapor molecules (fumes) of cyanoacrylate reacting to traces of amino fatty acids and proteins in the print and the moisture in the air. The result produces a white material that forms along the ridges of the print and becomes visible to the naked eye.[19]

The super glue must be in a gaseous state to produce fumes to adhere to the prints. Agent Girndt placed the barbell, a small open container of super glue and a container of water in an airtight glass fish tank. The container of water caused high moisture to form in the tank, which reacted with the super glue to produce fumes. Prints developed with cyanoacrylate permanently adhered to the evidence surface.[20]

A fingerprint developed on the duct tape of the holding area of the barbell. To further enhance and possibly bring out more detail in the print, Agent Girndt sprayed the print with MBD (Methoxybenzylamino, Nitrobenz, oxa, diazole) chemistry. This chemistry causes latent prints fumed with cyanoacrylate to fluoresce when viewed under a monochromatic alternate light source. A monochromatic alternate light source is a light source that can be set to different nanometer light settings in the light spectrum.[21]

I photographed the barbell to document the location of the print on the duct tape and performed close-up photography of the print on the duct tape using the alternate light source and an orange KV550 filter. The film captured the fluorescence of the MBD, bringing out even more definition of the print. There were no suspects at this time, so I filed the negatives and photographs of the fingerprint in the case file.

Mr. Reed's autopsy results revealed that he had bled to death from the powerful blow of the barbell to his chest.

As reported in the *Spartanburg Herald*, Mr. Reed's parents said, "He loved his work. He loved driving his truck. He was so good. He didn't have an enemy in the world." It also quoted the president of Sicomac Carriers as saying, "This is the most tragic thing that has happened to this company or one of our drivers in its twenty-year history. Mr. Reed had been with our company for one and a half years. He was loyal, dedicated and a total gentleman."

The investigation continued for a year with no results until the Spartanburg County Sheriff's Office received a tip from someone with information about four boys that would go to the overpass to throw things at cars.

From that information and additional investigation, on April 5, 1991, Timothy Lee Waldrop, twenty-two, Jonathon Arlo Schuler, eighteen, David Earl Alverson, eighteen, and William Roy Camp III, seventeen, were charged with the death of Philip Reed. On the day of the arrests, it was still uncertain as to who actually threw the barbell.

Known fingerprints of all four suspects were submitted to Agent Girndt. The left middle known fingerprint of Timothy Lee Waldrop was a positive match when compared to the photograph of the latent print on the barbell. This confirmed that Waldrop had at one time held the barbell and was most probably the one of the group that threw it off the overpass.

Waldrop confessed during his interview that he was the one that threw the barbell but said, "We didn't mean to kill somebody." Waldrop also admitted that this was not their only visit to the overpass. They had been there before to have some fun and throw rocks off the bridge.

At Timothy Waldrop's trial in August 1991, the jury took less than an hour to convict him of murder. Judge E.C. Burnett III sentenced Waldrop to the mandatory life sentence with the eligibility of parole after twenty years.

Jonathan Arlo Schuler pleaded guilty to an accessory charge and was sentenced to five years in prison and five years probation.

David Earl Alverson pleaded guilty to an accessory charge and testified for the state against Waldrop. He received a reduced sentence of four years probation.

Because William Roy Camp III was only sixteen when the murder occured, the Family Court handled his case.

This meaningless act took the life of thirty-eight-year-old Philip Earl Reed, a fine, hard-working young man innocently traveling through South Carolina doing the job he loved. He was the oldest of five brothers and one sister.

After the arrests, Spartanburg County Sheriff Bill Coffey stated, "The boys had no regard for human life. It was a game to them, a senseless game."

Sheriff Coffey informed me that Mr. Reed's parents planted a flowering tree where their son's truck came to a stop that night in March 1990, and they still stop by and say hello when they're in the area. He remembered Mr. Reed's father saying, "We can't feel sorry for the boys, but we do feel badly for their parents," and Mrs. Reed saying, "When the boys were finally caught, at least I could sleep a little better, knowing they couldn't do this to someone else's child."

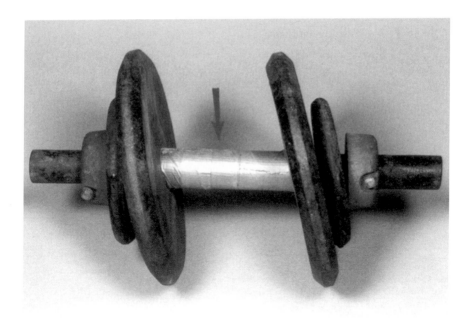

The barbell that penetrated the victim's chest. Arrow shows location of latent print on duct tape. *Courtesy of SLED.*

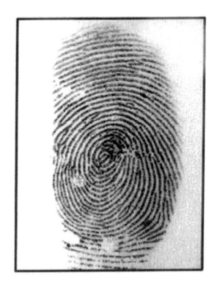

Fingerprint comparison chart of suspect, Timothy Lee Waldrop. *Courtesy of SLED.*

# Signature Written in Blood

Kingstree, South Carolina, is the county seat of Williamsburg County. It was named for white pines that grew there. The trees were called "king's trees" because they were used as masts for ships in the royal navy. The history brings beauty to local heritage and Southern charm along with the beauty of live oak trees that welcome visitors when they enter the town.

Saturday, August 31, 1991, was just another peaceful night in Kingstree until a car was found at Campbell Lumber Company around 12:42 a.m. The doors were open, the engine was running and the lights were on. Officers from the Kingstree Police Department found the car to be registered to Jennifer Sue Martin, a white female, nineteen years of age. In an attempt to locate Miss Martin, Officer Todd Driggers went to Miss Martin's mother's home on Sandy Bay Road. As he approached the house, it appeared that no one was home; however, the door was ajar. Officer Driggers called out. No one answered, so he cautiously entered and searched the house. There in the bedroom he discovered the partially nude and brutally beaten body of Jennifer Sue Martin. The room was in total disarray, and Miss Martin's bloody body was lying in the midst of boxes, clothing and other articles. There was blood throughout the room.

Further investigation revealed that Jennifer had attended her cousin's wedding on the afternoon of August 30, 1991. After the wedding, she and other family members went to her grandmother's home. After visiting for a while, the other family members left. Jennifer remained at her grandmother's

home until around 11:00 p.m., and then drove the short distance to her mother's home to use the telephone. From there she telephoned her fiancé around 11:18 p.m., and they talked for about ten minutes.

Sometime between 11:28 p.m. that evening and 12:42 a.m. the next morning, Jennifer was attacked, stabbed and viciously beaten to death while in her mother's home. Her face and neck were the major points of impact.

The SLED crime scene unit was called to assist Kingstree Police Department with the investigation. SLED Agent Tom Darnell and Kingstree Police Department investigators believed Miss Martin was stabbed and beaten in the face with a broken yellow broom handle, which was located on the floor between her legs. A bloody brick and table lamp were also found near her body. When they turned her body to the side they found the motor housing of an electric fan under her. Agent Darnell discovered what appeared to be a bloody palm print on the housing. Next to Jennifer's body was the grill of the fan.

Due to some past incidents of burglaries in Kingstree, Ellis Franklin's name came up. Franklin was known for loving to steal cars. Detectives with Kingstree Police Department went to Franklin's residence around 6:30 a.m.

Grill of fan found at crime scene. *Courtesy of SLED.*

the next morning, Saturday, August 31, to talk with him. When he answered the door, he didn't have a shirt on, and it was apparent he had been taking a bath. He had soap in his hair and on his back. They asked Franklin if they could see the shoes he was wearing Friday night. Franklin consented and took them into the bedroom and showed them a pair of shoes from his closet. The shoes had dust and spider webs on them. The detective said again, "I need to see the shoes you were wearing last night." Franklin then showed him a pair of Nike shoes that were wet and dripping with water. In between the shoelaces was a red substance that appeared to be blood. Also found in Franklin's possession were his bloodstained shirt and pants. In the pocket of his pants were two necklaces and a pink cigarette lighter. Franklin was placed under arrest. He resisted by fighting, screaming and kicking the officers but was controlled and transported to the Kingstree Police Department.

Family members later identified the necklaces as belonging to Jennifer, but said the pink lighter was not hers.

Ellis Franklin was booked and fingerprinted at the Kingstree Police Department jail. Upon learning of the arrest of Franklin, SLED Agent Tom Darnell transported the housing of the fan with the visible bloody palm print to the Kingstree jail.

Agent Darnell compared the bloody palm print on the fan with the known palm print of Ellis Franklin. Darnell made a positive match to Franklin's palm print right there on the spot in the jail. Blood analysis examination later proved that the blood of the palm print was the blood of Jennifer Sue Martin.

One of the best pieces of evidence that can be found at a crime scene is a suspect's print in the victim's blood. Franklin left his own personal signature, his bloody palm print in Miss Martin's blood on the housing of the fan, which was one of the weapons used in her brutal death. Ellis Franklin had no idea he had signed his name to the crime.

Later that evening, Dr. Sandra Conradi, forensic pathologist with the Medical University of South Carolina (MUSC) in Charleston, South Carolina, performed the autopsy on Miss Martin. Agent Darnell attended the autopsy. He still had the fan housing and fan grill with him. During the autopsy, Dr. Conradi pointed out a linear abrasion pattern on Miss Martin's skull. Agent Darnell viewed the pattern and simultaneously placed the grill of the fan over the abrasion. It fit over the pattern like a glove. This showed the blow to her head was made by a powerful impact from the fan's grill.

Agent Darnell submitted the fan housing to the SLED photography department the following morning for photographic documentation of the bloody palm print. I photographed the print using direct lighting. To eliminate any glare on the glossy housing of the fan, I diffused the direct light by holding a piece of milky Plexiglas in front of the light source. In most situations, the ridges of a print appear black and the furrows (valleys between ridges) appear white on a photograph. Because the print on the fan was in blood, the ridges of the print appeared white and the furrows appeared black on the photograph. Known inked finger and palm prints are printed in black ink, so in order to have the ridges in the bloody print match color with inked prints, I performed a reverse color negative. I used transmitted light (under lighting) and photographed the original negative, which actually produced a negative of a negative. Final printing of the reverse color negative thereby produced the colors of the ridges in the print as black.

For court proceedings, I prepared an enlarged photographic palm print chart of the latent palm print on the fan and the known palm print of Franklin. Agent Darnell marked off the matching points to display them to the jury.

Reverse color photo of Ellis Franklin's palm print in victim's blood on motor housing of fan. *Courtesy of SLED.*

I photographed the outsole of Franklin's Nike shoes and a partial shoeprint on a piece of paper found lying beside the victim's body at the crime scene. I printed a 1:1 (exact size) photograph of each for comparison purposes.

The death penalty trial of Ellis Franklin began Monday, January 11, 1993. Jury selection took several days, and testimony began Friday, January 15.

Family members testified to Jennifer's whereabouts the night of the murder. Her sister, Joanne, said during her testimony, "Around 10 p.m. after returning from a wedding, I took Jennifer to our grandmother's house to pick up her car. She kissed me good-bye and told me she loved me. That was the last time I saw her alive." Solicitor Wade Kolb showed Joanne the two necklaces found in Franklin's pocket the night he was arrested. She identified them as belonging to Jennifer and said softly, "I used to give her a hard time about wearing them together."

During Jennifer's mother's testimony, she told the jury, "I am a nurse. Jennifer's grandmother and her sister are nurses. Jennifer's dream, too, was to become a nurse and marry her fiancé." Tears filled her eyes as she identified items from her home: a broken lamp, broken broom handle pieces, a brick and an electric fan.

On the second day of the trial, SLED Agent Darnell testified that Franklin's Nike shoe outsoles were consistent in size and design with the partial latent shoeprint on the piece of paper lying beside the victim's body at the crime scene.

Darnell then presented the palm print chart displaying the matching points. He testified that the palm print found on the fan was an exact match to Franklin's right palm and pointed out fourteen points of the print found on the fan to fourteen matching points on the known palm print of Franklin.

Dr. Sandra Conradi testified to her findings of Miss Martin's autopsy. She told the jury of the numerous extensive facial fractures of her face: a broken nose, cheek, jaw and teeth. Conradi continued to describe the brutal details of further traumas to Miss Martin's body. She found a piece of yellow wood protruding from a cut on Miss Martin's left hand and yellow wood chips in her hair. Forensic examination proved the chips came from the yellow broom handle found next to Miss Martin's body at the scene.

The autopsy report also showed that Miss Martin was sexually assaulted.

SLED forensic serologist, Richard Hunton, told the jury that human blood on the broom handle, brick, lamp and fan housing was positive to Jennifer Martin's blood.

SLED DNA specialist David McClure testified that DNA results of semen collected from Miss Martin's body were that of Ellis Franklin. Also, DNA

results of blood found on Ellis Franklin's trousers that he was wearing on the night of the murder were a match to Miss Martin's DNA.

Around the same time, the murder case of Crystal Faye Todd in Conway, South Carolina, sixty miles from Kingstree, was also being investigated by SLED. The newly developed forensics analysis of DNA testing discovered the guilt in that case.

Ellis Franklin testified in his own defense and denied killing Miss Martin but admitted to having consensual sex with her. He was asked by the prosecution to explain how his palm print in Miss Martin's blood got on the fan. He replied loosely, saying that it probably got there when he turned the fan on after they had sex.

It took a little over an hour for the jury to come back with a guilty verdict for Franklin on four charges of murder, criminal sexual conduct, first-degree burglary and grand larceny.

After the twenty-four hour waiting period, Franklin's sentencing phase began Thursday, January 21, 1993, at 6:00 p.m. and ran late into the night.

During the sentencing phase of the trial, Judge Duane Shuler, who is no relation to author Shuler, allowed photographs of the murder scene showing Martin's tortured body and the instruments used to inflict that torture. The photographs showed her bloody, battered body at a distance. Close-up photographs showed Miss Martin's bloody face, eyes and teeth, some of which were missing, and a piece of a yellow broomstick under her buttocks.

Autopsy photographs of Miss Martin's body were also admitted into evidence. These photographs depicted pre-mortem wounds to Miss Martin's body and showed the full extent of the pre-mortem physical torture she suffered.

The defense objected to these highly sensitive photographs being allowed, as they graphically depicted a gruesome, bloody scene and would perhaps prejudice the jury.

Judge Shuler overruled, and stated, "In sentencing procedures, the trial court may permit the introduction of photographs which depict the bodies of the murder victims in substantially the same condition in which the defendant left them when material and relevant to an aggravating circumstance."[22]

In this case, the photographs were highly relevant in depicting precisely the aggravating circumstance of physical torture.

Also allowed in the sentencing phase were other crimes in the area that were directly related to Ellis Franklin. One resident testified someone broke into her home on Friday, August 30, and took a pack of Newport cigarettes, a pink cigarette lighter and forty dollars in cash from her bedroom.

Another resident testified to an attempted break-in at his home through a window. A palm print lifted from his home by Larry Gainey, a SLED fingerprint examiner, was found to be a positive match to Franklin's left palm. I prepared a photographic court chart of the palm prints. Agent Gainey presented the comparison photographic chart in court, pointing out fourteen points in the latent palm print found at the scene to fourteen matching points in the known left palm print of Ellis Franklin. Gainey also testified that a shoeprint found at the same residence was consistent with the size and design of the outsole of Franklin's tennis shoe.

The state's final argument to the jury reiterated that the torture and brutality of Jennifer Sue Martin's death shown by the graphic photographs warranted the death penalty. The last closing statement from the state was to sentence Franklin to death.

Thereafter, the defense came back with his statements: "Ellis Franklin suffered from an abusive childhood and abused alcohol and drugs. He basically grew up by himself wanting affection. Don't leave behind your good judgment and common sense. Death is cold, so make the decision you can live with."

Judge Shuler charged the jury around 7:00 p.m. on Friday, January 22. After three hours of deliberation, the jury came back with the verdict of death for Ellis Franklin.

Ellis Franklin has made appeals, but he still remains on South Carolina's death row.

# The Body Print

Newberry, South Carolina, is filled to the limits with Southern history and charm. It is home to the Victorian style Newberry Opera House known as the entertainment center of the Midlands.

Friday evening, February 28, 1992, in this peaceful town, Leslie Johnson went to check on her mother, Mrs. Maxine Davis. She and her husband, Brookes, arrived at her mother's home around 6:30 p.m. Leslie knew her mother always looked out a window to see who was at the door before answering it, and she wouldn't open the door for anyone she didn't know. When they did not get an answer after knocking, Leslie used her key to get inside. They entered and turned on the light. There they found her mother lying on the floor with apparent stab wounds to her body. She was not breathing. Mr. Johnson called the Newberry County Sheriff's Office.

Newberry County officers responded. Sheriff Lee Foster arrived and contacted the South Carolina Law Enforcement Division crime scene unit. SLED Agents Chuck Counts, John Christy and Richard Hunton responded to the scene. They photographed the scene and collected evidence to be carried back to SLED forensic lab for additional examinations.

There were visible stab wounds to Mrs. Davis's abdomen, chest, arms and left hand. A section around her pubic area had been cut away and was missing. There was blood residue over her body.

Agents Counts and Christy saw what appeared to be faint bloody print impressions on the inside of Mrs. Davis's right thigh. They photographed the area.

SLED Serologist Richard Hunton performed blood analysis on the blood from the print impressions. Results proved the blood belonged to Mrs. Davis.

The following day, Saturday, February 29, Forensic Pathologist Dr. Joel Sexton performed a post-mortem examination and autopsy on Mrs. Davis at the Newberry County Hospital. His results stated that she had multiple stab wounds to the chest and abdomen. Dr. Sexton's results showed the victim died as a result of stab wounds to the chest and had been dead approximately twelve hours before her body was found.

At the autopsy, Agents Counts and Christy sprayed the victim's legs and lower abdomen with a solution of amido black dye. The amido black dye developed visible ridge detail on Mrs. Davis's right inner thigh and was identified as a partial palm print. Agent Counts photographed the ridge detail with color and black and white film. Color film proved more advantageous for contrast and quality of the print. No usable visible ridge detail was seen until the area was treated.[23]

Mrs. Davis's daughter told authorities that on Thursday evening, February 27, her mother's boyfriend, Kenny Wicker, called and said he had talked to her mother that Thursday morning. He called her mother again later on that day but was unable to contact her.

Wicker, who lived with Mrs. Davis, said he last saw her about 4:30 p.m. as she was leaving for work on Monday, February 24. Wicker worked in Newnan, Georgia, and after Mrs. Davis left that day, he left for Georgia. The following Thursday morning, February 27, he called her from Georgia. That was the last time he talked to her.

Leslie tried to call her mother several times but never made contact with her. At that point, Leslie and her husband went to her mother's trailer.

Investigators interviewed Mrs. Davis's family members and friends. A friend told investigators that Woodrow Cooper had made several threats against Kenny Wicker, because Cooper claimed Wicker owed him money. He also stated Cooper carried two knives, a heavy folding hunting knife and a straight razor.

Investigators talked to one of Cooper's cousins. She told investigators, "He started talking to people telling them he had done something bad. He told me, 'I messed up and had to stab Maxine, but I didn't mean to. I had to kill her, but I am sorry I had to do it.'"

Woodrow Cooper was located and interviewed by SLED Agents Captain Jim Christopher and Eddie Harris and Newberry County Detective Gilliam. Cooper said his born name was Woodrow Cooper, but he became a Muslim and changed his name to Musa Abdul Salaam. He told the officers, "I started talking to Mrs. Davis when she was working at the Fast Fare. I had known her for about a year, and I was deeply in love with Maxine. On Thursday, about two or three o'clock in the afternoon, I went to her trailer, and we started arguing. I pushed her around and took the knife out of my back pocket and stuck her in the stomach. She fell to the floor. I stabbed her three or four more times, and I pulled her jeans down. I cut a piece of her body part off, and put it in a towel and took it with me. Later on, I walked down a dirt road and got a paper cup and put everything in the cup. The next morning, I threw everything in a dumpster on the main road."

On Tuesday, March 3, 1992, Agent Counts made a positive identification of the right palm print of Woodrow Cooper, aka Musa Abdul Salaam, to the bloody palm print on Mrs. Davis's right thigh.

On Wednesday, March 4, 1992, thirty-nine-year-old Woodrow Cooper, aka Musa Abdul Salaam, was charged with the murder of Maxine Davis.

Cooper led officers to a dumpster where he had thrown the bloody towel, the cup and the body part. The towel was retrieved and the blood on the towel was proved to be consistent with Mrs. Davis's blood. The body part was not found.

Forensic evidence showed that Mrs. Davis was stabbed with a knife blade approximately four and a half inches long. The knife was later located in the truck of one of Cooper's relatives.

I photographed the known palm print of Woodrow Cooper, aka Musa Abdul Salaam, and prepared a photographic court display with the known palm print and the amido black print impressions photographed at the autopsy.

Salaam pled guilty to the murder of Maxine Davis, so there was no jury trial. Eighth Circuit Solicitor W. Townes Jones IV outlined all of the evidence that was introduced against Salaam. This evidence included the palm print display showing the positive match to Salaam.

Solicitor Jones brought up that Salaam was convicted in 1978 on an assault and battery with intent to kill charge. In that case, he had cut off his victim's ear.

The judge sentenced Musa Abdul Salaam to life in prison. He will be eligible for parole in twenty years at the age of sixty years old.

# The Body Print

According to Solicitor Jones and SLED Agents Chuck Counts and John Christy, forensic history was made with the amido black procedure performed on Mrs. Davis's body. It was the first known documentation in the world that a palm print developed with amido black chemistry on human skin was identified to a suspect with positive results.

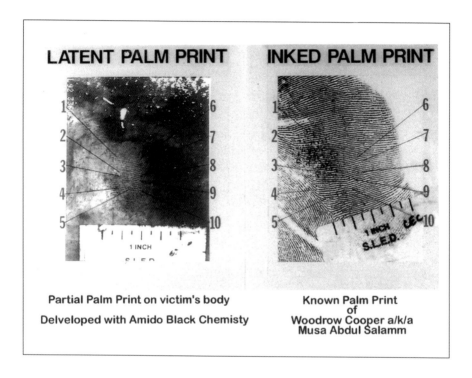

Palm print comparison chart of suspect, Woodrow Cooper, aka Musa Abdul Salaam. *Courtesy of SLED.*

# Signatures Left Behind

M anning, South Carolina, is the county seat of Clarendon County and is known for its Southern beauty, charm and hospitality. The oldest house in town dates back to 1855, so it has plenty of history and friendly folks.

August 5, 1989, started out as a typical Saturday morning in Manning. Children on Nelson Circle were already out at 8:30 a.m. playing in the early morning August sunshine. No one took the children seriously when they said they saw somebody lying on the ground at the new neighbor's house.

Nancy Harrington and her two children had moved into their Nelson Circle home four days before. It was a small, green house with a tin roof, just perfect for her at thirty-five years old, her son Phillip, fifteen, and daughter Kimberly, fourteen.

In the early morning hours that Saturday morning, Nancy was quietly moving around her house getting ready for work. She had to be at work by 5:00 a.m. and did not want to disturb her children, who were still asleep. Dressed in jeans, tee shirt and blue sneakers, Nancy opened the side door to her home around 4:30 a.m. and stepped outside into the early morning darkness and warm summer air.

Her children got up as usual on Saturday morning and watched TV. Around 11:00 a.m. Phillip heard some activity going on outside. Their neighbors' houses were within about five hundred yards of the Harrington house. He opened the side door, stepped outside and froze in his tracks. Down at the bottom of the steps, he saw his mother's body lying in a pool of blood.

He moved slowly down the steps and saw she was stripped from the waist down. Her jeans were down around her ankles, and she was unresponsive. He yelled for Kimberly.

They pulled her jeans back up and covered her body with a blanket. Phillip jumped in the car and headed to the Manning Police Department. Kimberly went to the neighbors to get help.

The neighbors called the Clarendon County Law Enforcement dispatcher. In a matter of minutes, police officers Walker and Gibson and the Emergency Medical Team arrived at Nelson Circle. They immediately checked Mrs. Harrington for signs of life. There were none.

With no delay, investigation began when Assistant Police Chief Joe Bradham and Coroner Randerson Stephens arrived at the scene. Officers believed Mrs. Harrington was attacked and stabbed that morning when she left for work, possibly by someone from that area who knew her, since there appeared to be no struggle.

Neither Nancy's children nor the neighbors had heard anything unusual in the early morning hours, but one of the neighbors told officers,

> I got up with my children around 8:30 that morning. I walked out on my back porch and watched my children playing in the yard. I looked into the Harrington's yard and noticed her car was parked in a different place than usual and saw something that looked like a dummy lying on the other side of the car. I know some people have these real-looking dummies for whatever reasons, so that's what I thought it probably was. I didn't really know the new neighbors that well yet, so I just brushed it off as strange and let it go at that. My mind shifted back to my children enjoying their Saturday morning, and as I called to them, they yelled to me they saw somebody laying in the neighbor's yard. I told them it was probably a dummy, and told them to stay in our yard and not worry about the dummy anymore. It wasn't until I saw all the police cars and ambulance coming into Nelson Circle that it really hit me, the dummy my children and I saw was a real body.

Dr. Joel Sexton and Dr. Keene Garvin performed the autopsy on Nancy Harrington's body the following Monday at the Newberry County Hospital. Results revealed that Mrs. Harrington died a violent death. There were superficial stab wounds, abrasions and contusions to the face and head. Stab

wounds to the left upper lobe of her lung and to the left ventricle of her heart were the fatal wounds that caused Mrs. Harrington to bleed to death.

The murder weapon was never found. Police did find Nancy's empty purse in a swampy area several blocks away, but the purse offered no help in finding her killer.

Even though the murder remained unsolved, the Manning Police Department continued to work on any leads and information, hoping for that one break that would lead them to Nancy Harrington's killer.

Approximately two years and three months after the murder of Nancy Harrington, on Saturday afternoon, November 23, 1991, Ronald Sims left his Manning residence to meet some friends for a drink. He returned home around 1:30 a.m. Sunday morning. As he drove into his yard, he noticed the lights on the outside and inside of his house were on. This was very unusual to him, as his wife and children would have already been in bed. He unlocked the door. Everything was quiet. He went into his bedroom. There was blood everywhere. His wife, Donna, was lying on the bed trying to say something to him. His two-year-old daughter Kimberly Dawn was lying facedown on the bed beside her mother. Sims quickly went to his son Ronnie's bedroom. There he found his five-year-old boy unconscious with blood all around his head. He gasped, "Oh! Lord they got him, too." In his shaken state of mind he ran back to his bedroom, picked up the phone and dialed 911. A recording started. He hung up and immediately called his friends, Ruby and Harry Welch. He was screaming into the phone, "I think my wife and babies are dead. Please call the police, please call the police." Without hesitation they said, "We're on our way."

The Welchs arrived at the Simses' residence and entered the house. With tear-filled eyes, Ronald said, "Look, Harry, look what they did to my babies and my wife."

Mrs. Welch glanced down the hall and saw a bloody sheet. Ronald screamed, "Don't go in there. Don't go in there."

Immediately, she called 911. It was now around 1:45 a.m. Sunday morning.

EMS and officers quickly arrived on the scene. Mrs. Welch was standing in the doorway of the Simses' residence yelling, "Looks like everyone in the house is dead." She pointed the officers and medical team to the bedrooms.

Mrs. Sims was lying on the bed in the front bedroom. She had two long cuts across her forehead. Her eyes were closed, and she was gasping for air. Kimberly was lying facedown on the bed next to her mother, barely breathing. Ronnie was in the back bedroom, unconscious from an apparent

heavy blow to his skull but still breathing. Blood from the victims was spattered all over the walls and ceilings of both bedrooms.

Mrs. Sims, Kimberly and Ronnie were rushed to Clarendon County Memorial Hospital.

Resident SLED Agent Gary Martin and the SLED crime scene unit were requested to assist the Manning Police Department with the investigation.

SLED crime scene investigators Don Girndt and Steve Derrick arrived and processed the crime scene. No weapon was found at the scene, and there were no apparent signs of a struggle.

Girndt and Derrick determined that entry into the Simses' residence was through the bathroom window. Two latent left palm prints were lifted off the bathroom wall right inside the bathroom window. Latent fingerprints were lifted from the bathroom window screen found on the ground below the bathroom window.

At this time, there were no suspects, so I photographed the palm lifts and fingerprint lifts and placed them in the case file.

The blunt force trauma to Kimberly's head caused multiple cranial fractures. She and Ronnie were rushed to the Medical University Hospital in Charleston, South Carolina. Kimberly died at 7:20 a.m., Sunday morning, November 24. Ronnie's skull was crushed in several areas. He had immediate surgery, and by the grace of God survived.

Donna Sims was transferred to Richland Memorial Hospital in Columbia. On November 26, officers interviewed Mrs. Sims at the hospital. Because of the severity of her injuries, she had to use hand signals to respond to some of the questions. She was able to communicate that the assailant was a tall black man. Tears filling her eyes, Mrs. Sims wrote a note, which read, "It seems he tried to kill Kim." She had not yet been told that her two-year-old daughter Kimberly had died.

Six days after the Simses' attack and just yards from their house, forty-eight-year-old Etha Mae Thompson sat peacefully in her home watching television. About 12:00 a.m. that Saturday morning, she heard someone at her back door. She wondered who would be coming to see her at that time of night and went to the door. There stood a tall black man with a long piece of wood in his hand. Thinking no one would be up at that time of morning, the man was taken by surprise seeing her at the door. He forcefully pushed the door open and started beating her all over. His blows slammed across Mrs. Thompson's face, hitting her directly in the eyes. She fell to the floor, and everything went dark. The man forced her back further into the room and tied her up with rope and phone cords from

inside her house and raped her. He left her there and started rummaging through her house and yelling, "Where is the money?"

In her weakened voice, she told him, "There is no money."

"Don't lie to me, bitch," he yelled as he started ransacking the house even more.

As he was going from one room to the other, Mrs. Thompson struggled to free herself. Even with limited vision from the powerful blows to her face, she was able to get out of her house and get to a neighbor for help.

Her neighbor told officers, "I heard a voice calling, 'Help me, help me. Call the police.' I opened the door and saw Mrs. Etha Mae standing at the screen door. She stumbled into the room and fell in a chair saying, 'I'm naked, please give me something to cover up with.' All Mrs. Etha Mae had on was a short, pink, unbuttoned housecoat, so I covered her up with a sheet. She started crying and told me, 'A tall black man broke into my house and beat and raped me. I didn't know who he was. All I know he was a black man, looked unkempt, and had a strange, smelly odor.'"

The neighbor contacted the police and EMS transported Mrs. Thompson to Clarendon Hospital in Manning. Because of the extensive injuries to her eyes, she was later sent to Richland Memorial Hospital in Columbia, where she underwent surgery for a ruptured globe of her left eye and multiple trauma lacerations on her face.

The SLED crime scene unit was called to assist with the processing of the scene at Mrs. Thompson's residence. Agents Chuck Counts and John Christy arrived on the scene. The SLED bloodhound tracking team, en route back to SLED headquarters from another incident in the state, went to Manning to assist in the search for Mrs. Thompson's attacker. The dogs were unable to pick up a scent, quite possibly because the Thompson residence was in a heavily populated area with a lot of foot traffic.

Investigators searched the Thompson residence, yard and surrounding areas. A three-foot, two-by-two piece of wood with nails protruding out of it was found inside the house, and a small similar piece was found outside in the yard. This was later proven to be the assault weapon that was used on Mrs. Thompson.

Agents Counts and Christy lifted latent finger and palm prints from the interior of the residence. A left palm print was lifted from the top of a coffee table. The agents determined that the left palm prints left at the Sims residence were made by the same individual as the left palm print left at the Thompson residence. This evidence led authorities to believe that the same person was responsible for both crimes.

Again, there was no suspect. I photographed the palm lifts and placed them in the case file.

An article in the *Sumter Item* reported one resident who lived near the Sims said, "It's got to be someone that lives in the neighborhood. He can get away so quickly. I used to see little Kimberly playing in her yard. I just don't understand how anyone could have done that to that sweet little girl. I stay awake a lot at night. Every little sound I hear, I jump up." The article included a statement from Assistant Police Chief Joe Bradham: "We're patrolling the devil out of this town and that's exactly who we're trying to catch."

The quiet and close-knit town of Manning with its 4,500 residents found themselves clenched in fear. The town was under surveillance twenty-four hours a day. These attacks put the fear of hell in all the townspeople.

Two months and twenty-two days after the attack on Mrs. Thompson, in Chitwood Trailer Park, which is in the same neighborhood as the Sims and Thompson residences, it happened again.

Around 2:30 a.m., February 22, 1992, thirty-two-year-old Michelle Merchant awoke to a noise outside her trailer. She went to the front door and was face to face with a tall black man with a gun yelling, "Let me in, let me in, or I'm gonna kill you."

When she hesitated, the man broke the glass in the door. Michelle pushed the door open and ran out past him, trying to get away from him. He reached out and grabbed her and started hitting her with a metal rod. He started tearing her clothes off as she fell near the steps of her trailer screaming, "Help me, help me." He was forcibly attempting to ram the pole between her legs.

Michelle's screams for help brought the neighbors out of their trailers to see what was happening. They saw a man on top of her on the ground appearing to be raping her. They screamed at him, "Stop, Stop, Stop." He turned, jumped up, ran away, jumped over some hedges, fell down, got back up and ran into the woods.

One of the neighbors called 911. Manning police officers and EMS arrived. Ms. Merchant was transported to the Clarendon County Hospital in Manning.

Officers began talking to the neighbors at the scene. They were all consistent in their accounts of the events and the description of the attacker. He was a black male, about five feet eight inches tall and weighed about 140 to 150 pounds. He had a big box haircut and was wearing a long black trench coat.

Then came the big break law enforcement and the entire town of Manning had been waiting for for over two and a half years.

One of the witnesses had been at the Go Go Club in downtown Manning that Friday night. She left the club and walked to Chitwood Trailer Park to spend the night with a friend that lived there. Her friend was not at home when she got there so she sat in front of her trailer and waited. The sounds of a lady's screams, "Help me. Somebody please help me," came out of the cold darkness of the early morning. She jumped up and ran toward the screaming, which was coming from Michelle's trailer.

She told officers,

> I saw Michelle on the ground between her steps and a car. There was a young black guy on her having sex. Her head was toward the steps, and she just kept on yelling, 'Help me, God! Help me'. I saw him hit her with what looked like a broomstick. Other neighbors came out and started screaming, and he got up, ran, jumped some hedges, fell down, got up and ran into the woods. He was slim and looked about 5'8" tall and about 140 lbs. He had a high top box hair cut. He was wearing light blue stone washed jeans and a long black trench coat. I didn't see his face, but he looked like somebody I know…Ron Conyers. I had seen Ron at the trailer park around 5:30 Friday afternoon before I went down to the Go Go Club. He was wearing the same trench coat and light colored jeans, and later on Friday night around 10 o'clock, I saw Ron again at the Go Go Club wearing the same trench coat and light colored jeans.

Investigators immediately began checking out Ron Conyers. The pieces of the two-and-a-half-year-old mystery of the Manning attacker started falling into place.

Records showed all of the attacks, including the Harrington killing three years before, occurred within a three- or four-block area. Conyers's house was almost in the center of the area.

The SLED forensics unit was called to process the crime scene. In the past three months, the forensics unit had worked three rapes and two murders in the town of Manning that were still unsolved. They believed this case might be connected. Agents Larry Gainey and Nancy Greene responded to the scene. Eleven prints were lifted from inside Ms. Merchant's house

and submitted to the SLED photography department for photographic documentation. Once again, two of these were left palm prints.

I photographed all eleven lifts and placed them in the file, but this time they wouldn't lay dormant for weeks and months as in the past.

Because of the seriousness of Ms. Merchant's injuries, she was transported by helicopter to Richland Memorial Hospital, sixty miles away, for more specialized treatment. She suffered injuries and puncture wounds to her left shoulder and severe lacerations to her nose, right cheek and above her left eye. Some of her teeth were knocked out, and there were large bruises on the back of her head.

I photographed Ms. Merchant's injuries as she lay in her hospital bed. Photographs of wounds and bruises are explicit documentation to show the intense trauma that was inflicted. When I walked into her room, she turned toward me. The pain showed on her swollen bruised face. Speaking softly, I introduced myself and informed her I was there to photograph her injuries. I was aware of the events of her incident, but it seemed calming to her to talk about it. I could feel the trust she had for me as I took the photos, and as I left she smiled and thanked me for my help. The image of her swollen face lingered with me as I left, and the image of her face as a survivor is still with me.

The trails to Ron Conyers led investigators to Manning High School, where Conyers was a student. On Monday morning, February 24, investigators asked for the assistance of John Bassard, former principal of Manning High School. Mr. Bassard had contacted the parents of Conyers numerous times about Ron missing school. Investigators prepared a six-man photo lineup by obtaining Conyers's photo and five photos with similar facial features of other students from the school yearbook. SLED Agent Roy Paschal showed Ms. Merchant the six-man photo lineup in her hospital room. Without hesitation, Ms. Merchant picked out the photo of Ron Conyers and firmly stated, "This is the man that attacked me, beat me, and raped me."

As a result of Ms. Merchant's identification of Ron Conyers from the photo lineup, arrest warrants for Robert Lewis "Ron" Conyers were obtained by the Clarendon County Sheriff's Office.

On Wednesday, February 26, 1992, around 12:30 a.m., an arrest team consisting of SLED agents and officers from the Manning Police Department and Clarendon County Sheriff's Office went to the home of Camilla Conyers and arrested her son, seventeen-year-old Ron Conyers.

Conyers was taken into custody and read his Miranda rights. When he was booked, he told authorities his born name was Robert Lewis Conyers,

but everybody called him Ron. He was documented as Robert Lewis Conyers aka Ron.

SLED Agent Larry Gainey fingerprinted and palm printed Conyers. Gainey compared the left palm prints lifted from inside the Merchant residence to the known left palm print of Robert Conyers. They were positive matches. Gainey also determined that the left palm print lifted from the bathroom wall at the Sims residence and the left palm print lifted from the coffee table from the Thompson residence were positive matches to Conyers's left palm print.

A search warrant was issued to search the Conyerses' house. Specific items were seized pursuant to the warrant. One item was a pair of ladies black warm-up pants.

Conyers's black trench coat was found in the house.

Ron Conyers agreed to talk with Captain Freddie Nelson of the Clarendon County Sheriff's Office and Lieutenant David Caldwell, SLED's psychological profiler.

At 3:20 a.m. on Wednesday, February 26, Conyers began his statement.

> I went to the Sims house one day to see my aunt who was babysitting for them. While I was there, I saw a VCR, liked it, and one night decided to steal it. I didn't think anybody was home because the truck was gone. So I broke in through the bathroom window. When I got inside, I spotted the VCR, but didn't know the lady was home until she woke up when she saw me in her bedroom. She reached for something, and I hit her with a metal rod I found in her backyard. As I was hitting her, the little boy walked in her bedroom and came up behind me. I was scared and turned around and hit him, too, cause I didn't know who he was.

Caldwell asked, "How many times did you hit him?"

"Once."

"Robert, did you have sex with this lady?"

"Yeah! No, I don't think so...Might uh!...I don't think I did anything to that lady."

"You say you didn't have sex with her, so how did her clothes get off her?"

"Huh! I didn't take nothing off but her shirt, maybe just her shirt."

Caldwell asked, "Well, just how did Donna Sims's black warm-up pants get to your house then?"

"I don't know nothing about that," Conyers said.

Caldwell remarked, "So, those pants just somehow got over to your house all by themselves?"

"I don't know."

Conyers did not mention the baby until Investigator Nelson asked, "What about the baby in the bed with the lady? What happened to her?"

Conyers remarked, "Uh! I didn't see the baby. The baby must have been under the cover and when the lady fell back on the bed when I was hitting her, I must have hit the baby then, too."

Lieutenant Caldwell asked sharply, "Do you remember hitting the baby?"

Conyers stammered, "I didn't mean to hit the baby. I didn't mean to hit the baby."

Conyers changed the subject, "I got scared when I saw a truck pull up to the house and a man got out, so I started making it to the back door and ran out."

Caldwell asked, "So, Robert, what did you do with the metal rod that you beat these people with?"

"I ran and I throwed it. I remember throwing it in a drain pipe at the edge of the woods by a little store."

"And did you get blood on you that night?"

"Huh? Yeh! It was all over my clothes, so I washed it off when I got home."

Lieutenant Caldwell and Investigator Nelson then began questioning Conyers about the assault of Etha Mae Thompson.

Conyers answered, "Maybe a couple of months ago around September, I broke in to Mrs. Etha Mae Thompson's house. I knocked on her front door first, but she didn't answer, so I went to the back door and broke in when she came to the door. All I was wanting was money. I didn't see her at first, but then she yelled, 'Who is it?' I had picked up a piece of wood off her porch and took it inside. So when she started yelling, I started hitting her."

"Why did you beat her?" Caldwell asked.

"I think she had an axe or something, and when she was going for it, I hit her. She kept yelling, 'Please don't hit me no more.'"

Caldwell sharply said, "You remember her eye being knocked out? You remember seeing that laying on her face?"

Conyers changed the subject. "I wasn't drinking."

Caldwell asked, "Did you have sex with that lady after you beat her in the face?"

"Yeh! I had sexual conduct with her, but I was really looking for money."

"Did you take something from her house?"

"I think she had a dollar and some change, but I left it in her pocketbook."

"Were you drinking?"

"Yeh! I was drinking a little bit, but I wasn't on no drugs."

"And when you left?"

"I left the same way I came in, through the back door, and I threw the piece of wood in the backyard when I ran out the door."

Caldwell asked him about Michelle Merchant.

"I gave Michelle…I don't know her last name…about sixty dollars worth of marijuana, but she didn't pay me. Last Friday night about nine o'clock, I met Michelle again and asked her for the money. She still didn't give me the money."

> Me and a friend went to the Go Go Club and split a quart of Old English beer and St. Ives beer. I danced with a lot of different girls. We left sometime after midnight, and I went to the trailer park where Michelle lives and knocked on her door. She came to the door, and I asked her for the money again. She said, "I don't have it." I found a piece of metal on the ground and broke the window out of the door with it. I stuck my hand through the window and opened the door. She came out and stumbled down the stairs, and I started hitting her with the metal rod, and I tried to stick the rod in her private area. People came out of their trailers and started yelling at me. I got up and started to run. I tripped and fell but got up and ran home by the edge of the woods.

"What were you wearing that night, Robert?"

"I was wearing blue jeans, a dark button down shirt with flowers on it, and my black trench coat."

Lieutenant Caldwell moved in closer to Conyers, and very smoothly said, "Robert do you remember the green house behind ya'll a few years back?"

Conyers stammered again saying, "I remember the lady out front out there in the nude and somebody murder…stick a knife in her, in her chest."

"Go ahead and tell us about that Robert," Caldwell said.

> Well, like two summers ago when I was 14 years old, we was at my mama's house one night and mama had gone out. It was real early in the morning, like about 4 or 5 o'clock…wasn't even light yet. I went outside and saw this woman coming out

of the green house back behind us. She was getting in her car, and I asked her to give me a ride across town to a friend's store. She got scared and got on in her car. She started rolling the window up, and I reached in and stabbed her in the heart with a kitchen knife that I brought from my house. I pulled her back out of the car and she fell to the ground. I pulled her clothes down and had sex with her while she was still moving, you know while she was still alive.

"You had sex with her after she fell to the ground?"
"Yeah!"
"And you just left her out in the yard?"
"Yeah!"
"Right at her back door step?"
"Yeah!"
"Did you know this lady's name?"
"No! Not 'til I saw it in the newspaper."

The arrest of Robert Lewis Conyers was announced at a press conference that same morning after Conyers gave his confessions and statements of his crimes.

Conyers was charged with the murder of two-year-old Kimberly Dawn Sims on November 24, 1991. In connection with the Sims incident, Conyers was also charged with first degree burglary, two counts of assault and battery with intent to kill, and first-degree sexual conduct in the assault of Kimberly's mother. Conyers was sixteen years old when he attacked the Sims family and beat Kimberly to death.

He was charged with assault and battery with intent to kill, first-degree burglary and first-degree criminal sexual conduct in connection with the beating and assault of forty-eight-year-old Etha Mae Thompson on November 30, 1991. Conyers was seventeen years old when he attacked Mrs. Thompson.

He was charged with assault and battery with intent to kill, assault with intent to commit first-degree criminal sexual conduct and first-degree burglary in connection with the beating of thirty-two-year-old Michelle Merchant on February 22, 1992. Conyers was seventeen years old when he committed this assault.

For the three-year-old cold case of the assault and murder of thirty-five-year-old Nancy Harrington when Conyers was fourteen years old, he was charged with a second count of murder and first-degree sexual assault.

In a bond hearing Monday, March 2, 1992, Conyers, dressed in his orange jail-issued jumpsuit and with his hands and feet bound in chains, stood in the courtroom. He occasionally glanced around and actually smiled at relatives of his victims present in the courtroom watching the hearing.

Deputy Solicitor Ferrell Cothran Jr. and Judge Duane Shuler agreed that Conyers not only posed a serious threat to the community, but the community posed a serious threat to Conyers. Judge Shuler denied bond for Conyers saying, "I am really concerned about what somebody will do to him if I put him back on the street."

After everything was entered into record, Conyers informed his lawyer that he was happy he would not be getting out on bond because he feared for his life.

In a hearing in June 1992, Conyers pleaded guilty to attempted murder and sexual assault of Michelle Merchant. Judge Thomas Cooper sentenced Conyers to life plus thirty-five years in prison. Conyers made no comment as his sentence was read.

Ms. Merchant was present during the hearing, sometimes breaking into tears as she listened to the details of her attack. Reported in the *Sumter Item*, Ms. Merchant said after the sentencing, "While my physical scars are healing, my mental wounds will continue to ache, and I don't feel a bit sorry for him. Maybe the women can rest easier now that he's gone."

The murder charges for Kimberly Sims and Nancy Harrington were still pending for Conyers. These were the only two crimes Conyers committed that warranted the death penalty. He was fourteen years old when he killed Mrs. Harrington and sixteen years old when he killed the Sims child. The U.S. Supreme Court in general prohibited the death penalty to be considered on an offender before fifteen years of age. Solicitor Wade Kolb petitioned to try Conyers as an adult on those charges, but first it had to be taken to the Family Court in order to be waived to the higher court.

This resulted in Conyers being given a life sentence for the murder of Nancy Harrington when he was fourteen years old, but he would be tried as an adult for killing Kimberly Sims when he was sixteen years old.

The trial date was set for February 14, 1994. Prior to that date, Conyers pleaded guilty to all of the charges. Because of his plea, there would be no jury trial.

His plea for the murder of Kimberly Sims placed Conyers's fate in the hands of presiding Judge Duane Shuler.

After four days of listening to testimony and evidence and viewing the photographs that showed the unprecedented brutality of Conyers's crimes,

Judge Shuler took only one hour to make his decision to sentence Robert Conyers to death by electrocution for the murder of Kimberly Dawn Sims.

As with all death sentences in South Carolina, Robert Conyers received an automatic appeal.

In March 2005, the United States Supreme Court ruled against execution of juvenile killers under eighteen years of age. In Sumter, South Carolina, on September 22, 2005, Judge Howard P. King resentenced Robert Conyers, now twenty-eight, to life in prison without parole. Conyers's other charges remained in effect.

Former SLED Agent Perry Herod, now Sumter Police major, was one of the officers that arrested Conyers in 1992. He and I were present at Conyers's resentencing.

Conyers stood nonchalant and showed no emotion when the sentence was delivered. Major Herod turned to me and said, "What an undramatic ending to a case that had an entire town and county gripped in immense fear for so long."

Ron Conyers's first victim, Nancy Harrington, was his backyard neighbor. *Courtesy of SLED.*

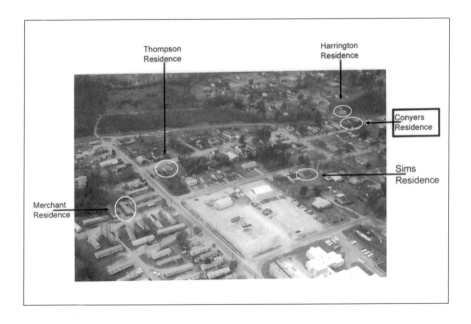

Victims' homes were within three to four blocks of Conyers's parents' home. *Courtesy of SLED.*

Conyers's "high top box haircut" was a major link to being identified. *Courtesy of* The Item.

Enlarged view of palm print

Conyers's left palm print was found on the inside wall of the Simses' house near the bathroom window. *Courtesy of SLED.*

Conyers's black trench coat was found in his room at his parents' house. *Courtesy of Manning Police Department.*

# The Business Card

The small but lively town of Pelion, South Carolina, is known statewide for its annual boiled peanut festival. It is also known for being one of South Carolina's low crime areas.

Mrs. Nadine Poole lived just a few miles outside of Pelion. She was sixty-four years old, lived alone and loved to go to church. She was a peaceful lady who enjoyed working in her garden next to her trailer and visiting with her family and neighbors.

On Friday, September 25, 1992, Mrs. Poole's daughter and fourteen-year-old granddaughter stopped by her home early that morning to visit, but no one answered the door. They assumed that she was not at home, so later that afternoon they returned to the trailer. Again no one came to the door. Her daughter looked through the window and saw the kitchen cabinet doors were open. Knowing that her mother kept a neat home with everything in place, she pushed the door of the trailer open and entered. There in the living room she found her mother dressed in her nightgown, leaning against a wall. She ran to the phone to call for help and found that the line was dead. She immediately left the trailer, got to the nearest phone and called the Lexington County Sheriff's Department.

The SLED crime scene unit was called to assist the Lexington County Sheriff's Department with the investigation. When investigators arrived at the scene, they observed that Mrs. Poole had three gunshot wounds to her upper chest and left arm. The room was in disarray, and miscellaneous

items and papers were scattered over the room. In Mrs. Poole's back bedroom the investigators found her white purse and contents scattered on the floor. SLED crime scene investigators John Christy and Chuck Counts collected the contents of the purse from the floor, carried them back to the SLED latent print lab and processed the items for latent prints. Ninhydrin (triketohydrindane hydrate), a chemical method for developing latent prints on porous surfaces, was used to process the paper items from Mrs. Poole's purse. Latent prints that are invisible to the naked eye become fully visible with this development by means of color indicators for proteins or amino acids. Heat expedites the application for development to appear more quickly.[24] After treatment of the items with ninhydrin, Agents Christy and Counts used an electric steam iron to apply heat to the print. The investigators were focusing on possible latent fingerprints on the items from the purse, but they got a major hit when a partial shoeprint appeared on the corner of the back of a three-and a-half-by-two business card.

It appeared that the intruder had fixed himself something to eat in Mrs. Poole's kitchen and possibly stepped in some grease or debris that transferred onto the card when he stepped on it as he was rummaging through her bedroom.

Partial shoeprint on back of business card found in Mrs. Poole's house. *Courtesy of SLED.*

I photographed the shoe impression on the business card with specialized cross lighting, bringing out even more minute details in the shoeprint.

Prior to the murder of Mrs. Poole, several residents in the area had reported that their phone lines had been cut from the outside and their homes broken into. Entry had been gained into these residences by prying open the doors and items were missing.

One thing common to each break-in was that the intruder always made himself at home in the kitchen and fixed himself something to eat.

In the early morning hours of September 25, 1992, a Ford pickup truck parked on the property of one of the break-ins was broken into and the ignition wires of the truck had been tampered with. The owner's 12-gauge shotgun that he kept in the truck was missing. During investigation of this incident, officers collected shotgun cartridges from the gun owner's residence that he had fired for target practice from the stolen 12-gauge shotgun.

On Sunday, September 27, two days after the murder of Mrs. Poole, a hunt club in the vicinity was burglarized and was entered into by discharging a 12-gauge shotgun into the door. A spent 12-gauge shotgun shell was found near the door. Again the phone line was cut in the same manner as the residences.

On that same Sunday in the early morning hours, a white male identified as Terry Lee Hutto was found roaming around a residence in the vicinity of all the break-ins. He was wearing a red flannel jacket and blue jeans and had a red bandana tied around his head. The owner of the residence became concerned for her safety because Hutto's explanation of his activities during the dark early morning hours did not make sense. She told him to get in her car, and she would take him to his residence, which was in close proximity to her home. Upon returning to her home she found her phone inoperable and called the Lexington County Sheriff's Office. Officers found that the lines had been cut in a manner consistent with the phone lines at Mrs. Poole's residence and the other break-ins.

She did not know that the passenger she had just let out of her car had killed two days before.

On Tuesday, September 29, four days after the murder, again in the early morning hours in the same vicinity, owners of another Ford truck located a white male lying in the cab of the truck. He was wearing the same clothing, a red flannel jacket, blue jeans and a red bandana around his head. One of the owners recognized the man as Terry Lee Hutto, and he had a 12-gauge shotgun in his possession. He jumped from the vehicle and ran into a wooded area. A bloodhound and helicopter search

commenced, but Hutto was not located. The owners later found that the ignition wires on the truck were tampered with in a manner consistent with the aforementioned Ford truck.

All the incidents had occurred within an approximate radius of three to five miles of one another. The home of Terry Lee Hutto was located within close proximity to all of the incidents. It could be said that Terry lived a nocturnal life, because he did his roaming and walking around all through the night and early morning hours before daylight.

A search warrant was obtained for Hutto's home. When investigators arrived at Hutto's home, he was soaking his feet. It appeared that he had been walking for hours, because he had blisters on the bottoms and sides of his feet. While investigators were searching the home, they found his shoes on the back porch underneath some clothes and a red bandana. They were collected and carried to SLED for further examination and comparison tests.

I photographed the outsoles of Hutto's shoes. Agents Christy and Counts matched seven areas from the latent shoeprint left at the scene on the business card to seven areas on the outsole of Hutto's right shoe. That small but enormous piece of evidence placed Terry Lee Hutto at the crime scene in Mrs. Poole's bedroom. Investigators found shoeprints in Mrs. Poole's yard that were also consistent to Hutto's shoes.

Another key find was a spent 12-gauge shotgun cartridge behind a flowerpot in Mrs. Poole's home. The suspect had obviously removed the other spent cartridges from the scene. Ballistic tests revealed that the spent cartridge found at Mrs. Poole's house matched the spent 12-gauge cartridges found at the lodge and the 12-gauge cartridges that had been fired for target practice found at the residence of the owner of the shotgun. The shotgun was never found, but the ballistic tests proved that the stolen 12-gauge shotgun was the same one used to shoot Mrs. Nadine Poole.

Hutto was charged with murder, first-degree burglary and malicious injury to telephone and electric utility system.

Terry Lee Hutto was thirty-six years old when he went to trial in August 1995.

The major evidence that Assistant Eleventh Circuit Solicitor Fran Humphries presented was the shoeprint impression found on the business card at Mrs. Poole's home that was matched back to Hutto's tennis shoes.

Agent Counts later told me that when the solicitor questioned him during testimony in court about the odds of this shoe not being the exact one that made the print, he stated, "One in seven zillion."

Hutto's attorneys presented no defense in his two-day trial.

The Lexington County jury deliberated less than an hour before finding him guilty of murder, first-degree burglary and malicious injury to telephone lines.

Hutto was sentenced to ten years on the malicious injury charges and life sentences on the burglary and murder convictions with eligibility for parole in twenty years at the age of fifty-three.

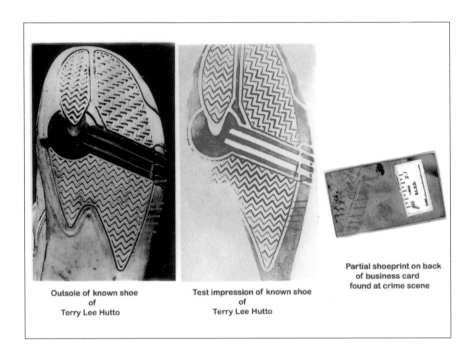

Outsole of known shoe of Terry Lee Hutto

Test impression of known shoe of Terry Lee Hutto

Partial shoeprint on back of business card found at crime scene

Hutto's shoe comparison chart presented in court. Arrows show matching characteristics. *Courtesy of SLED.*

# The Rocking Chair

Bath, South Carolina, is a small town in a row of small towns right outside of Aiken, South Carolina. Residents say they're down in the valley, and where one town ends the other one starts.

On a cool fall evening, Thursday, October 8, 1992, Mrs. Elizabeth Gatti was preparing dinner at her home in Bath. Her neighbor, Mrs. Helminiak, came over and brought her a pie and some banana bread. Mrs. Gatti was seventy-two years old and lived alone. She and Mrs. Helminiak had been friends for twenty years.

The following morning another neighbor, Mr. Fields, became concerned about Mrs. Gatti when he noticed her morning newspaper was still in her driveway and her car was gone. Mr. Fields knew Mrs. Gatti was a person of habit, one who retrieved her newspaper very early every morning. She would read the paper and, like clockwork, by eight o'clock each morning she would throw it over to his driveway so he could read it. Later on the evening of Friday, October 9, the newspaper was still in the driveway and her car was still gone, so Mr. Fields called emergency services.

Aiken County Sheriff's investigators arrived at Mrs. Gatti's home around 9:15 p.m., October 9. There were lights on inside the house and the house was locked. The officers entered the residence with a key provided by her neighbor. As they entered, they found the house had been ransacked and they noticed perishable food items on the kitchen counter. They did a walk-through of the house, and in the basement they discovered Mrs. Gatti's

body underneath a gold bedspread on the floor. Her sweater and blouse were ripped open and pulled down over her arms. Her pants were ripped down the seams, and the crotch was torn out of her panties. Her hands and feet were hog-tied behind her back with a white electrical cord officers later found to have come from a lamp in Mrs. Gatti's upstairs bedroom. Layers of duct tape were wrapped around her head, from her forehead down to her neck. A deodorizer aerosol can was found between her legs. A Murphy Oil Soap bottle and a bottle of Soft Scrub cleanser were on the floor next to her left leg. On the outside of the Murphy Oil Soap bottle was a red substance that appeared to be blood.

Aiken County investigators called for assistance from the South Carolina Law Enforcement Division. SLED Agent Danny Choate, resident agent in the Aiken area, arrived at the scene around 11:30 p.m. SLED crime scene investigators Chuck Counts and Tom Darnell arrived around 12:30 a.m.

While processing the interior of the house, investigators observed articles from Mrs. Gatti's dresser thrown around the room and on the floor of her upstairs bedroom. An open container of her body powder was spilled on the carpet. They found two partial dusty shoeprint impressions on the seat of a rocking chair near the closet. As they studied the shoeprint impressions closer, the impressions appeared to be in the same powder that was spilled on the carpet. They believed the suspect stepped in the powder on the carpet and then stood in the chair to look around in the top of the closet for money and anything to steal.

SLED Agent Tom Darnell used gelatin lifts to lift the dust impressions from the seat of the chair. He submitted the gel lifts to the photography lab the following morning. I photographed the dusty impressions on the gel lifts using the high-intensity light procedure, which brought up two well-defined, partial dusty shoe impressions. I printed a 1:1 exact size photograph of each impression. At this time, there were no suspects.

Mrs. Gatti's autopsy report revealed someone had attempted to physically strangle her, but the cause of death was asphyxiation due to suffocation as a result of the duct tape wrapped around her head. The ingestion and aspiration of cleaning fluids and the binding ligatures on the wrist were contributing factors to the cause of death. Aspiration indicated she was forced to drink the cleaning fluid. The report indicated she could have been alive for only minutes, but if she was able to get some air under the tape by moving her head around she could have been alive for a longer period of time. There was a laceration to the middle finger of her right hand and severe bruising around her right elbow area consistent with defensive

wounds. There were lacerations in the vaginal and rectal areas that indicated penetration by a very stiff object, possibly the Murphy Oil Soap bottle or the Arm and Hammer aerosol can.

On Sunday, October 11, three days after the murder, Mrs. Gatti's 1972 Buick LeSabre was found several miles from her home parked behind an apartment complex in Graniteville, South Carolina. SLED Agents Counts and Darnell processed the car for evidence and prints. Fingerprints were found in the car on the driver's side window and lifted by Agent Counts. Items stolen from Mrs. Gatti's home were found in the car. Among these items was a checkbook belonging to Mrs. Gatti. Other items found in the car were a cigarette pack and an electric saw. These items were collected and carried back to SLED for additional processing.

Investigators then proceeded to question residents in the apartment complex for any possible helpful information. At the same time, an employee of the complex saw a black male come out of Apartment 1102 and take a bag of trash to the dumpster. When investigators left the area, the employee saw the black male go back to the dumpster, get the bag out of the dumpster and go back into Apartment 1102. Thinking this action was unusual, the employee informed the manager, Ms. Ivy, and she informed investigators.

Ms. Ivy knew the man did not live in the apartment, and the resident of that apartment was not at home. No one was supposed to be in there. When investigators returned to the apartment complex, they went to Apartment 1102 with Ms. Ivy to make sure everything was okay. They entered the apartment and found a black male in the bed of the upstairs master bedroom, asleep. They woke him and asked who he was. He said his name was James Counts. When he got out of bed, he was fully clothed including his shoes. He did not have a reason for being in the apartment, so the manager told him he would have to leave. Counts then left the area, jumped a chain link fence and went down a path in the woods behind the apartments.

Later, as Agent Choate was walking around the same area of the path, he noticed a shoeprint in the sand that resembled the shoeprint found on the rocking chair at the crime scene.

While investigators and SLED agents continued talking to the residents, the resident of Apartment 1102, Wendy Danley, arrived at her apartment, and with her was James Counts.

Agents and investigators returned to her apartment to talk with her and Counts.

Agent Choate and Agent Counts asked James Counts if they could look at his shoes. He consented. Agent Counts noticed there was a noticeable

resemblance of James Counts's shoe outsoles to the shoeprints left in the rocking chair at Mrs. Gatti's house. Agent Counts asked if he would let him take his shoes back to SLED headquarters, and he took his shoes off and voluntarily gave them to the agents. He also voluntarily provided investigators with hair samples and his fingerprints at the same time.

A search warrant was obtained to search the apartment of Wendy Danley. A silver platter and a beige towel were collected from the apartment and later identified by Mrs. Gatti's daughter as belonging to her mother.

Later, Danley was interviewed at the Aiken County Sheriff's Department, and she said James Counts was not the man's name. "His name is Donney Council and he's my boyfriend. Donney was acting strange the day after the killing. He was wearing some of his clothes backwards and a hood over his head while he was in my apartment."

While at the Sheriff's Office, investigators asked Danley to view a surveillance tape of a robbery on October 1, 1992, at The Depot convenience store in the town of Bath. She identified the person on tape beating the clerk with a tire iron during the robbery as Donney Council.

Captain Wayne Huff with the Aiken County Sheriff's Office contacted Agent Counts at SLED and informed him that while questioning Wendy Danley, she identified the person who gave his name as James Counts as Donney Council. Captain Huff informed Agent Counts that Donney Council had a prior criminal record, and his fingerprints were on file at SLED.

Agent Counts retrieved Donney Council's fingerprint file and compared his prints to the prints bearing the name of James Counts. Agent Counts concluded that the same individual produced both sets of prints.

Fingerprints taken from Mrs. Gatti's car were identified as prints of the suspect, Donney Council. Agents Counts and Darnell processed the cigarette pack, the electric saw and Mrs. Gatti's checkbook found in her car for prints. Fingerprints were developed on all three pieces of evidence. Three prints were positively matched to the known fingerprints of Donney Council.

Agent Counts positively matched the shoeprints from the chair in Mrs. Gatti's bedroom with the outsoles of the known shoes of Donney Council. The residue found on the seat of the chair positively matched debris found on Council's shoes and the powder on the floor in Mrs. Gatti's bedroom.

Warrants were obtained for Council's arrest and officers went to his mother's residence, where he was believed to be. Council saw them coming and fled. After several hours of searching, Council was apprehended and taken into custody. While being questioned, he admitted being at the Gatti

house but said he had nothing to do with killing her. The only time he saw her was downstairs, tied up and still alive. He told officers, "I was with a black man named Frankie J. Frankie J. went in the house, and I circled the block in Frankie J.'s blue Ford Granada. The only thing I done in the house was to look through the living room and help Frankie J. take a TV out the house."

Council told officers he could take them to where Frankie J. lived in Augusta, Georgia. The trip proved futile. Frankie J. was later identified as Frank Douglas, who was being sought by SLED Fugitive Task Force in connection with forgeries being committed all over the state. He was arrested in Augusta, Georgia. Donney Council's name came up during the interview with Douglas, and he told officers he had run into Council at a friend's house in Augusta. Douglas denied being with Council at Mrs. Gatti's house and being involved in her death. Examination of all the evidence found in Mrs. Gatti's house and in her car proved no match to Frank Douglas.

Donney Council, a thirty-year-old black male, was arrested on October 12, 1992, four days after Mrs. Gatti's murder.

Six days after Council's arrest, he asked to talk to officers again. He gave a signed written request, which stated, "I, Donney S. Council, do wish to speak with investigators of the Aiken County Sheriff's Office and SLED."

Investigators met with Council, and he again stated that he did go to Mrs. Gatti's house with Frank Douglas, but claimed he did not take part in the crimes. He wanted to take a polygraph exam and wrote and signed a statement requesting the polygraph.

Captain Huff and Agent Choate transported Council to SLED headquarters in Columbia for the polygraph. After SLED polygraph examiner Wayne Mitchell administered the exam, he told Council his answers showed some deception. Council then voluntarily admitted to Mitchell he did have sex with Mrs. Gatti. Mitchell informed Huff and Choate of Council's admission.

On the trip back to Aiken, Donney Council started running his mouth. He told Huff and Choate, "Man, ya'll ain't got shit on me."

Huff said, "Donney, you don't know what we got on you. We've got more than you think, and the best thing to do is let's not talk about it."

But Council didn't shut up, "Well, you don't have no fingerprints. You know if I had done something like that, I would have been wearing gloves or socks."

Agent Choate told Council to be quiet, but he arrogantly blurted out, "Well, I did have sex with her in more than one way." Then he burst out laughing.

Totally shocked by that outburst, the officers immediately pulled the car over. Choate again told Council to be quiet, and Captain Huff made notes of Council's statements.

Under a court order, Council supplied blood, head and pubic hair and saliva samples.

SLED hair and fiber examinations showed that pubic hair recovered from the victim's bed at the crime scene were consistent to hair samples taken from Council. Scrapings from the fingernails of the victim contained blood found to be consistent with the blood samples taken from Council. Cigarette butts taken from the inside of the victim's vehicle produced a saliva sample found to be consistent with the saliva sample taken from Council. Semen found on tissue paper in Mrs. Gatti's bedroom was consistent with samples taken from Council.

Lieutenant Gaile Heath, a SLED questioned document examiner, positively identified that Donney Council forged three of Mrs. Gatti's checks. Council had actually made the checks payable to himself in the amount of $380 and cashed them at various banks. I photographed these checks and later prepared a court display for Lieutenant Heath's testimony during the trial.

Four years after Donney Council was arrested and charged with the murder of Mrs. Elizabeth Gatti, he went on trial for his life. The trial began Monday, October 14, 1996. A jury of eight whites and four blacks was seated to hear the case.

During Solicitor Morgan's opening statement, she told the jurors that the state would take them on a journey to murder in which the evidence and facts would show Council was the person who raped, robbed and killed Mrs. Elizabeth Gatti.

Council's attorney, James Whittle, told the jury that this was a horrible crime but it did not happen at the hands of Donney Council. "I will show you there was a third party involved here."

As the guilty phase of the trial began, Solicitor Morgan attempted to introduce a series of crime scene photos. Judge Henry Floyd allowed into exhibit only one shot of the death scene but allowed numerous photos of Mrs. Gatti's home where she was murdered. One photo of her bedroom showed the rocking chair at the door of her closet, which Council had stepped on to look in the top of the closet. Here he left the major positive piece of evidence that placed him at the crime scene: his shoeprints in Mrs. Gatti's body powder.

I worked with Solicitor Barbara Morgan to prepare the photographic shoeprint comparison charts. This was during the same time that the

O.J. Simpson trial was going on in California. Because of the worldwide publicity and contents of Simpson's trial, Ms. Morgan requested I enlarge the court displays of the shoeprint comparisons to O.J. Simpson size that was being used in his trial. I enlarged them three times the norm for her court presentation.

Agent Chuck Counts presented these displays in court showing the matching areas and markings on the shoeprints left at the scene in the rocking chair and the outsoles of Council's shoes. Counts testified, "These shoes and no other shoes in the world could have made these impressions in Mrs. Gatti's house. Each shoe is unique to itself. It could never exactly be reproduced. It is the same today as it was four years ago."

Counts summarized his testimony by telling the jury Council's fingerprints were not found in Mrs. Gatti's house, but the shoeprints Council left in the rocking chair positively placed him at the crime scene and in Mrs. Gatti's bedroom.

Agent Tom Darnell followed with testimony matching Council's fingerprints to fingerprints found in Mrs. Gatti's car and on the electric saw and an empty pack of Newport cigarettes found in Mrs. Gatti's car.

SLED Serologist Nancy Green gave her testimony of the fingernail scrapings, saliva and semen at the scene being consistent with Council's.

Captain Wayne Huff told the jury of the profanity and vile slurs against Mrs. Gatti that Council made in his and Agent Choate's presence in the car as they transported him back to Aiken from Columbia. "He then burst out laughing. Agent Choate and I saw what happened at the crime scene, and for someone to make that remark and laugh, it was very upsetting."

SLED polygraph examiner Mitchell gave a very brief testimony that after administering a polygraph examination on Donney Council, he admitted he did have sexual intercourse with the victim.

SLED hair and fiber expert John Oturno testified that the pubic hair recovered from Mrs. Gatti's bedroom was consistent with the pubic hair taken from Council.

To confirm Ortuno's findings, the state introduced testimony from FBI DNA specialist Joseph Dizinno regarding the analysis performed on the pubic hair recovered from Mrs. Gatti's bed clothing and known pubic hair from Donney Council. Dizinno explained to the jury about using the new science of mitochondrial DNA, or in layman's terms "gene tracking or genetics within genetics," to link hair evidence to known hair samples.

Mitochondrial DNA, commonly known as mtDNA, is found in mitochondria outside the nucleus of a cell and serves as the cell's energy

and power sources. It differs from nuclear DNA, which is found in the nucleus of a cell. Nuclear DNA contains genetic material inherited from both the mother and father and is unique to the individual. Mitochondrial DNA contains genetic material inherited only from the mother, and it is not unique to the individual; therefore, siblings share maternal mitochondria. There are many more copies of mtDNA in the cell than there are copies of nuclear DNA, since each cell contains many mitochondria but only one nucleus; therefore, the chances of extracting mtDNA from a sample is increased. Unlike nuclear DNA, which is only present in the living cells at the root of the hair, mtDNA is present in the shafts of hair.[25]

Because mitochondrial DNA was still in its early stages of use and based on the available database, Dizinno testified that Donney Council could not be excluded as the person who deposited the pubic hair recovered from the bed sheets of Mrs. Gatti, and the hair most probably belonged to Donney Council.

Ortuno and Dizinno both testified to examining the hair from a man identified as Frank Douglas, and the mitochondrial DNA results on the pubic hair totally excluded him as the one who left the hair at the crime scene.

Dr. Clay Nichols, who performed the autopsy on Mrs. Gatti, described in graphic detail how Mrs. Gatti died. He also told the jury, "The victim was raped with a cleaning fluid container, and when I removed the duct tape from her head, I detected a strong odor of cleaning fluid and mucus oozing out of her nostrils and mouth. It could have taken up to three or four hours for her to die."

SLED Questioned Document Examiner Lieutenant Gaile Heath testified that Mr. Council forged three checks written on Mrs. Gatti's account and cashed them within three days of her murder.

The bank teller that cashed one of the checks at a drive-in window in Aiken identified Council in the courtroom. She said, "Although the checks were made payable to Donney Council, I not only wrote down his driver's license number for check cashing identification, but I also wrote down the tag number of the tan-colored car he was driving that day."

The tag number showed Council was driving Mrs. Gatti's car at the time.

Mrs. Gatti's newspaper carrier testified that she saw Council around 5 a.m., October 9, 1992, near Mrs. Gatti's home. He was driving a tan-colored car that pulled alongside her when she had stopped on the side of the road. She later picked Council out of a photo line-up saying, "I could not forget the face of the man I saw that morning."

Because Council never admitted to killing Mrs. Gatti, his attorney attempted to focus on the possible third party, Frank Douglas, saying he had

lured Council to Mrs. Gatti's home the night of the murder. Even though none of the physical evidence matched Douglas and the mitochondrial DNA excluded Douglas as a suspect, Douglas's name was still brought up numerous times during the trial, but the defense never produced Mr. Douglas for trial. Attorney Whittle did point out that if Mr. Douglas did show up, he would put him up to testify against Council. Douglas never showed.

The defense offered only three witnesses, all of which were independent forensic examiners. They could not challenge the competence and findings of the state's expert witnesses.

Solicitor Barbara Morgan stated in her closing arguments, "This was a malicious, evil-hearted murder."

Council made a statement to the jury: "I had nothing to do with killing Mrs. Gatti. I just went to the house with the person that did it."

The jury took three and a half hours to return a guilty verdict against Donney Council for murder, kidnapping, administering poison, grand larceny and two counts of criminal sexual conduct in the first degree.

Council's family did not receive the verdict well. As he was led from the courtroom there were outbursts from the family as well as him. He yelled out, "I want this trial investigated." Officers quickly removed him from the premises.

After the twenty-four-hour waiting period between the guilty and sentencing phases of the trial, the defendant was escorted back into the courtroom on Tuesday, October 22. He was shackled with waist and ankle restraints and locks.

Before the jury was brought in, Council started mouthing off at Judge Henry Floyd, "Why can't I get a fair trial?"

Judge Floyd turned to him, "You are getting a fair trial, Mr. Council, and it won't do you any good to show out in front of the jury. Ok, Mr. Council, I'm telling you to sit there and behave."

Council quieted down and stared angrily around the courtroom.

Opening statements from Solicitor Morgan once again focused on the horrifying manner of Mrs. Gatti's death as she said, "The overwhelming evidence will prove the only appropriate sentence for Donney Council would be death."

She told the jury of Council's history of violence, which began as far back as elementary school. Records showed assaults on teachers, store clerks and law enforcement officers.

To show his violence, the convenience store clerk, Esther Thomas, who was beaten and robbed, told the jury that Donney Council was the man that

did that to her. The surveillance videotape of the incident was then played for the jury showing Council striking her with the tire iron.

Judge Floyd ruled all photos of the crime scene would be admissible in the sentencing phase of the trial. Solicitor Morgan addressed the jury, "I would like to apologize beforehand on what you are about to see."

For almost two hours, the jury viewed photographs taken during the initial investigation of the crime scene. SLED Agent Chuck Counts explained specifically how these photographs depicted precisely the torturous manner in which Mrs. Gatti died and showed the condition in which the defendant left her. The jury now saw, through the photographs, what was testified to in the guilt phase of the trial: Mrs. Gatti's body under a gold bedspread, her hands and legs hog-tied behind her back, duct tape wound around her entire face and head, a bottle of Murphy Oil Soap next to her body, an Arm and Hammer deodorizer aerosol can between her legs.

Solicitor Morgan again told how Mrs. Gatti was forced to drink cleaning fluids before the duct tape smothered her. She smelled of cleaning fluid and lived for a while after all that was done to her.

Council's mother was the only witness called by the defense. She begged the jury to let her son live.

During closing arguments, Solicitor Morgan pointed at Council and said, "The torture of Mrs. Gatti is the most horrific part of this case. It was a vile, evil and horrendous crime, and what that man did to Elizabeth Gatti defies comprehension."

Her final words to the jury were once again, "The only appropriate sentence for Donney Council should be death."

Council's attorney, James Whittle, ended with, "As a matter of law, a life sentence for Donney Council would be a death sentence because he would not be eligible for parole and would die in prison."

Council made a statement to the jury during closing argument. With his head bowed and speaking almost in a whisper he said, "I have did wrong, but it is also wrong for the state to take somebody's life for a crime they didn't commit."

The jury took only two hours to recommend death for Donney Council. The clerk read the sentence around 4:00 p.m., Wednesday, October 23, 1996.

The courtroom was totally silent as Donney Council, clad in his arm and leg restraints, stood in front of Judge Floyd as he ordered him to be put to death, Friday, December 6, 1996.

South Carolina's death sentences carry an automatic appeal, and Mr. Council would be appealing for years to come. He continues to try to have his sentence overturned.

Something that touched me deeply during the time I was assisting the investigators and the solicitor with the preparation of evidence for court was the personal feelings they all shared with me. In their own words, "This was one of the most brutal crimes I have ever seen, and I'll never forget Council's appalling slurs."

Council didn't have a clue about all the physical evidence he left behind which pieced together the truth of his evil actions.

After the trial, Solicitor Morgan said to me, "This case was the most forensically put together as you will ever see." And then her powerful statement of how she described all of this: "Evil is total absence of empathy."

In September 1996, *State of Tennessee v. Ware* was the first case in the United States where mitochondrial DNA evidence was introduced at trial. Council's trial was the first in South Carolina history and the second in the United States where mitochondrial DNA was admissible.[26]

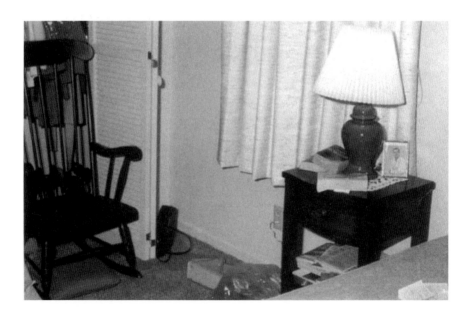

Council's dusty shoeprints were found in the seat of the rocking chair in Mrs. Gatti's bedroom. *Courtesy of SLED.*

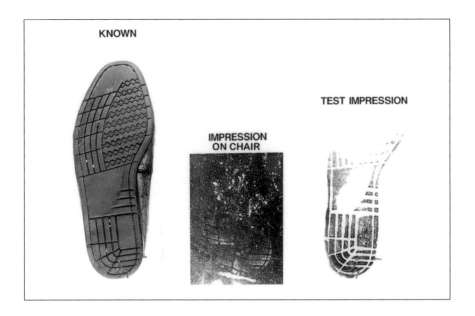

Council's right shoe comparison chart presented in court. Arrows show matching characteristics. *Courtesy of SLED.*

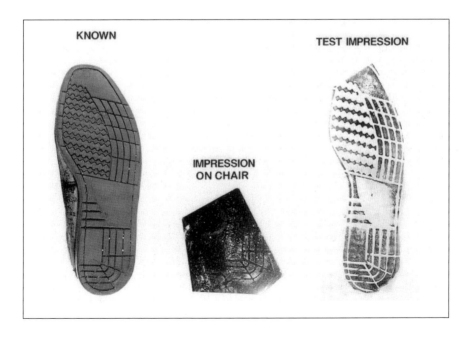

Council's left shoe comparison chart presented in court. Arrows show matching characteristics. *Courtesy of SLED.*

# Twenty-eight Days of Terror

**M**y early morning run felt good. It was already seventy-five degrees and another picture-perfect day at Edisto Beach, South Carolina; one of the last unspoiled beaches on South Carolina's coast with a laid-back atmosphere and Southern charm. This was one of my getaway R&R weekends for crabbing. I was 160 miles from SLED headquarters in Columbia, and everything was right with my world.

I made a supply run to the corner IGA grocery store to get more chicken backs for crab bait and, of course, beer and ice. Crabs always seem to bite better when there's beer around.

I jumped out of my Jeep at the IGA, did a quick glance at the newspaper rack and stopped dead in my tracks. The bold headlines of *The State* newspaper read, "Missing teenager feared abducted," and next to it was a photo of Sharon "Shari" Faye Smith. I grabbed it and started reading:

> Sheriff deputies and volunteers conducted an air and ground search for a 17-year-old high school senior feared abducted. Around 3 p.m. Friday, Shari's parents found her blue Chevette at the end of their driveway near their mailbox on Platt Springs Road, ten miles from Lexington. The engine was running and her purse was on the front seat, but there was no sign of Shari. Mr. Smith called the Lexington County Sheriff's Office, and Sheriff James Metts requested the assistance of the South Carolina Law Enforcement Division.

## Missing teenager feared abducted

**Car found in her driveway; door open, engine running**

By BOBBY BRYANT
and DEBRA-LYNN BLEDSOE
State Staff Writers

Sheriff's deputies and volunteers conducted an air and ground search of a wooded area of rural Lexington County Friday for a 17-year-old high school senior feared abducted after her car was found abandoned in the driveway of her family's home.

Shari Smith

A family member found Shari Smith's blue Chevette, the door open and engine running, parked in the driveway shortly after 3 p.m., according to Lexington County Sheriff James R. Metts.

The house is on Platt Springs Road, about a mile past S.C. 6 in the Red Bank community.

The teenager was wearing a swimsuit at the time she disappeared and apparently was barefoot, Metts said. Deputies found footprints leading from the car to the mailbox by the road, but no return tracks, he said.

At 10:30 p.m., Metts said searchers had found a red bandana belonging to Miss Smith on Platt Springs

Road leading away from West Columbia.

Earlier in the night, Metts said authorities had no clues to Miss Smith's disappearance.

"Nobody saw anything. We have nothing," he said. "She vanished."

There was no evidence to indicate the teenager had been kidnapped, Metts said, "but it's the only logical alternative."

The sheriff said he had received reports of two suspicious vehicles in the area, but there was no

See Girl, 9-A

Front page headlines, Saturday, June 1, 1985. *Courtesy of* The State.

Sharon "Shari" Faye Smith. *Courtesy of SLED.*

As I left Edisto Island Sunday morning, June 1, 1985, heading back to Columbia, I picked up the Sunday paper. The search for Shari was again front-page news.

The Smiths informed investigators that Shari had a rare form of diabetes, Diabetes Insipidus, commonly known as water diabetes. It required drinking large quantities of water and taking her prescribed medication. They found her medication in her purse on the front seat of her car.

I knew this case would be waiting for me when I got to work Monday morning. The early morning was silent and peaceful as I stepped out my door for my morning run before work. It was around 6:45 a.m. when I got back from my run. As I opened the door, the phone was ringing. I worked so closely with the crime scene investigators that they all knew my morning routine of a run before work.

The caller was Lieutenant Jim Springs, SLED latent print crime scene investigator, and he was hastening, "Rita, I guess you were out running. I've been calling. We need you at headquarters ASAP to photograph a letter involving the Shari Smith disappearance. The letter has been intercepted at the Lexington Post Office and is being delivered to SLED as we speak."

Specialized photography was imperative to document the original form of the letter and envelope before any scientific analysis could be performed.

A call had come in to the Smiths' house around 2:20 a.m. that morning, Monday, June 3, informing them that they would be getting a letter in the mail that day from Shari. A male caller described details in the letter. No ransom demands were made, so money did not appear to be the issue.

The call was traced to a pay phone about twelve miles from the Smiths' home. The caller had vanished when officers arrived at the location. No useful evidence was found.

With the assistance of the Lexington County postmaster, an envelope addressed to the Smith family was located in the bag of Lexington-addressed mail that had arrived from the Columbia distribution post office earlier that morning. Shari's father was transported to the post office to take delivery of the letter. It was a white legal size envelope. The Smith family and address was written on a small loose-leaf, pocket size, blue-lined sheet of paper approximately three-and-a-half-by-five inches. The sheet was pasted to the envelope. It was postmarked June 1, 1985, in Columbia and had a twenty-two-cent mallard duck stamp in the upper right corner. There was no return address. Inside the envelope were two sheets of blue-lined yellow legal paper eight-and-a-half-by-eleven inches in size bearing handwriting and printing.

After photographic documentation of the letter, SLED Questioned Document Examiner Lieutenant Mickey Dawson examined the letter, which was titled "Last Will & Testament" and dated June 1, 1985, at 3:10 a.m. He compared the handwriting in the letter to known handwriting of Shari Smith and positively identified the letter to be in Shari's handwriting.

Lieutenant Dawson processed the envelope and letter on the Electrostatic Detection Apparatus instrument (ESDA). The ESDA is an instrument that develops indented writings from paper products. It works on the opposite principle of a printing press. Instead of coating raised letters with ink to create an image, the ESDA fills in the indentations on the document in question with graphite particles called "carrier particles." When an imaging film similar to Saran Wrap is pulled tight over the document, a readable image could possibly come through, making the indentations legible in varying degrees in such a manner that the indentations may be captured in hard copy form and the information from these indentations available for investigative use.[27]

In this case, if anything was written on the sheets of the legal pad before the sheet that Shari wrote her "Last Will and Testament," there was the possibility that the pressure of the writing instrument, pen or pencil, would make the indentations go through to her sheet.

The product of the ESDA process disclosed numerous indentations on the first page of the "Last Will and Testament." There were faint impressions of letters and numbers. Some of the numbers had the appearance of telephone numbers.

Agent Springs processed the documents for latent prints. Shari's right ring finger, right thumb and right palm were positively identified on the letter.

Another phone line was set up at the Smith home, and a recording device was placed on their personal line in the event the person would call again.

Envelope of "Last Will and Testament." *Courtesy of SLED.*

6/1/85          3:10 AM     I Love ya'll)

## Last Will & Testament

G
O
D

i
S

L
O
V
E

in

I Love you mann, daddy,
Robert, Dawn, + Richard and
everyone else and all other
friends and relatives. I'll be
with my father now, so
please, please don't worry!
Just remember my with
personality + great special times
we all shared together. Please
don't even let this ruin your
lives just keep living one day
at a time for Jesus. Some good
will come out of this. My
thoughts will always be with +
in you... (casket closed) I love you
all so damn much. Sorry dad,
I had to cuss for once! Jesus
forgave me! Richard sweetie – I
really did & always will love
you + treasure our special
moments.. I ask one thing though,
accept Jesus as your personal
savior. ☺ My family has been
the greatest influence of my life.
Sorry about the cruise Imore. Some
body please go in my place.

ShaRichard ♡

Page one of "Last Will and Testament." *Courtesy of SLED.*

I am sorry if I ever disappointed you in any way, I only wanted to make you proud of me. Because I have always been proud of my family. Mom, dad, Robert & Dawn there so much I want to say that I should have said before now. I love you!

I know y'all love me and will miss me very much but if y'all stick together like we always did - y'all can do it!

Please do not become hard or upset. Everything works out for the good for those that love the Lord.

I love Ya'll
w/ All my Heart

All My Love Always -
Sharon (Stan) Smith

P.S. Nana - I love you so much. I kind of always felt like your favorite. You were mine.
I love you alot

Page two of "Last Will and Testament." *Courtesy of SLED.*

The same person called again on Monday, June 3, at 3:08 p.m. and 8:07 p.m., and on Tuesday, June 4, at 9:54 p.m. He gave detailed information about Shari, the abduction and the letter, so the Smiths knew that this must be the man who had Shari.

All calls were traced. And, as before, the caller had left the location, and no useful evidence was found.

Five days after Shari's abduction, Wednesday, June 5, at 11:54 a.m., an abrupt call came in to the Smiths' home. Shari's mother answered the phone.

"Hello."

"Listen carefully. Take Highway 378 west to traffic circle. Take Prosperity exit, go one and a half miles, turn right at sign. Masonic Lodge #103, go one quarter mile, turn left at white framed building, go to backyard, six feet beyond, we're waiting. God chose us."

Officers rushed to the location. A white female's body was found six to ten feet into the wood line behind the Masonic Lodge #103 in Saluda County. Time and the extreme one-hundred-degree temperature had taken its toll on the body.

Lexington County and SLED ID teams processed the crime scene. The area was thoroughly searched for evidence with no results.

The body was positively confirmed to be Sharon Faye Smith by Miss Smith's dental records.

Forensic Pathologist Dr. Joel Sexton performed the autopsy. He confirmed the cause of death could not be determined with exact medical certainty because of the decomposition of the body and because Shari had a medical condition which would have led to death in one or two days if she was unable to drink sufficient fluids or take medication. His results showed that the two most likely causes of death were extreme dehydration or asphyxia due to soft ligature strangulation or smothering. He did confirm that the matter of death was definitely homicide because it occurred during the abduction.

On Thursday, June 6, at 2:00 p.m., yet another call was made, but it wasn't to the Smiths' house. The person called Charlie Keyes, a reporter with a local Columbia TV station, WIS. The caller told Keyes that this was concerning Shari Faye Smith, and he wanted to use him as a medium and would give him an exclusive interview. He rambled on that it just went too far, and he needed to turn himself in, or he might take his own life.

At 8:57 p.m. that same evening, the caller placed a collect call to Shari's older sister, Dawn. He rambled on and on asking the family to forgive him because it just got out of hand and continued alluding that he might take his own life. Then he told Dawn to be strong and gave his details of how Shari

died: "Ok, I gave her a choice, to shoot her or give her a drug overdose or suffocate her. She chose suffocation. I tied her up to the bedpost with electric cord. She didn't struggle, cry or anything. I took duct tape and wrapped it all the way around her head and suffocated her."

Saturday morning, June 8, was Shari's funeral. After the Smiths arrived home that afternoon, their phone rang at 2:21 p.m. Again, it was a collect call to Dawn. He told them that he was at Shari's funeral and continued on and on with more of the same ramblings as before, still alluding that he might take his own life.

The call was traced out of state to a service station in Augusta, Georgia, about sixty miles from the Smiths' home. Again, no evidence was found.

Six days passed. The caller was silent. Had he carried out his threat to kill himself? Authorities thought not. They felt that he was getting too much pleasure out of what he was doing. In the silence, the unknown became the extreme fear. Authorities knew this killer could strike again.

Crime Stoppers TV program did a television reenactment of Shari's disappearance and death on Friday, June 14. Crime Stoppers is a partnership of the community, the media and law enforcement designed to combat crime, for which someone can call to give tips or information about a crime or person(s) involved in a crime, and still remain anonymous. An article on the Crime Stoppers program was also run in *The State* newspaper.

On that same day, at 4:07 p.m., twenty-five miles from the Smiths' home and exactly two weeks and almost to the hour that Shari Faye was abducted, it happened again.

It was a bright sunny day and the weather was still unseasonably hot in the midlands. Nine-year-old Debra May Helmick and her six-year-old sister, Becky, and three-year-old brother, Woody, were running and laughing as they played in the yard in front of the family's mobile home in the Shiloh Mobile Home Park on Old Percival Road.

Debra May's mother, whose name was also Debra, was getting a ride to work with her friend, Vickie, who also lived in the mobile home park. The children were going to ride with them, and they would stay with Vickie until their father got home from work.

As Mrs. Helmick was coming out of the trailer, her husband, Sherwood, arrived home from work, so Debra May and Woody stayed at home with him. Becky went with her mother.

A friend who worked with Mr. Helmick went inside the trailer and sat on the couch in the front room while Mr. Helmick went to the rear bedroom of

the trailer to change clothes. The air conditioner in the front room window of the trailer was running on high. Debra May and Woody stayed outside in front of the trailer and continued playing.

About 4:00 p.m. that afternoon, a car turned into the park entrance and drove down the short driveway that dead-ended in a wooded area between the trailers. The driver paused for a moment, turned the car around and slowly started his way back up toward the entrance of the trailer park. He stopped the car in front of the Helmicks' trailer. He opened his door and left the engine running.

Four trailers down and across from the Helmicks', Ricky Morgan was in his kitchen mixing up a pitcher of orange juice. Ricky did not have his air conditioner on, and he had his windows open. He looked out the kitchen window and yelled, "Oh, my God." He saw a white male get out of the driver's side of the car parked in front of the Helmicks' trailer and grab Debra May around her waist from the back, then take off running to his car.

The car sped off as Ricky ran out of his trailer toward the Helmicks' trailer.

At the same time, Mr. Helmick thought he heard one of the children yelling but thought they were just playing until his friend said, "One of your kids is yelling and hollering out there." Mr. Helmick ran to the front door of the trailer and jumped outside. He saw Woody, scared and shaking, crawling around under a bush on the side of the trailer. Woody was yelling something to him, but he couldn't understand what he was trying to tell him.

That's when Mr. Helmick heard Ricky yelling to him, "Did you see that man take your daughter?"

Mr. Helmick ran around the trailer looking for Debra May. Not seeing her, he and his friend jumped in the car and quickly drove down to the intersection of Old Percival Road and Alpine Road. Mr. Helmick jumped out and stopped cars asking if they had seen a speeding car heading in any direction. He then saw a police car coming toward him. He flagged it down yelling, "Someone has taken my daughter."

The officer radioed for assistance.

Authorities' thoughts turned instantly to the abduction of Shari Faye, wondering if this might be the act of the same person; if it was, they knew what he was capable of doing. Although they had no clue at this point if there might be a connection, there had been an abduction and another girl was missing. Was it just a coincidence that it happened exactly two weeks and within an hour of the time that Shari was abducted?

Mr. Helmick's mother rushed to pick Debra May's mother up from work and tell her that Debra May had been kidnapped. On their way

back to the trailer, Mrs. Helmick flashed back to that same afternoon, thinking how the kids would usually ride to work with her and Vickie because Sherwood was not at home when she left for work. Today he came home early, and Debra May said she would stay and watch Woody. Becky wanted to ride with her. Debra May was waving goodbye and had Woody propped up on her hip. "Oh, my God," she thought, "If Debra May and Woody had just gotten in the car and rode to work with me, Debra May would still be here."

Ricky Morgan described the suspect as thirty to thirty-five years old, five feet nine inches tall, 215 pounds with sort of a beer belly, closely cropped brown beard and mustache and brown receding hair. He told officers, "When he approached the children, he leaned over like he was talking to them. He grabbed Debra May, and she started kicking and screaming. I saw her feet hitting the top of the car as he threw her across the seat, and then in a matter of seconds she stopped kicking."

He thought the car to be a 1982 or 1983 silver-gray Grand Prix or Monte Carlo with red racing stripes. It had a South Carolina license plate, and he remembered the first letter on the plate was "D."

Officers talked to Woody. Still shaking and scared, he kept saying, "The bad man said he was coming back to get me."

Debra May's abduction thickened the cloud of fear over Lexington and Richland Counties. Everywhere the conversation was most always on Shari Faye and Debra May.

The State

Columbia, South Carolina — Saturday, June 15, 1985

South Carolina's
Largest Newspaper
94th Year — No. 166
3 Sections — 46 Pages

# Child kidnapped

## Man grabs 10-year-old, speeds off in car

By SCOTT JOHNSON and CHARLES POPE
State Staff Writers

A "shy and cautious" 10-year-old girl playing in her yard off Old Percival Road was abducted Friday afternoon by a man who drove away with her in a silver-colored car.

Richland County Sheriff Frank Powell said Debra May Helmick, of Shiloh Trailer Park, was abducted at 4:07 p.m. from the yard alongside her family's mobile home. The kidnapper was described as a white man in his mid-20s, weighing about 200 pounds, wearing only short pants

The sheriff said the girl was playing with her 3-year-old brother in a small patch of grass in front of the mobile home, about 10 feet from the road. The incident was witnessed by a man who lives in a trailer several doors away.

"All I know is I heard her screaming about 4:10," said the witness' wife, who was with her husband when the child was abducted. "He was in the kitchen getting something to drink when he said, 'Oh my God' and ran out the door. But there wasn't anything he could do, there wasn't any time. He just snatched her right out

of the front yard."

The woman said her husband saw a silver Monte Carlo drive to the end of the mobile home park's short driveway, pause and turn around.

Then, as it was leaving, the car stopped in front of the Helmicks' mobile home and the man abducted the child.

"Her father was right inside," Powell said. "Someone who saw it ran up and banged on the door. The father did not even know his daughter had

See Abduct. 17-A

Debra May Helmick

Front page headlines, Saturday, June 15, 1985. *Courtesy of* The State.

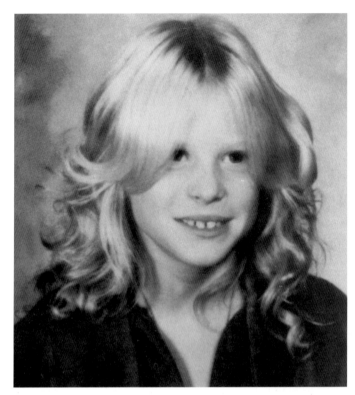

Debra May Helmick. *Courtesy of SLED.*

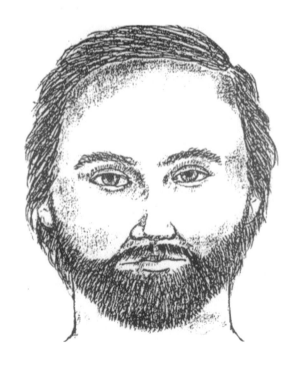

Artist composite drawing of Helmick suspect. *Courtesy of SLED.*

Ricky Morgan worked with an artist in preparing a facial composite of the suspect. The composite drawing was circulated in the media. Calls flowed in from concerned citizens who believed they knew the man. All tips proved futile.

And then there was a calm before yet another storm.

Eight days after Debra May's abduction and thirty miles away, the Smith family's phone rang. It was 12:17 a.m., Saturday, June 22. It had been fourteen days since Shari's abductor and murderer had called. Dawn answered the phone. The operator came on the line.

"I have a collect call from Shari Faye Smith."

"Yes, I'll take the call."

"Thank you, Dawn? Uh, you know…uh…God wants you to join Shari Faye. It's just a matter of time…this month…next month…this year…next year. You can't be protected all the time…and you know…uh…have you heard about Debra May Hamrick [*sic*]?"

"Uh, no."

"The ten-year-old…H-E-L-M-I-C-K."

"Richland County?"

"Yeah, Uh-huh, ok, now listen carefully…Go 1 North…well…Bill's Grill. Go three and a half miles through Gilbert. Turn right. Last dirt road before you come to stop sign at Two Notch Road. Go through chain and no trespassing sign. Go fifty yards and to the left. Go ten yards. Debra May is waiting. God forgive us all. Dawn E., your time is near. God forgive us and protect us all. Goodnight for now, Dawn E. Smith."

This call was traced to a phone fifty miles from the Smith residence, and as all the times before, the caller had vanished and left nothing behind.

The voice was the same. The words were the same. The explicit detailed directions to Debra May's body as to Shari's were relayed the same, and now he was threatening Dawn.

Officers rushed to the location, and there in a wooded area, they found the decomposed body of a child lying in leaves and brush. Once again, time and the extreme hot weather had taken its toll on the body.

Pathologist Dr. Erwin Shaw performed the autopsy, but because of decomposition, a thorough autopsy was not possible. He did surmise that suffocation was a prime possibility as the cause of death.

No dental records were available for Debra May. Mrs. Helmick provided the right and left inked foot impressions done at the hospital the day of Debra May's birth to Agent David Caldwell. Caldwell compared these impressions to the tissues of the feet of the deceased and made a six-point

match of the left foot tissue and the inked impression of the left foot of baby Debra May.

Debra May had been fingerprinted when the Helmicks lived in Ohio. Her records were retrieved and sent to Agent Caldwell at SLED. Caldwell compared the right thumb tissue from the deceased with the known right thumb on the fingerprint card of Debra May Helmick. It was a positive match.

I photographed the clothing from the deceased body. Investigators spared the Helmicks from having to view the clothes removed from the decomposed body by showing them the photographs of the clothing. They positively identified Debra May's white shorts and her little short-sleeved lavender tee shirt.

Mr. and Mrs. Helmick were also shown a pink barrette found near the body. Debra May's mother said, "Yes, that's hers. That day, I washed her hair, brushed it and put two pink barrettes in it. That's one of them."

Hair found at the scene was consistent with the known hair of Debra May Helmick. Tape residue was present in the hair.

That Monday afternoon, the body found was confirmed to be nine-year-old Debra May Helmick.

At a news conference on Monday, June 24, Sheriff James Metts announced, "We now believe the cases of Shari Faye Smith and Debra May Helmick are one and the same."

Debra May's funeral was Wednesday evening, June 26.

It was twenty-seven days since Shari's abduction.

It was thirteen days since Debra's abduction.

And finally it ended.

An investigative team had concentrated in-depth on the indented numbers on the ESDA exam of Shari's "Last Will and Testament." Using many different combinations of numbers, they came up with a number that turned out to be a Huntsville, Alabama, telephone number.

The telephone number was targeted through the FBI as being called from a residence and a business in the Lexington and Saluda County areas.

The number was that of Sharon and Ellis Sheppard, who lived in Saluda County, which was fifteen miles from the Smiths. The business number was that of Sharon Sheppard.

A call was placed to the number in Alabama, and the party was asked if they knew anyone in South Carolina. He answered, "Yes, my mother and father live in Saluda County, Ellis and Sharon Sheppard."

Wednesday evening, June 26, authorities established contact with Mr. and Mrs. Sheppard.

Asked about the telephone number that they called frequently in Huntsville, Alabama, they replied, "It's our son Joey's number. He's stationed at an army base in Huntsville."

The Sheppards told officers, "We travel and are away from home a lot, so when we are away, we have a house sitter who stays at our house. His name is Larry Gene Bell."

They described Bell as a white male in his mid-thirties, around five feet ten inches, with a sort of flabby belly, reddish brown hair, short and close-cropped reddish brown beard and mustache.

Mr. Sheppard stated that Bell started working for him off and on in the early spring of 1985 as an electrician. When he and Mrs. Sheppard traveled, they did not like to leave the house vacant, so they thought Bell would be an excellent house sitter.

ESDA examination of first page of "Last Will and Testament."
*Courtesy of SLED.*

Mrs. Sheppard said they always had a legal pad beside the phone in the kitchen to use for notes. Before they left on their trip, May 13, they wrote information on the pad for Bell that included telephone numbers in case he needed to contact them. One of the numbers they had written down was their son Joey's in Huntsville, Alabama.

After a lengthy interview, a copy of the excerpts of the telephone call concerning Debra May Helmick was played for the Sheppards. They both identified the voice as their house sitter, Larry Gene Bell.

Mrs. Sheppard broke into tears.

Mr. Sheppard gasped, "My God, he threw her body out around Bill's Grill. Larry told me numerous times that Bill's Grill in Gilbert was one of his favorite places to eat. Now, I am mad."

Further information on Larry Gene Bell was developed throughout the evening and it revealed that over the past ten years, Bell had many altercations with the law with assaults on women. He pleaded guilty to each and was placed on probation each time.

With the additional investigative information, an arrest warrant was issued for Larry Gene Bell.

Around 2:00 a.m. that morning, a roadblock was set up about a mile from the driveway of Bell's parents' residence on Shull Island at Lake Murray. The net of fear that had covered South Carolina for twenty-eight days was only minutes from being lifted.

Around 7:30 a.m., Bell's car slowly approached the roadblock and came to a stop. Officers asked him to identify himself. He answered, Larry Gene Bell. They asked for his driver's license and instructed him to step out of his car. He offered no resistance and very calmly said, "This is about those two girls. Can I call my Mama?"

Investigators and Sheriff Metts interviewed Bell at the Lexington County Sheriff's Office. Throughout the interviews, the tapes of calls made to the Smith family were played for him. He never confessed to the kidnappings or murders of Shari or Debra May. He kept saying, "It was not this Larry Gene Bell that did this, it was the bad Larry Gene Bell."

He did however answer Sheriff Metts final question: "You know for a fact that is you on the tapes?"

"Yes, sir, by the voice thing unless somebody is disguising it or something like that. There's no doubt about it."

Bell asked Sheriff Metts if he could talk to the Smith family, because if it ended up being him, he wanted God and them to forgive him.

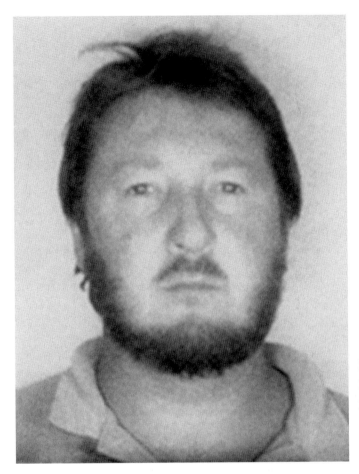

Larry Gene Bell's booking photo the morning of his arrest. *Courtesy of SLED.*

Authorities hoped that being face to face with the family might trigger something in Bell and break his shield. So, Bell's request to talk to the Smith family was granted.

As soon as Larry Gene Bell opened his mouth and spoke, Dawn and Mrs. Smith immediately recognized the voice. This was the voice that had invaded their home and terrorized them for weeks, and this was the face that belonged to that voice.

Again, Bell did not confess but did tell Dawn and her mother, "They have the evidence against me. There's bad in me, and I feel terrible about this if it was the result of something bad in me."

At the Sheppards' house, SLED Questioned Document Examiner Mickey Dawson took possession of the original sheet from Mrs. Sheppard that they had written notes on for Larry and labeled it "Sheppard Document."

Mrs. Sheppard cringed as she looked at Joey's telephone number on the paper, the ten digits that led authorities to Larry Gene Bell, the person they entrusted their home to.

SLED Agent Ken Habben collected hair from the Sheppards' guest bedroom and bathroom, which Bell used. Red fibers were observed on the bed sheet. Duct tape was found in the living room and in the Sheppards' truck that Bell worked out of.

In the trunk of Bell's car that he was driving when he was apprehended was a license plate. The first letter of the tag was a "D."

Mallard duck stamps were found in a drawer in Bell's bedroom at his parents' house, and a business card of Bell's sister and her husband, who owned a topsoil, sand and gravel business directly across the road from the Shiloh Trailer Park on Old Percival Road where the Helmicks' lived, was also found. It was later learned that Bell worked with them at the sandpit when they needed extra help.

Another card was located near the telephone in the Bells' kitchen for Bill's Grill in Gilbert, South Carolina.

Original sheet (Sheppard Document) that the Sheppards wrote notes on for Larry. *Courtesy of SLED.*

At the foot of Bell's bed was a newspaper dated Saturday, June 15, 1985, folded so the picture of the recreation of Shari's abduction was in plain sight. On top of it was a pair of tennis shoes, and on the shoes were two small spots that resembled blood.

Duct tape was found inside the residence, in an outside storage house and in the blue pickup truck that Bell drove, which was parked in the yard.

At 8:15 p.m., Thursday evening, Sheriff Metts announced the formal arrest of Larry Gene Bell for the kidnapping of Shari Faye Smith.

SLED Questioned Document Examiner Gaile Heath and I met with the Sheppards later that week for them to view the ESDA product of the "Last Will and Testament" letter. They identified all partial indentations, including the telephone number, 205-837-1848, as being their entries.

With the additional information from the Sheppards, Lieutenant Mickey Dawson and Agent Gaile Heath determined that the document retrieved from the Sheppards' home was at one time on top of the sheets on which Shari wrote her "Last Will and Testament."

SLED forensic analysis results showed that the hair found in the Sheppards' house was consistent to the known hair of Shari. Small red fibers were found in Shari's hair during the examination and were consistent to the red fibers found on the bed sheet from the Sheppards' guest bedroom.

One of the two spots that resembled blood on the shoes collected from Bell's bedroom proved positive for human blood. It was tested and found to be Type A. Shari's blood type was A.

Numerous stains on the blue mattress cover were analyzed and three stains were identified as semen and urine stains. A court order was obtained to request blood and saliva samples from Larry Gene Bell, but Bell refused to give them.

Investigation continued with interviews of social and business acquaintances of Larry Gene Bell. They remembered Bell rambling on to them during conversations about the Smith abduction and murder.

At one time, Bell was employed by Eastern Airlines in Charlotte, North Carolina, and lived in Rock Hill with his wife and two-year-old son. North Carolina authorities assisted in interviewing acquaintances of Bell in the Charlotte area. During the interviews, North Carolina authorities began to see similarities to several unsolved homicides in Charlotte, so they interviewed Bell. Officers reported that their questions to him regarded the North Carolina cases. He, on his own, made some references to Shari Smith and Debra May Helmick.

On Monday, August 12, 1985, a Saluda County grand jury indicted Bell for the kidnapping and murder of Sharon Faye Smith. Bell was served the death penalty notice if convicted.

On Wednesday, September 4, 1985, a Lexington County grand jury indicted Bell for the kidnapping and murder of Debra May Helmick. Bell was served the death penalty notice if convicted.

In preparation for trial, I prepared photographic enlargement charts of the envelope, the two pages of the "Last Will and Testament," the ESDA product of the first page of the letter and the "Sheppard Document."

These four charts were the crucial court exhibits to show what evidentially led authorities to Larry Gene Bell.

Bell did not know when he mailed Shari's "Last Will and Testament" that he was also mailing the silent witness that broke the case and stopped him: ten numbers indented in Shari's final message to her family.

### Smith Trial

The trial began on Monday, November 11, 1985, in Saluda, South Carolina. Solicitor Donnie Myers and Defense Attorney Jack Swerling began questioning potential jurors. Questioning moved at a slow pace.

On Wednesday morning, Judge John Hamilton Smith made a surprise announcement, "Larry Gene Bell will not be tried in Saluda." He was convinced there was probability that Bell could not receive a fair trial in the small town and community of Saluda County because of the extensive pre-trial publicity and media coverage.

Judge Smith announced that Bell's trial would be moved to the South Carolina Lowcountry town of Moncks Corner in Berkeley County, which is 127 miles from Saluda.

On Monday, February 10, 1986, the trial began. The jury was sworn in at 3:10 p.m., Wednesday, February 12, 1986.

All of the recorded tapes were played for the jury except the last tape of June 22, giving directions to Debra May Helmick's body. For eleven days they listened to extensive testimony from families, witnesses, law enforcement officers, mental experts and forensic experts.

Bell testified and was on the stand for about six hours. All during his testimony, he continuously blurted out bizarre comments and carried on nonstop theatrics. He refused to give answers by just rambling on and on. "Silence is Golden" was his favorite when he didn't want to answer a question. At one time he even yelled out, "I would like Dawn E. Smith to marry me."

These constant actions resulted in many sidebars at the judge's bench and in-camera (out of the presence of the jury) discussions.

Defense Attorney Swerling called for several competency hearings with mental experts during the trial to make sure that Bell was mentally competent to stand trial.

After each hearing, Judge Smith ruled. "Some say he has the ability to understand the proceedings and to assist his attorneys. Others say he is psychotic, out of touch with reality and cannot assist with his defense. Mr. Bell does have a flair for theatrical. He does answer those questions that he wants to and not those that he doesn't. He decides to give us his knowledge of clichés, which is quite extensive. I find that the defendant is fit to stand trial."

During closing arguments, Solicitor Myers said, "Need we even talk about Shari's 'Last Will and Testament' and the 'Sheppard Document,' the evidence that broke the case? The telephone number was on that pad. Who was the only one in that house, the only one with a key? Who was the pad left for, the 'Last Will and Testament' being written on that same pad? Listen to the phone calls, and what they tell you, and the interview when he finally said that was his voice, but it must have been the bad Larry Gene Bell, not the good one. Does that convince you beyond a reasonable doubt?"

Mr. Swerling followed, "I am going to do something that probably hasn't ever been done before. I will tell you right now that the State has proved beyond a reasonable doubt that Larry Gene Bell is guilty of kidnapping. They got Mr. Bell for the abduction. Mr. Bell's voice is on those tapes. Now, as far as the murder, I don't know. Was Mr. Bell's revelations on that tape the result of what really happened, or was it the ravings of a lunatic who is out of his mind, and didn't know what was happening? You will have to use your good common sense, and go back and determine whether or not the State has proved guilt beyond a reasonable doubt as to the homicide."

All of this left no reasonable doubt for the jury. After only fifty-five minutes of deliberation, they reached a verdict at 6:20 p.m., Sunday, February 23.

The verdict was read. "State of South Carolina vs. Larry Gene Bell: Count one, guilty of kidnapping. Count two, guilty of murder."

SENTENCING PHASE

After the twenty-four-hour waiting period between the guilt and sentencing phases, court reconvened Tuesday morning, February 25.

As with the first phase, extensive testimony was presented from family members, witnesses, law enforcement officers, mental experts and forensic experts.

Also in this phase, the defense put up character witnesses for Bell that included neighbors of the Bells on Lake Murray, friends and employees that had worked with Bell. They described him as easygoing, laid-back, an excellent employee and a perfect neighbor and friend.

Solicitor Myers presented a powerful closing argument to the jury. His final words were,

> You have done your job. We have tried our best. Mr. Swerling has done great. Where was Shari Smith? What court was she in? Who passed her law? Larry Gene Bell was the senate. He was the House of Representatives. He was the governor that signed it. And what crime did Shari Smith commit? Being a loving 17-year-old Christian, a talented girl getting her mail, that was her crime. Yet, who arrested her? Police officer Larry Gene Bell, and what court did he take her to? The court of Larry Gene Bell, and who was the Judge? Judge Larry Gene Bell, and who was the solicitor? Solicitor Larry Gene Bell, and who was the defense lawyer? Defense lawyer Larry Gene Bell, and who was the jury? Larry Gene Bell was all twelve, and who imposed the sentence? Larry Gene Bell.

Myers's next move was electrifying. He walked over to the jury box and placed a pen on the banister and spoke directly to the jury: "The pen was passed to Shari Smith. Some good will come out of this, she says in her last words. We now pass this pen to you. Sign your name to the right sentence. Let us never again hear that horrible bell ringing of sadism, no conscience, no remorse and no sorrow. Let your verdict bring a sweet sound to Shari Smith."

Swerling's final plea: "You have observed that man. You have observed that man talk. You have observed him do things inappropriately in the courtroom. You know he is sick. You know that. He committed this crime with a distorted judgment and mind of one who is mentally ill. I ask you when you go back to the jury room to weigh all the evidence, to talk about life, not about death. I ask you to make a life decision and not a death decision for Larry Gene Bell."

The jury retired to the jury room, Thursday, February 27, at 11:33 a.m. for deliberations, and after two hours and fifteen minutes, they had a verdict.

The Clerk of Court published the verdict.

> State of South Carolina vs. Larry Gene Bell: We the jury in the above-entitled case, having found beyond a reasonable doubt that a murder was committed while in the commission of the statutory aggravating circumstance of kidnapping, now recommend to the court that the defendant, Larry Gene Bell, be sentenced to death for the murder of Sharon Faye Smith.

Judge Smith sentenced Larry Gene Bell to suffer death by electrocution on the May 15, 1986.

Larry Gene Bell did not die on his set execution date because of South Carolina's immediate automatic appeal.

### Helmick Trial

On Monday, March 23, 1987, almost thirteen months to the date Larry Gene Bell was sentenced to death for the murder of Shari Faye Smith, the trial for the kidnapping and murder of Debra May Helmick began.

Because of statewide publicity of both murders, Debra May's trial was moved from Lexington County to Pickens County, 120 miles away in upstate South Carolina.

Presiding Judge Lawrence Richter began the jury selection.

Bell's demeanor was much more subdued than in Berkeley County, and he remained quiet.

On Wednesday, March 25, the jury was sworn in. After opening arguments from Solicitor Donnie Myers and Defense Attorney Jack Swerling, testimony began.

For five days, the jury listened to testimony from the Helmick, Smith, Sheppard and Bell families, law enforcement officers, witnesses, mental experts and forensic experts.

Ricky Morgan testified to his sighting of Debra May being taken on that Friday, and later working with an artist to prepare a facial composite of Debra May's abductor.

Solicitor Myers asked Ricky to look around the courtroom, and if he saw the man that took Debra May to point him out.

Ricky pointed to Bell.

A lengthy in-camera discussion followed concerning the admissibility of the evidence and bad acts from the Smith case to be introduced in the Helmick

case. After hearing the similarities that intertwined the two cases, Judge Richter ruled that such evidence must be necessary, but only certain evidence would be allowed.

Only portions of the taped calls to the Smith family, directly showing a link between Debra May and Shari's murder or directly mentioning Debra May's abduction, were played for the jury.

June 4, 1985, 9:54 p.m.: "Shari Faye was kidnapped from her mailbox with a gun. She had the fear of God in her." Solicitor Myers reminded the jury that Debra May was also kidnapped from near her mailbox.

June 5, 1985, 11:54 a.m.: Started with "Listen carefully," and gave detailed directions to Shari's body.

June 6, 1985, 8:57 p.m.: "And I took duct tape and wrapped it all the way around her head and suffocated her."

June 8, 1985, 2:21 p.m.: Started with "Listen carefully now, Dawn," and he described that when he took the duct tape off, it took a lot of Shari's hair with it. Myers reminded the jury that duct tape residue was also found in Debra's hair.

June 22, 1985, 12:17 a.m.: "Have you heard about the Hamrick [*sic*] girl…the 10-year-old…H-E-L-M-I-C-K?" and then, "Listen carefully," and gave exact directions to Debra May's body. Myers reminded the jury that the call giving directions to both bodies began with the words, "Listen carefully," and was the only call that mentioned Debra May Helmick. It was also the last call to the Smith family and the crucial piece of evidence tying both murders together.

Solicitor Myers called Debra May's mother to the stand, speaking gently as he asked her about Debra May.

"She was my oldest daughter. She was a straight A student and wanted to be a school principal."

He asked her about Friday afternoon, June 14, 1985. "I washed Debra May's hair before I left for work around two o'clock and put two pink barrettes in. It was clean and neat. She was wearing a pair of white shorts and her little lavender tee shirt with short sleeves. After the body was found, officers brought us pictures of the clothing from the body and the pink barrette found at the scene. The pink barrette was one of the ones I put in Debra's hair that afternoon, and the shorts and lavender tee shirt were Debra May's."

Mrs. Smith and Dawn testified to the phone calls and also meeting face to face with Bell at the sheriff's office. They both said that after they heard Bell's voice, there was no doubt in their minds that the voice was the same voice that called their home repeatedly.

Ellis Sheppard testified as he had in Shari's trial to his working and personal association with Bell. He also identified Bell's voice as the voice on the tape giving directions to Debra May's body and that Bill's Grill was one of Bell's favorite places to eat.

Friday morning, March 27, 1987, the fifth day of the trial, the jury was brought in and Judge Richter called Mr. Swerling to present the defense.

Mr. Swerling opened with a stunning statement: "Your Honor, Mr. Bell will not present a defense in this case," and directly followed with, "The defense rests."

Solicitor Myers pointed to Bell as he ended his closing arguments. "Right now, Mr. Bell sits over there, and the law says that he is wrapped in a cloak of innocence. He has a robe of righteousness around his shoulders and it stays there."

Myers then turned around, picked up a roll of duct tape and waved it in front of the jury. "Wasn't Debra May Helmick wrapped with something the final moments of her life? And was that something not ripped off? I submit that the evidence should rip off that cloak of righteousness or that robe of innocence and strip him to the bone of one verdict, the one thing that speaks the truth and justice and that's guilty as charged."

In summary, Mr. Swerling told the jury, "I concluded this morning that there's only one verdict in this case that you could come back with, so as his attorney I am not offering a defense as to what happened in this case, but I advise you that down the road I am going to tell you why it happened. Follow your conscience and do what is right."

The jury retired to the jury room at 12:35 p.m., Friday, March 27, 1987, to begin their deliberations and returned to the courtroom with a verdict at 1:53 p.m.

The Clerk of Court read the verdict. "The State vs. Larry Gene Bell: Verdict Count One: Kidnapping, guilty. Verdict Count Two: Murder, guilty."

### Sentencing Phase

Judge Richter did not hold court on Sunday, so because of the twenty-four-hour waiting period between the guilty and sentencing phases, court resumed Monday morning, March 30.

The state moved forward with several former victims of Bell testifying to how he tried to abduct, harass and threaten them.

In this phase, the complete contents of the tapes of the telephone calls to the Smith family, taunting them about Shari's death and leading officers to Shari's and Debra May's body, were played for the jury.

Solicitor Myers called Dawn Smith to testify to the June 22 phone call at 12:17 a.m. giving directions to Debra May's body. He asked, "Dawn, did the caller say some other things to you during that phone conversation?"

Dawn answered, "Yes, he told me that I would be next."

With that the state rested.

The jury listened to testimony after testimony of mental experts called by the defense in an attempt to try and show Bell was mentally ill and didn't know what he was doing when he abducted and killed Debra May. The defense put up character witnesses for Bell as they did in the Smith trial, and again they described him as easygoing, laid-back, an excellent employee and a perfect neighbor and friend.

Bell did not testify.

As Myers ended his closing arguments, he picked up the barrette from the evidence table and held it in front of the jury. "If this barrette could talk it would tell you the horror ensued. What did he say to you Debra May? How long did he keep you? What happened? What did he do?"

He pointed to Bell. "He knows, and he wants mercy. Right now, you're about twenty-five feet from a convicted, cold-blooded child killer in this courtroom. Remember how he took duct tape and used it to suffocate both Miss Smith and Miss Helmick?

"If you go back to the jury room and you have any doubts, hold this barrette in your hand. Put this duct tape in the other hand and close your eyes for a little bit and hold your breath. It's your decision. You have the opportunity to do what's right. If it's not right in this case, it's never right. There is but one verdict in this case and that is death. Stand strong, and do what's right. If you don't, it will be a blight on the memory of a nine-year-old girl, Debra May Helmick."

Mr. Swerling ended with, "The Solicitor asked for revenge, and I ask for mercy. Larry Gene Bell is sick. He's ill. He's got a mental disorder. The death penalty is the ultimate penalty there is. Death by electrocution is final. All we ask you for is justice. In this case, justice means a recommendation of mercy, a recommendation that Mr. Bell not be put to death. That he be sentenced to life imprisonment."

The jury retired to the jury room at 11:39 a.m., April 2, 1987, and began their deliberations. After an hour and seven minutes they had a verdict.

Judge Richter asked the defendant to stand as the Clerk of Court published the verdict.

*The State vs. Larry Gene Bell*: We the jury, in the above-entitled case having found beyond a reasonable doubt that a murder was committed while in the commission of the statutory aggravating circumstance of kidnapping recommend to the court that the defendant, Larry Gene Bell, be sentenced to death for the murder of Debra May Helmick.

Judge Smith sentenced Larry Gene Bell to suffer death by electrocution on May 18, 1987.

Bell did not die on his set execution date. The verdict was automatically appealed to the State Supreme Court, as was the appeal for the death penalty Bell received a year previously for Shari's murder.

This began years of appeals for twice-convicted murderer Larry Gene Bell.

### EXECUTION

On Thursday, October 3, 1996, the State Supreme Court and the fourth U.S. Circuit Court of Appeals turned down last-minute appeals from Bell's lawyers to stop his execution, and South Carolina Governor David Beasley refused to grant clemency.

During Bell's years in prison, I felt that I was going to be in the crowd at the prison when he was executed, but as I slowly drove up, my heart told me no. I didn't stop. I turned toward home, and I thought of life, not death.

In the peacefulness of my home, I watched the news when the announcement was read: "The death sentence of Larry Gene Bell was carried out at 1:12 a.m., Friday, October 4, 1996."

*Most of us continue to believe that those who show utter contempt for human life by committing remorseless premeditated murder justly forfeit the right to their own life.*

Alex Kozinski, U.S. Ninth Circuit Court of Appeals

Life is an amazing process. When I think of the ones whose lives were taken, I think of life, how they touched my life and how they still do.

# Notes

PROLOGUE

1 South Carolina Department of Archives and History, Florence County Court Docket, March 1954.

2 South Carolina punishment for murder statute, Statutes of South Carolina 1894, Vol. XXI, Section 109, 785.

SOUTH CAROLINA LAW ENFORCEMENT DIVISION

3 Bruce Littlejohn, Littlejohn's Political Memoirs (1934–1988) (Spartanburg, SC: private printing, 1989).

FORENSIC PHOTOGRAPHY

4 State of South Carolina v. Warren Douglas Manning, 24727 (Supreme Court of South Carolina).

SOUTH CAROLINA DEATH PENALTY

5 South Carolina Code of Laws 1976, Section 16-3-10.

6 Statutes of South Carolina 1869, Vol. XIV.

7 Statutes of South Carolina, 1894, Vol. XXI, Section 109, 785.

8 Furman v. Georgia, 408 U.S. 238 (1972).

9 Acts and Joint Resolution General Assembly, State of S.C., Sec. 1-16-52, 236l.

10 Gregg v. Georgia, 428 U.S. 153 (1976).

11 South Carolina Code of Laws 1976, Title 16, 16-3-20.

12 Appellate Practice in South Carolina, second edition (2002).

13 www.doc.sc.gov/publicinformation/capitalpunishment

# Notes

## My First Month
14 www.firearmsID.com
15 *State of South Carolina v. Joseph Carl Shaw*, 20973 (Supreme Court of South Carolina).

## He Said, He Said
16 Lt. Tom Darnell (SLED agent/fingerprint examiner), in conversation with the author, 2001; John Christy (SLED agent/fingerprint examiner), in conversation with the author, 2001.
17 *State of South Carolina v. Tommy Lee Campbell*, court transcript; testimony by Lt. Tom Darnell, SLED agent/fingerprint examiner.
18 Diane Bodie (retired SLED agent/fingerprint examiner), in conversation with the author, 2001.

## The Barbell
19 www.ccs.neu.edu/home/feneric/cyanoacrylate.html
20 Don Girndt (former SLED agent/fingerprint examiner), in conversation with the author, 2001.
21 Ibid.

## Signature Written in Blood
22 South Carolina Code of Laws 1976, Title 16, 16-3-20 (revised 2003), 99.

## The Body Print
23 Charles E. Counts, "Utilizing Amido for the Development of Latent Prints" (article, International Association of Identification Conference, Conyers, GA, August 1993).

## The Business Card
24 Charles "Chuck" Counts (former SLED agent/fingerprint examiner), in conversation with the author, 2001; John Christy.

## The Rocking Chair
25 *State of South Carolina v. Donney Council*, 24932 (Supreme Court of South Carolina).
26 C.L. Davis (1998) Mitochondrial DNA: *State v. Paul Ware*, Profiles in DNA 1(3), 6,7.

## Twenty-eight Days of Terror
27 Lt. Gaile Heath (SLED questioned documents examiner), in conversation with the author, 2001.

# Bibliography

Acts and Joint Resolution General Assembly, State of South Carolina, Section 1-16-52, 236l.

Appellate Practice in South Carolina, second edition, 2002.

Bodie, Diane (retired SLED agent/fingerprint examiner), in conversation with author, 2001.

Christy, John (SLED agent/fingerprint examiner), in conversation with author, 2001.

Counts, Charles "Chuck" (former SLED agent/fingerprint examiner), in conversation with author, 2001.

Counts, Charles E. "Utilizing Amido for the Development of Latent Prints." Personal article, International Association of Identification Conference, Conyers, GA, August 1993.

Darnell, Lieutenant Tom (SLED agent/fingerprint examiner), in conversation with author, 2001.

Davis, C.L. (1998) Mitochondrial DNA: *State v. Paul Ware*, Profiles in DNA 1(3), 6, 7. www.promega.com/profiles/103/ProfilesinDNA_103_06.pdf

*Furman v. Georgia*, 408 U.S. 238, 1972.

Girndt, Don (former SLED agent/fingerprint examiner), in conversation with author, 2001.

*Gregg v. Georgia*, 428 U.S. 153, 1976.

Heath, Lieutenant Gaile (SLED questioned documents examiner), in conversation with author, 2001.

Littlejohn, Bruce. *Littlejohn's Political Memoirs* (1934-1988), Spartanburg, SC: Bruce Littlejohn, private printing, 1989.

Powell, Captain Walter (retired SLED agent), in conversation with author, 2005.

SLED investigative case files, victims: Betty Claire Cain, Harvey Allen, Betty Swank, Tommy Taylor, Carlotta Harness, Bill Moon, Myrtie Moon, Wanda Summers, Louise Sellers, Linda Cope, Phillip Earl Reed, Maxine Davis, Nadine Poole, Elizabeth Gatti, Jennifer Martin, Nancy Harrington, Kimberly Sims, Donna Sims, Ronnie Sims, Etha Mae Thompson, Michelle Merchant, Lula Mae Bass, George Radford, Shari Faye Smith and Debra May Helmick.

South Carolina Code of Laws 1976, Section 16-3-10.

South Carolina Code of Laws 1976, Title 16, 16-3-20.

South Carolina Code of Laws 1976, Title 16, 16-3-20 (revised 2003), 99.

South Carolina Department of Archives and History, Florence County Court Docket, March 1954.

South Carolina punishment for murder statute, Statutes of South Carolina 1894, Vol. XXI, Section 109, 785.

*State of South Carolina v. Donney Council*, Opinion No. 24932, Supreme Court of South Carolina.

*State of South Carolina v. Ellis Franklin*, No. 24190, Supreme Court of South Carolina.

*State of South Carolina v. Joseph Carl Shaw and James Terry Roach*, court transcripts.

*State of South Carolina v. Joseph Carl Shaw*, No. 20973, Supreme Court of South Carolina.

*State of South Carolina v. Larry Gene Bell*, court transcripts.

*State of South Carolina v. Terry Lee Campbell*, court transcripts.

*State of South Carolina v. Warren Douglas Manning*, Opinion No. 24727, Supreme Court of South Carolina.

Statutes of South Carolina 1869, Volume XIV.

Statutes of South Carolina, 1894, Volume XXI, Section 109, 785.

Vachss, Andrew. "The Difference Between 'Sick' and 'Evil.'" *Parade*, July 14, 2002.

Wilson, Major Jim (retired SLED agent), in conversation with author, 2005.

# Bibliography

## NEWSPAPERS

*Associated Press*
*Columbia Record*
*Dillon Herald*
*Florence Morning News*
*Georgetown Times*
*The Item*, Sumter, SC
*Manning Times*
*News and Courier*
*Spartanburg Herald*
*The State*
*Sun News*, Myrtle Beach, SC
*United Press International*

## WEBSITES

www.ccs.neu.edu/home/feneric/cyanoacrylate.html

www.doc.sc.gov/publicinformation/capital punishment

www. firearmsID.com

www.promega.com/profiles/103/ProfilesinDNA_103_06.pdf

www.sled.state.sc.us

www.vachss.com

# About the Author

Lieutenant Rita Y. Shuler was supervisory special agent of the Forensic Photography Department with the South Carolina Law Enforcement Division (SLED) for twenty-four years. She interfaced with the attorney general's office, solicitors and investigators, providing photographic evidence assistance in the prosecution of thousands of criminal cases.

Her interest in photography started as a hobby at the age of nine with a Kodak brownie camera.

Before her career as forensic photographer, she worked in the medical field as a radiologic technologist for twelve years. Her interest in forensic science evolved when she x-rayed homicide victims to assist with criminal investigations.

Shuler received her specialized law enforcement photography training at the South Carolina Criminal Justice Academy in Columbia, South Carolina, and the FBI Academy in Quantico, Virginia.

Shuler holds a special love for South Carolina's coast and is a devoted crabber and runner. She resides in Irmo, South Carolina.